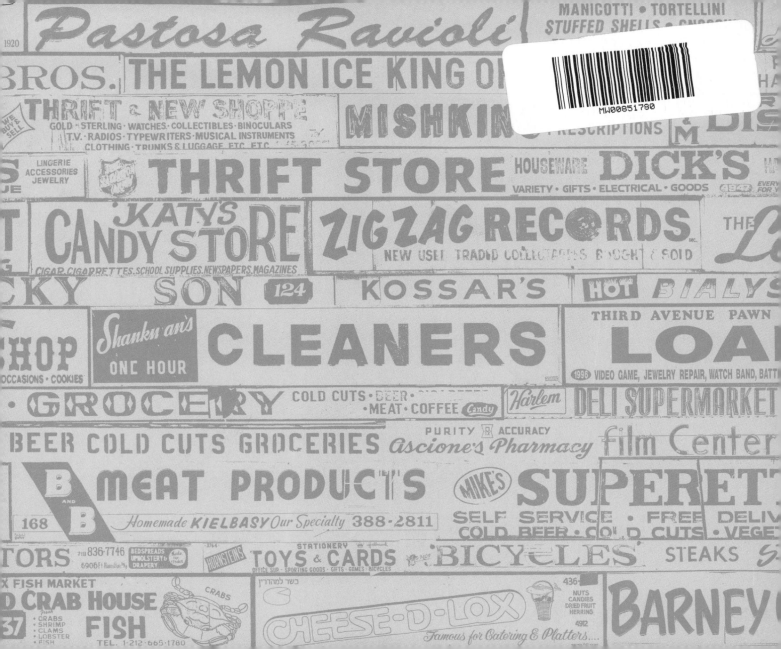

GINGKO PRESS

STORE

THE DISAPPEARING FACE OF NEW YORK

FRONT

James T. & Karla L. Murray

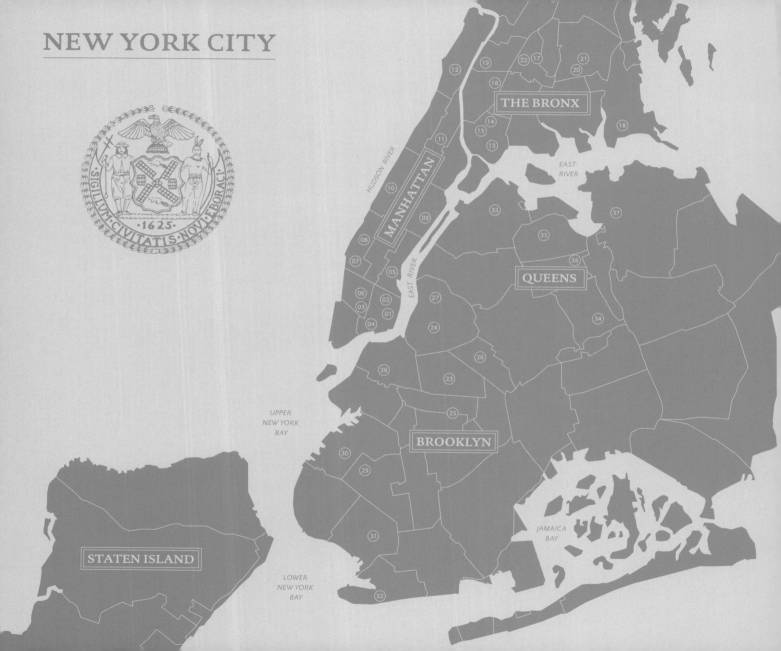

NEW YORK CITY

THE BRONX

MANHATTAN

HUDSON RIVER

EAST RIVER

EAST RIVER

QUEENS

BROOKLYN

STATEN ISLAND

UPPER NEW YORK BAY

LOWER NEW YORK BAY

JAMAICA BAY

SIGILLVM · CIVITATIS · NOVI · EBORACI · 1625

CONTENTS

INTRODUCTION

We have been documenting New York City's storefronts for over eight years. They are arranged here by neighborhood and borough. The location of each storefront is captioned below the image, along with the year the photograph was taken. A brief description of the area and store is provided, and where possible, an interview with the owner or manager is included.

Astoundingly, almost one-third of the stores pictured here have disappeared. This is a trend we couldn't help noticing early on, and what set this project in motion. We happened to witness first hand the alarming rate at which the shops were disappearing, and decided to preserve what we could of what remained. The story of New York City's storefronts is one that had to be told.

Our journey began while photographing the city's streets and walls for an altogether different project. During the late 1990's, we combed the streets of New York City searching out and documenting its graffiti art scene for a book we were making that also involved large-scale photography. In the process of publishing two books and several articles documenting graffiti art, we got to travel and discover many distant neighborhoods of the city. The nature of graffiti art is such that it constantly changes as new art covers what had been there before. We would often return to the very same locations and see new artwork there. This necessitated many trips to a particular block. Despite the short time frame between visits however, we noticed that some blocks looked drastically different. Many neighborhood stores had closed, or we would come across 'old' stores, still in business, but somehow different. They were either refaced, remodeled, or original signage had been substituted with new, bright and shiny plastic awnings. The whole look and feel of the neighborhood had changed and much of its individuality and charm had gone. The result was unsettling.

The traditional storefront that has prevailed in some cases for nearly a century is facing several new setbacks. These family-run businesses started out as traditional 'mom and pop' stores, and there was a time when they defined our neighborhoods. Many were humble stores tucked away on narrow side streets, while others had become well-known institutions on historic avenues. Each store turned out to be as unique as their customers, run by owners with a commitment to tradition and special service. The neighborhood store has always been a foothold for new immigrants and a comfortable place where familiar languages are spoken, where ethnic foods and culture are present. These shops are lifelines for their communities, vital to the residents who depend on them for a multitude of needs. When these shops fail, the neighborhood itself is affected. Not only are these modest institutions falling away in the face of modernization and conformity, the once unique appearance and character of our colorful streets suffer in the process.

We made it our mission to thoroughly document these stores. We set out with our 35 mm camera and micro-cassette recorder. After taking only a few pictures and speaking with only a handful of storeowners, we knew we had a compelling story. Many storeowners felt honored that we would take the time to photograph their business and ask them about their store's history. We often sat down with them for hours, talking and reminiscing. We felt welcomed into their 'homes' and many wouldn't let us leave without taking 'tokens' of their appreciation such as loaves of bread, pastries, sausages, or pizza. We taped the interviews with a recorder, it being less obtrusive than a video camera.

Our choice to use a 35 mm film camera, rather than a digital camera was obvious; we wanted to remain 'old-school' like the stores we were documenting. We also produced panoramic composite photographs depicting the feel of entire blocks. This was our only concession to modern technology: to combine successive single 35 mm film images of rows of storefronts, which comprise an entire city block, into a seamless linear presentation using a computer. With these panoramas, the viewer gains a bold, new perspective. Splendid details such as signage, architectural adornment, and hand-made window displays are presented in context, as they exist on the street. These panoramic photographs are the only way to view these entire blocks of storefronts at once, with no obstruction from parking meters, street signs, parked automobiles and trucks,

or any other element of New York's crowded sidewalks.

There is no typical New Yorker but there are quite distinct neighborhoods in New York City, often defined, in part, by their storefronts. There is much to discover in these photographs about the color and character of entire streets. With or without a personal connection to New York City, anyone can benefit from this visualization of the city beyond the scope of the most thorough visitor's guide or observant resident.

In our interviews, we learned so many fascinating details from the owners about the struggles of surviving as a business in New York City. One of the most common things we heard was how their neighborhoods have changed over the years and how this has affected their business. Gentrification and skyrocketing rents were huge concerns. Owners who were fortunate enough to own the entire building where the business was located still worried about the future. In some cases they had no one in their family who wanted to take over the business when they retire, bringing to an end a long line of family tradition. Many owners told us about New York City's rules and regulations concerning store signage and awnings, and the aggravation and huge expenses these cause. We had no idea permits and fees were required for neon signs or large overhanging signs, and that the city is no longer issuing new permits. In fact in many areas of the city, strict zoning ensures that storefront signage and awnings remain discreet and not hang over 18 inches from the sidewalk. Older stores are often forced to comply with these newer regulations and must modernize despite the owners' wishes.

The owners in their own words tell each story. The stories are interesting and give witness to a rich history. There is much to learn and reflect upon. Some of the highlights included finding out that true delicatessens like KATZ'S DELICATESSEN in the Lower East Side are rare because they continue a tradition of meat preparation and preservation that pre-dates refrigeration. We discovered that MCSORLEY'S OLD ALE HOUSE in the East Village was the last bar in New York City to admit only men. We were dismayed to learn that the closure of E. KUROWYCKY AND SONS MEAT MARKET in our own neighborhood of the East Village occurred because the owner was suddenly forced to remove the smoked ham, bacon, salami, and pork kielbasa hanging from hooks in his store window. A fate shared by many. We heard that the water in New York City is crucial to the resultant taste and texture of homemade mozzarella. Many cheese-producing shops that relocated out-of-state must now arrange to have New York's water tanked in to their shops, sometimes as far as to California! We discovered the oldest teahouse in Chinatown, learned that CAFFÉ REGGIO in Greenwich Village was the first to introduce cappuccino into the United States, and could confirm first-hand that the C & N EVERYTHING STORE in The Bronx literally does sell everything! THE WONDER WHEEL in Coney Island was bought as a wedding present for the wife of its owner. The owner's son told us the gift was akin to "a ring so big that everyone in the world would see how much he loved her." The birthplace of the teddy bear, next door to JIMMY'S STATIONERY & TOYS in Bedford-Stuyvesant, had President Teddy Roosevelt's personal blessing.

This book is arranged into roughly five chapters corresponding to the five boroughs of New York City: Manhattan, The Bronx, Brooklyn, Queens and Staten Island. All five boroughs were created in 1898, during consolidation of the government of the County of New York, when the city's current boundaries were established. Brooklyn (Kings County) was actually an independent city until it merged with the County of New York in 1898, which then included parts of The Bronx, Staten Island (Richmond County) and the western portion of Queens. Throughout all five boroughs there are many distinct neighborhoods, each with its own interesting history, extraordinary character, and ethnic background.

We hope and wish these photographs and stories will help preserve an important part of New York City and bring awareness to the importance of maintaining it. These storefronts have the city's history etched in their facades. They set the pulse, life and texture of their communities.

— JAMES & KARLA MURRAY *New York City, August 2008*

MANHATTAN

is the smallest in area of the five boroughs of New York City. It consists primarily of the island of Manhattan and the neighborhood of Marble Hill, which is geographically part of the Bronx. The borough also consists of several islands, including Roosevelt Island, Randall's Island, Ward's Island, Governors Island and Liberty Island. Uncertainty surrounds the origin of the name Manhattan but it has been traced to various Native American words, including manahactanienk ('place of general inebriation'), manahatouh ('place where timber is procured for bows and arrows'), menatay ('island'). The name first appeared on a map in 1610 as Manahatta. Manhattan is the oldest and densest of all the boroughs and its southeastern tip was the first part of New York City to be settled. As more immigrants arrived, the population gradually moved northward.

Manhattan, according to the grid plan adopted in 1811, is loosely divided into downtown, midtown and uptown with Fifth Avenue dividing the East Side from the West Side. Central Park, which runs from 59th Street to 106th Street between Fifth and Eighth Avenues, was not part of the 1811 grid plan. There are twelve numbered avenues running north or south. They are approximately parallel to the shore of the Hudson River beginning with Twelfth Avenue on the West Side. There are also several intermittent avenues east of First Avenue, including four additional lettered avenues, Avenue A to Avenue D in Manhattan's East Village. The numbered streets in Manhattan run east and west, or in both directions, and there are almost exactly 20 city blocks per mile. Despite its small size, the borough became the business and financial heart of the United States as well as home to many of the institutions, buildings, and diverse neighborhoods that have made New York City famous.

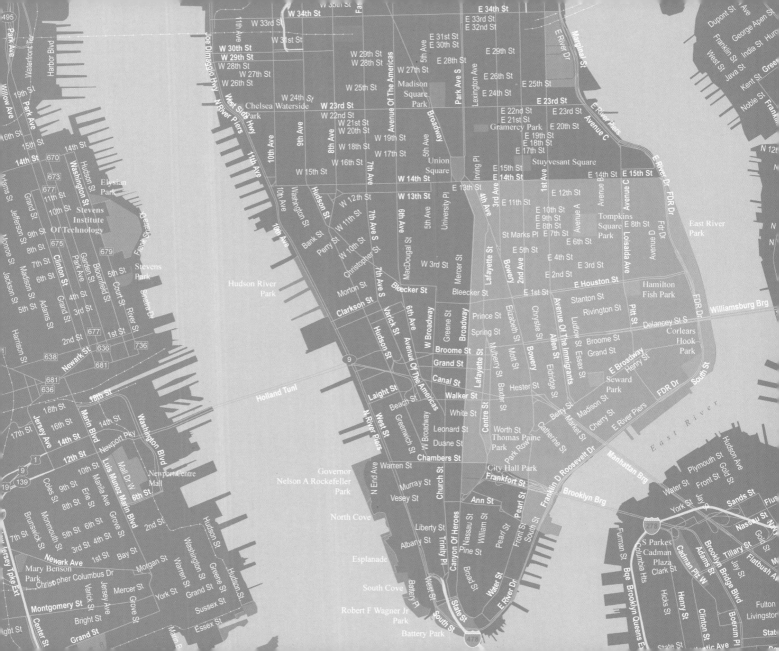

The Lower East Side

MANHATTAN

The Lower East Side is a vast area of lower Manhattan, which is bounded to the north by 14th Street, to the east by the East River, to the south by Fulton and Franklin Streets, and to the west by Pearl Street and Broadway. Within its boundaries are the neighborhoods of the East Village, Chinatown, Little Italy, Tompkins Square, Astor Place, and NoLita. The first tenements in New York City were erected in The Lower East Side in 1833 and the area quickly became a big-city slum as tens of thousands of immigrant families, first the Irish and the Germans, then followed by Italian immigrants and Jewish immigrants from Eastern Europe and finally the Hispanics and Chinese settled in the neighborhood, despite unprecedented overcrowding and poverty. As the different immigrant groups became successful, they moved out of the area's overcrowded tenements, and the neighborhood changed drastically.

The Lower East Side was the first home to many Eastern European Jews and by 1910 they made up almost a quarter of the City's population. Many of them moved into overcrowded tenements and set up pushcarts and tiny market stalls throughout the streets of the Lower East Side, where they sold food and dry goods. Street peddling was popular among immigrants because it required little money, skills, or knowledge of English. It was an alternative to the sweatshop but still required long hours of hard work. By the early 1900's, the streets in the Lower East Side resembled the Jewish quarters of old European cities and became known as the 'Ghetto Market.'

On December 1, 1938, Mayor Fiorello La Guardia outlawed all pushcarts in the city and abolished all open-air markets. The streets of the Lower East Side instead became lined with shops. All business was moved entirely indoors.

IDEAL HOSIERY is a family-owned business that was opened in 1950 by Len Friedman. The sign and storefront are original.

GERTEL'S BAKERY (›Page 14) was in business from 1914 until June of 2007. This Jewish bakery, owned by Abe Stern, was known for its rugelach, hamantaschen and challah bread, which were all baked on premises. In Gertel's place, a developer plans to build an eight-story condominium.

M. SCHAMES & SON (›Page 15) paint store has been in the same family for four generations. Mendel Schames and his eldest son, Leo emigrated to the United States from Russia in the early 1900's and made their home on New York's Lower East Side. Marshall Schames now owns M. Schames & Son Paint along with his son Brian, a fourth-generation family owner. They have been in their present location on Essex Street since 1945.

Fifteen years ago we were seeing the end of a mostly Jewish neighborhood. The Kosher Dairy restaurant next door has long since closed, along with the Garden Cafeteria and the Forward newspaper. Chinatown has grown to the point of swallowing up most of Little Italy with Cantonese replacing Spanish and Yiddish as the predominant language on our small corner of Essex Street. Ninety-five percent of our business is contractor-based, and customer service is indisputably the key element to our success. I mean extreme service. We will do just about anything to get the product to the customer, and in a demanding market like New York City, the requests aren't always reasonable. One time we had this customer named Freddy who needed some paint on St. Patrick's Day. This sounds simple but the building happened to be located in the middle of the parade route. We made our way through somehow and delivered one gallon of paint to the 43rd floor. We never say no. We've built our reputation on it.

Another incident happened around 1985 when a frantic woman entered the store in the afternoon, ran into the back room and yelled, "Help me, help me, he's going to kill me" in Spanish. A moment later, an irate man bursts through the door, also yelling in Spanish, "Where is she? I'm going to kill her." Hoping to avoid bloodshed, our staff managed to corral the angry man, and he retreated, bumping into two Hassidic customers. Enraged, he grabbed one of them by the collar and punched him in the face, knocking him out. Everyone was suitably shocked; this was the equivalent of attacking a priest! Hassidim are ultra-Orthodox Jews who are averse to getting involved in disputes, so imagine our surprise when the second Hassid flipped the assailant and proceeded to beat him, as the accosted Hassid pulled a gun. Turns out they were really two undercover cops staked out in preparation for a drug bust. My father, Marshall, later told this story to his friend, George Ratner, the former owner of Paragon Paint who was also a playwright. George wrote a script based on the story, which eventually made its way off-Broadway. I believe the reviews were mixed.

— BRIAN SCHAMES *fourth-generation owner*

LICHTENSTEIN & CO. WOOLENS AND TAILOR SUPPLIES (›Page 16–17) located at the corner of Delancey and Eldridge Streets has been in operation on the Lower East Side since 1903. This textile business was founded in 1502 by Mr. Lichtenstein's ancestors in North Africa, and has remained a vital family-run business for over 500 years. The present storefront and signs are from the 1960's.

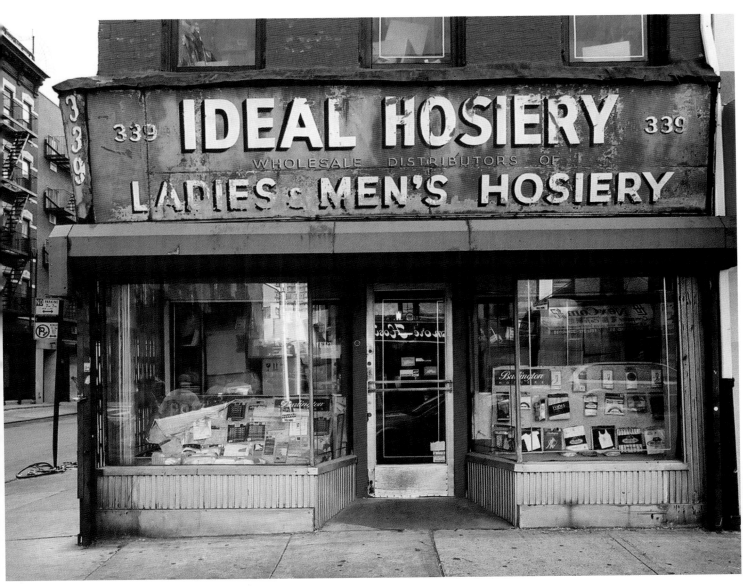

Grand Street at Ludlow Street (2004)

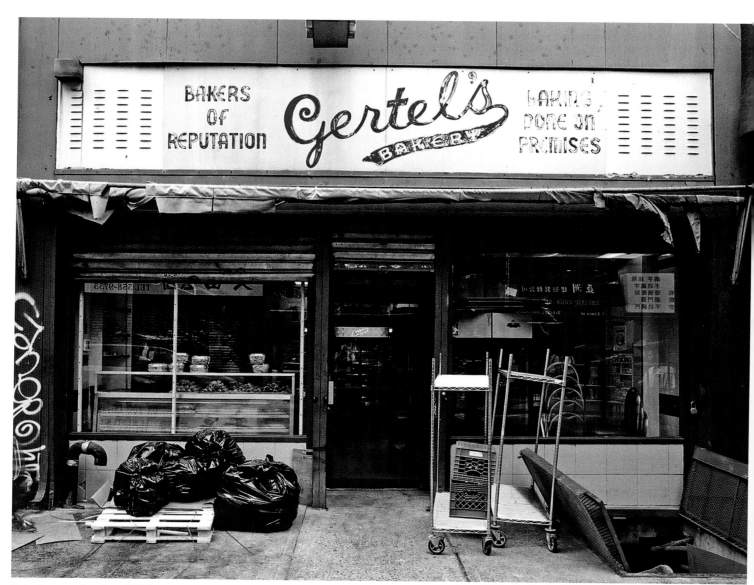

Hester Street near Essex Street (2004)

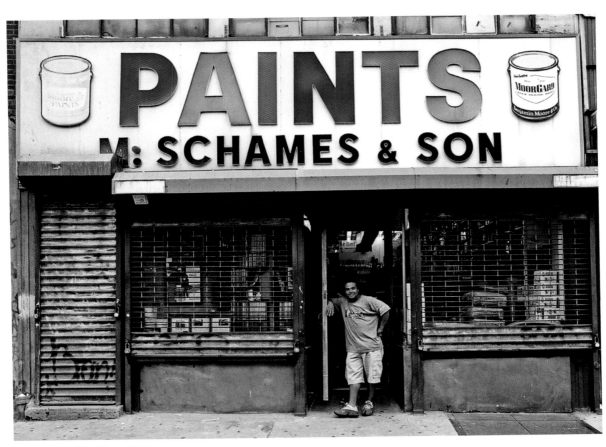

Essex Street near Canal Street (2004)

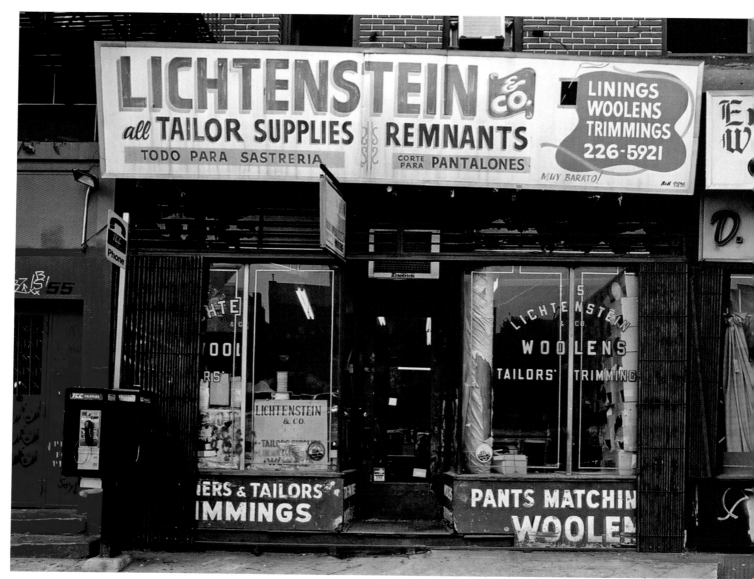

Delancey Street at Eldridge Street (2004)

016.017

YONAH SCHIMMEL KNISH BAKERY has been in operation since 1910. The storefront and interior are original, including the sign, tin ceilings, tables, wood-framed glass showcases, and brick ovens. Rabbi Yonah Schimmel emigrated from Romania and started his own knish business on the Lower East Side by selling from a pushcart until he opened this restaurant. The knish was developed by Eastern European Jews who wrapped dough around mashed potatoes or kasha (buckwheat groats) as a way of adding interest to an affordable but monotonous diet. The knish became a very popular item in the early 1900's because it was cheap and filling.

Yonah Schimmel's knishes are the best because we make them by hand using an old family recipe. We don't use any preservatives. Everything is natural. We make them fresh every day and we bake them. They are not fried! We cook the potatoes, broccoli, spinach ... all the stuffings, all through the night. At the same time we make the dough and then the dough has to rise for a while and then we add the stuffings and bake them in the oven. The round potato knish is the best-selling but we also stuff the knishes with kasha and other types of vegetables or with cheese and berries. This store is now owned by the 4th generation family member but nothing has changed here over the years. Everything is the same. The recipe is the same and the potato and salt and pepper are the same. We also sell homemade yogurt here that is still made from the same culture that was brought over from Romania in the late 1800's. It takes time to make yogurt. You can't just make it in one day ... but when it's hot weather, the process goes faster. Our yogurt is very good for the stomach. Lots of people with stomach troubles get out of Beth Israel Hospital and come straight down here. They drink a little yogurt

and they feel better. It's better than medicine. We sell bagels here too but we don't care about bagels, we care about knishes.

— ALEX VOFFMAN *manager*

KATZ'S DELICATESSEN (›Page 20–21) has been in business since 1888. It's famous for its Jewish deli foods such as kosher hot dogs, hot pastrami, and corned beef sandwiches. A ticket is given upon entering, which serves as a bill that must be handed in when leaving. According to *The Encyclopedia of New York City* more than sixty delicatessens specializing in eastern European Jewish cuisine were open on the Lower East Side by the early 1900's.

True delicatessens like Katz's are rare because they continue a tradition of meat preparation and preservation predating refrigeration. Long before refrigeration, there were methods of prolonging the useful life of food, such as smoking, pickling, and other curing methods. We still have our original storefront and neon signs and the interior is also pretty much unchanged. If you were a customer in 1948 and you came back today, it would look pretty much the same. Originally, the deli was owned by two families, the Katz's and the Icelands, who emigrated here from Eastern Europe. All of the recipes we still use today are from the original Katz and Iceland families, including recipes for pastrami pickling, corned beef preparation, pickling tongue and even for preparing pickles themselves. We prepare and pickle most of our items right on premises. One of our popular items is our corned beef, which is basically brisket beef meat that is pickled or cured into a salted product. We get thousands of pounds of beef brisket delivered a few times a week and we have big tanks located in a huge walk-in refrigerator that we stack the meat into and put salted water into and allow the meat to cure. It takes about six weeks roughly from start to finish for the curing of corned beef.

Pastrami is our most popular selling item and we can go through several thousand pounds of pastrami on its own per week. Our slogan, 'Send A Salami To Your Boy In The Army,' started during World War II. The boy in the army was actually my cousin who was in the Army Air Corps in the Pacific Rim. My uncle was one of the owners at that time and my grandfather was the manager of the store and we had customers coming in that would say to him, "I have a son that's in the service, what can I send him?" So my grandfather would say, "Why don't you do what I do, send a salami to your boy in the army."

I've been working here for over 30 years and the neighborhood has drastically improved. The Lower East Side used to be a neighborhood of immigration and it still is but when I started here in 1976 there was a lot of drug dealing going on along Ludlow, Orchard, and Forsyth Streets. It was pretty rough during the night-time and you'd be a little leery but during the daytime you could still walk around. But now if you come down here at night, and we are open till 3 o'clock in the morning on Friday and Saturday nights, the neighborhood is hopping. There are a lot of new restaurants and bars and nightclubs so the area has really changed for the better in the last fifteen years. There are still enclaves of elderly Jewish people living here from when it used to be very cheap but today there are lots more young professional people who have moved in here from around the country and it's gotten very expensive. We are the last Jewish deli in the neighborhood. When I started here in 1976 there were maybe five or six Jewish delis but now we are the last one and we were always the largest.

— ROBERT ALBINDER *manager*

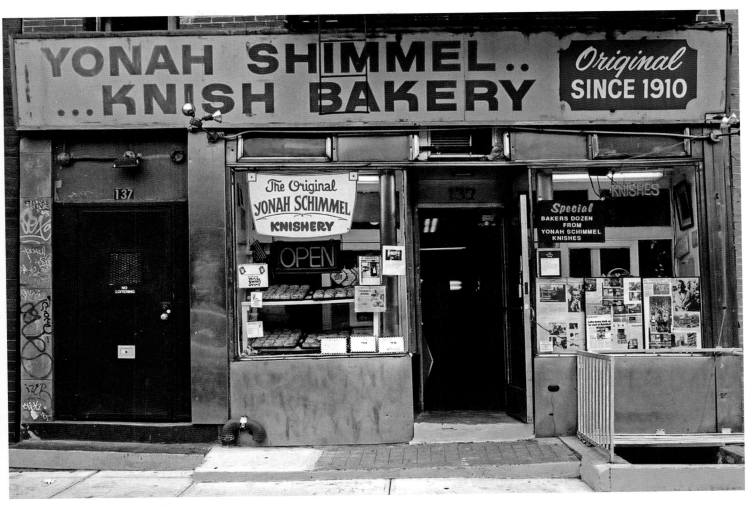

Houston Street near Chrystie Street (2004)

MANHATTAN *The Lower East Side*

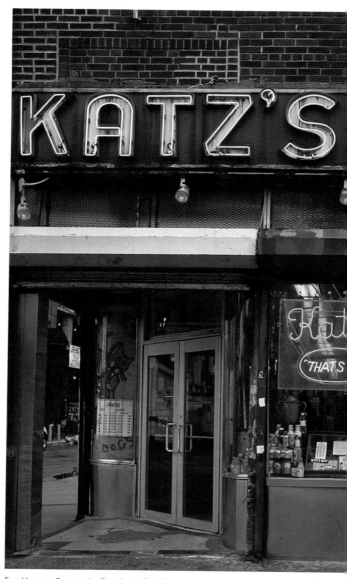

East Houston Street at Ludlow Street (2008)

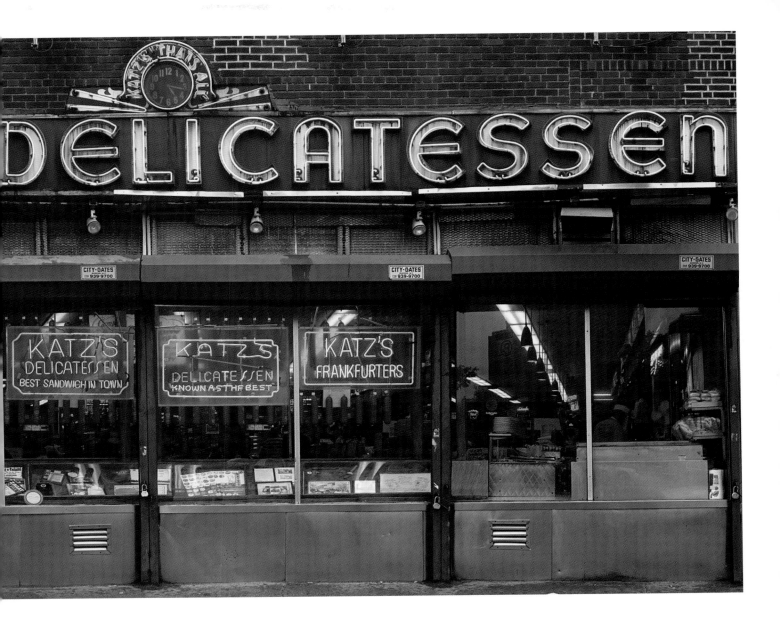

Grand Street between Essex and Norfolk Streets (2005)

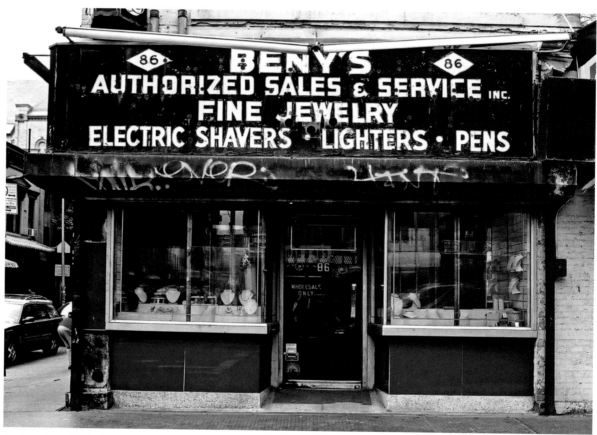

Canal Street near Eldridge Street (2004)

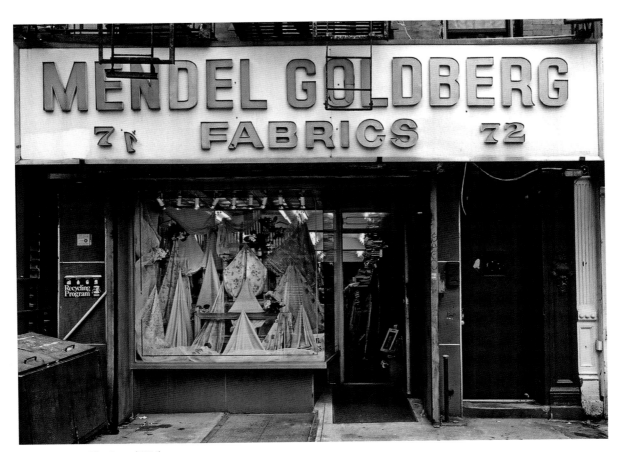

Hester Street near Allen Street (2004)

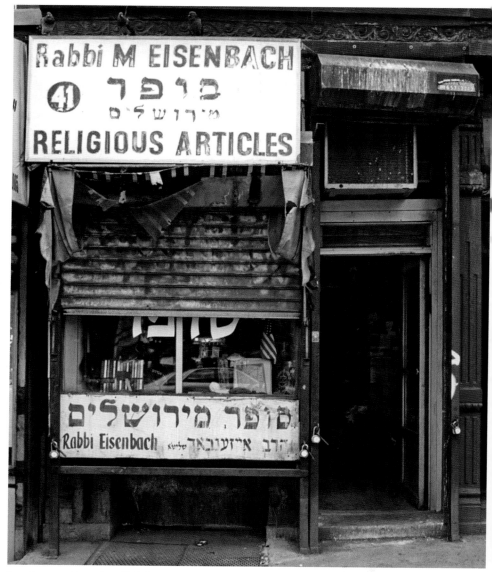

Essex Street near Hester Street (2004)

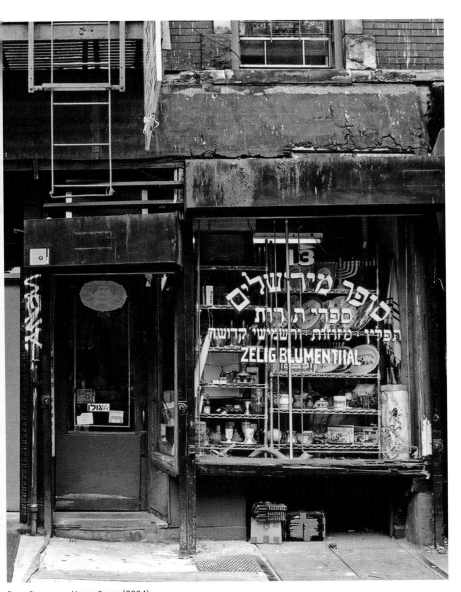

Essex Street near Hester Street (2004)

RUSS & DAUGHTERS APPETIZERS is a fourth-generation family business now run by Joshua Russ Tupper whose grandmother was one of the original founding daughters. The store is known for their smoked salmon and their vast caviar selection. They also carry herring, pickles, sauerkraut, bagels, dried fruits and nuts. According to *The Encyclopedia of New York City*, there were more than four hundred appetizing stores in the city in 1936, including thirty-six on the Lower East Side.

The store was opened by my great-grandfather Joel Russ in 1914 as Russ's Cut Rate Appetizers. He originally had a pushcart around the corner on Orchard Street and then after selling from a pushcart for a while, he decided it would be better economically for him to have a storefront. Maybe he got tired of walking around. The storefront has been renovated over the years and the original store was much narrower in size. Around 1940, my family expanded the store and sometime in the 1950's, we put up the neon sign that stands today. The neon is getting harder and harder to maintain because the ballasts and the starters the sign uses aren't made anymore. But we are going to keep it. The pickling recipes we use here for things we make like the whitefish salad have been handed down from generation to generation but the curing and the smoking of the fish are all done by suppliers because we are not allowed to do those things in Manhattan due to pollution laws. It's always been done in Brooklyn or Upstate New York. Right now, the laws are stricter than ever and at least from the turn of the 20th century, there has never been any smoking of fish allowed here in Manhattan.

The origin of the name appetizing store lies in the Jewish dietary laws under which meat and dairy products may not be eaten or sold together. However, fish and certain dairy products are sold together, like smoked fish and cream cheeses. Because of these strict religious dietary laws, two types of food stores sprang up in New York. Stores that sold pickled, cured and smoked meats were known as delicatessens but another name was needed for the stores that sold fish and dairy products and that's how the name 'appetizing' came to be. But the actual origin of the word is somewhat of a mystery and no one really knows where it came from. It's a word that definitely did not exist in Eastern Europe. It's an American word that some immigrant came up with and it just spread throughout the Lower East Side community. There used to be over thirty appetizing stores on the Lower East Side alone but now this is the only one left in the neighborhood. There are a couple of more uptown on the Upper East and West Side but down here, where it all really started, this is it. When many of the Eastern European immigrants saved enough money to move away from this neighborhood, all the other appetizing stores began to close. A lot of our customers who lived in the neighborhood but now live out west or in Florida still remain loyal to us because we ship everything to them. We ship our items nationwide and we have a website now so we are moving into the future.

We do a lot of shipping because it's nearly impossible to find these items anywhere else. There's really nowhere else in the country where you can find this quality and type of food and that is all because of tradition. The smokehouses around this area have the most experience and make the best product. Certainly there are smokehouses in different parts of the country but nothing like we have here in New York and they've been doing it for over 100 years.

My family owns this building so we will never have to leave this neighborhood. There were a lot of ups and downs in the Lower East Side and now it's turning into one of the hot spots of New York nightlife. So it's back. It's back on top. But the downturn of the neighborhood in the 1980's certainly did hurt our business. We went through difficult times. My uncle was running the business then and I used to come down to work here and just walking from the car into the store was a little concerning. It was a frightening place to walk around in and to be in. It was not some place you would walk around in on the weekend for fun or come out at night to for fun. And now, it's become just that. There are fabulous restaurants and bars around and great boutique shops. Kids want to be down here. And now the grandchildren and great grandchildren of the immigrants who moved away from the Lower East Side are moving back in ironically, and paying a lot more in rent for sure.

— JOSHUA RUSS TUPPER *fourth-generation owner*

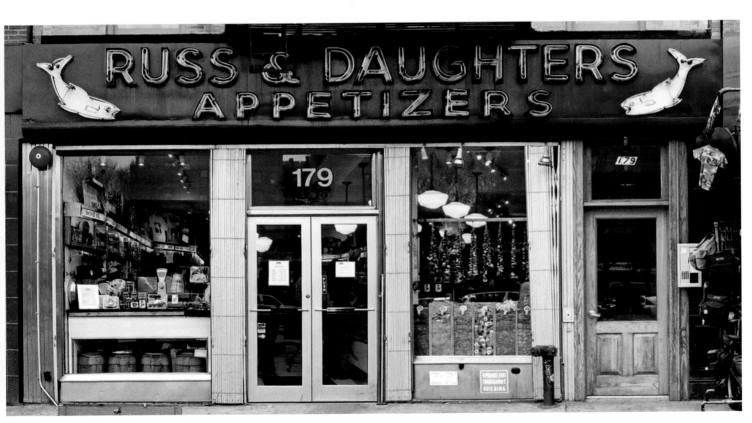

East Houston Street near Orchard Street (2004)

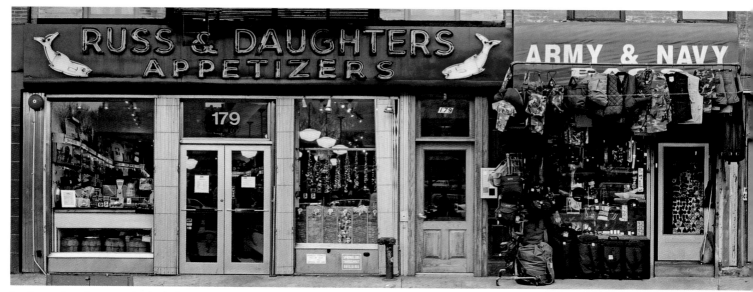

East Houston Street between Orchard and Allen Streets (2004)

The East Village

MANHATTAN

The East Village neighborhood in lower Manhattan is bounded to the north by 14th Street, to the east by Avenue D, to the south by Houston Street, and to the west by the Bowery and 3rd Avenue. Starting in the 1830's large numbers of Germans moved into the East Village, which was considered a part of the Lower East Side. The area became known as 'Klein-deutschland' or 'Little Germany.' When the wealthiest German families left in the early 1900's and moved uptown to Yorkville, Eastern European Jewish immigrants from the overcrowded tenements of the Lower East Side took their place. In the 1960's, the area changed radically and acquired its own identity when intellectuals, artists, musicians, and writers, who were being priced out of Greenwich Village, began moving east. The East Village's cheap rents allowed it to became a center for radical politics and art and the neighborhood became known for its avant-garde theaters, bookshops, bars, poetry houses and coffeehouses. In the 1970's drugs brought about a general decline to the neighborhood and a resulting massive abandonment of housing.

As the Spanish-speaking population increased throughout the 1980's, the area was referred to as 'Loisaida,' derived from the phonetic spelling of the original name Lower East Side. By the 1990's the East Village became the largest community of Ukranians outside the Ukraine and is known as 'Little Odessa.' The East Village today is a thriving, diverse neighborhood.

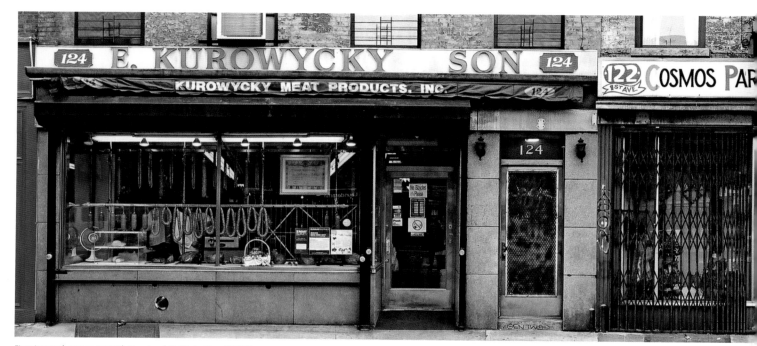

First Avenue between East 7th Street and St. Marks Place (2001)

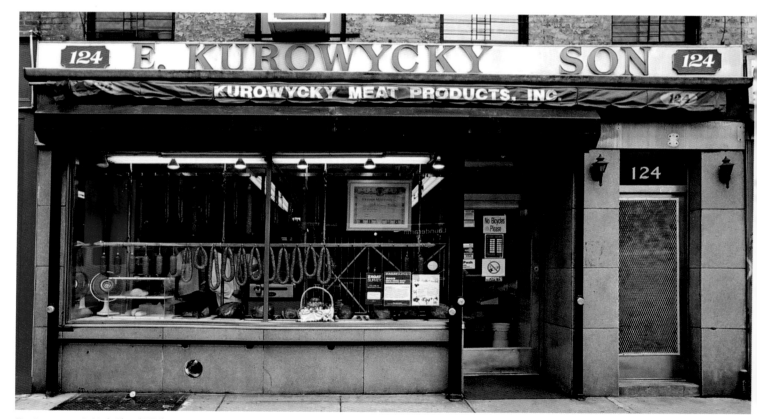

First Avenue near St. Marks Place (2001)

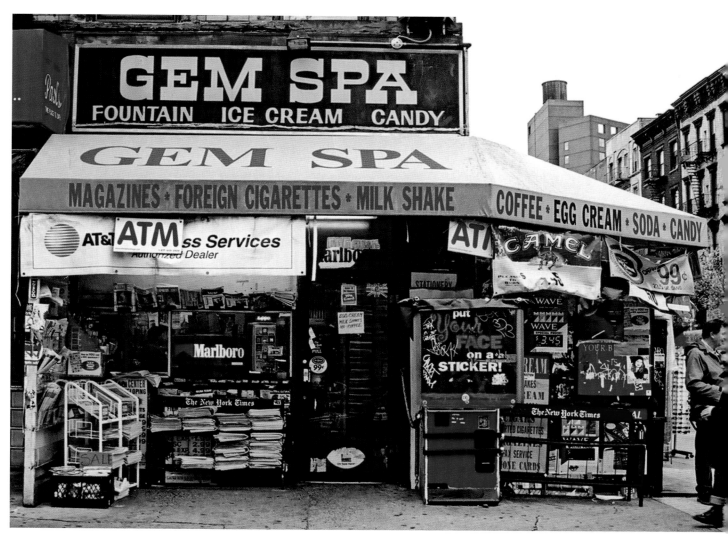

Second Avenue at St. Marks Place (2001)

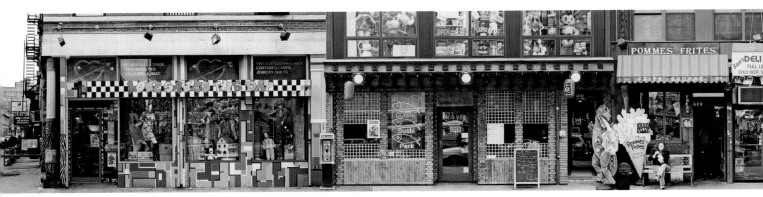

Second Avenue between East 7th Street and St Marks Place (2001)

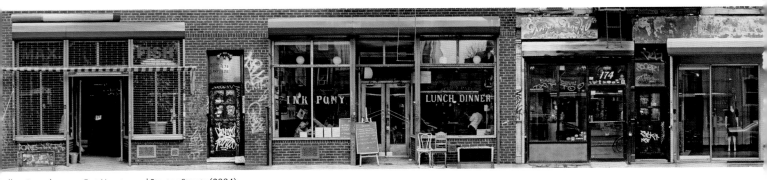

Ludlow Street between East Houston and Stanton Streets (2004)

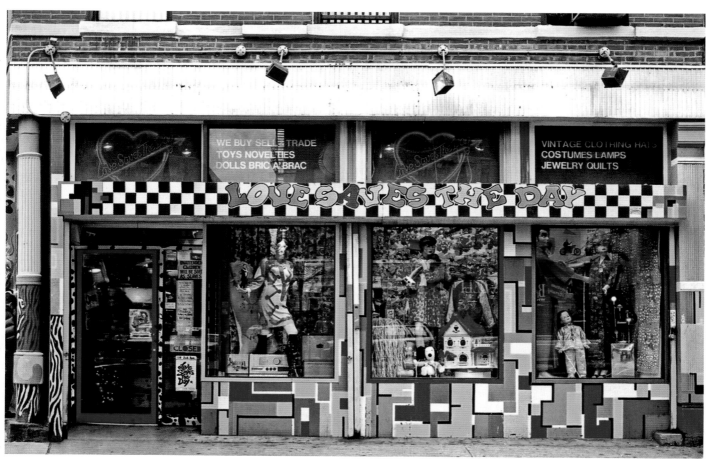

Second Avenue at East 7th Street (2001)

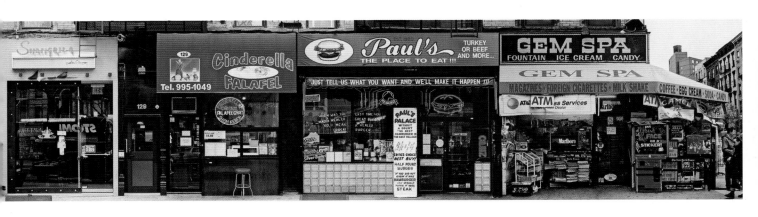

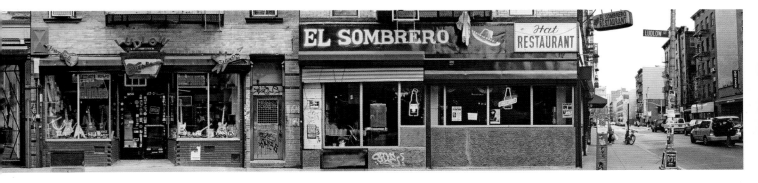

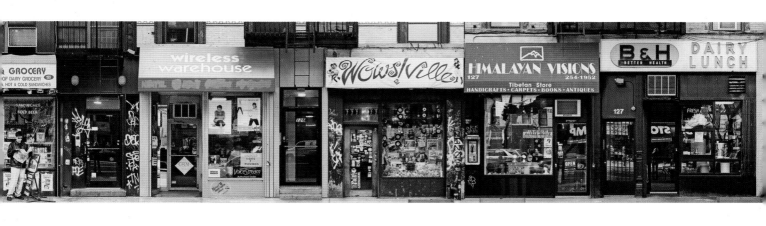

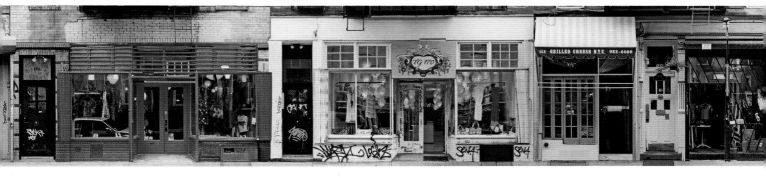

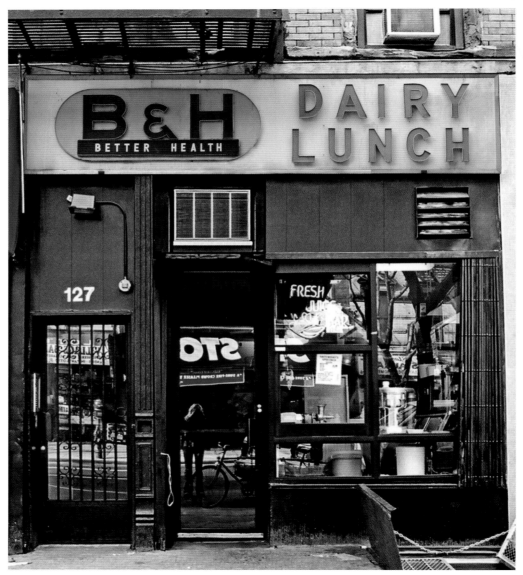

Second Avenue near St. Marks Place (2001)

E. KUROWYCKY & SONS MEAT MARKET (‹Page 36) was in business from 1958 to 2007. This family-owned store specialized in Eastern European sausages and hams.

This store has been a meat market since the 1920's but my family didn't get into this actual space until 1974. Our first store was on this block since 1958, but just two doors over. The smokehouse plant in back is the original from the 1920's and we still have the original tin ceilings and wood shelving. My grandfather got into this business in Ukraine. He was a sausage manufacturer by trade there and then he moved to the United States in 1949. My grandfather's diploma to be in the meat business is hanging in the window of the store. It was almost medieval in Ukraine if you wanted to get into the trade. He first was an apprentice, and then a journeyman, and once you were a master you were awarded a diploma and then you could open up your own store and hire people. The only job he ever had besides working for himself was working for the gentleman who originally owned this meat market. He worked for him for five years and then he opened up his own store. In 1974 he bought this store's business and the entire building.

I learned everything about the meat business from my father and I'm the third generation Kurowycky owner. We make everything we sell on the spot here ourselves. We smoke and prepare all the meat. Everything we do here is done the way my grandfather did it in Eastern Europe before World War II. Nothing has changed. We use the same family recipes. We are allowed to smoke meats on premises because we are grandfathered in as our smoker is concerned, since it's been in operation since the 1920's. You are not really allowed anymore to smoke meats in New York City but since we had this operation pre-existing the law, we are allowed to operate it. We smoke our hams and things like that overnight. Our kielbasas are smoked for a few hours. Our hams and our kielbasas are our best-selling items. We've been fortunate enough over the years to get a lot of publicity from food writers and chefs so people have heard of us, not only neighborhood people.

We still have many customers who used to live in the neighborhood and have moved away but still come back to shop. This East Village neighborhood has changed a lot over the years. It's always traditionally been a very big immigrant neighborhood. It was heavily German, then Polish and Ukranian and now it's a transitional area. It's always in flux but now it's become very expensive. And a lot of younger couples and single people have moved in. I don't think it's a family neighborhood anymore because you don't have the space and it's become fairly expensive to live here. My family owns this building and if I had to pay the kind of rents they get in this neighborhood, I would have been out of business a long time ago. That is what saved me.
— JERRY KUROWYCKY JR. *third-generation owner*

In 2005, Mr. Kurowycky had to remove the smoked ham, bacon, salami, and pork kielbasa, which hung from sharp hooks lining the windows of his store. Agricultural inspectors ordered that the sausages and fresh meats be removed from the windows and kept refrigerated because of potential hazards resulting in E. Coli, staph, salmonella, and listeria infections. In June 2007, Mr. Kurowycky closed his store due to the sharp decline in business.

LOVE SAVES THE DAY (‹Foldout) has been in business since 1966.

This store was originally located down the street on East 7th Street and I moved to this Second Avenue location in 1983. An employee painted the sign and the storefront with a colorful pattern in 1990. When I first opened Love Saves The Day it was more of a vintage clothing store but now I also sell vintage jewelry, bric-a-brac, and toys and collectibles, both old and new. This store is really an institution and many of my customers who don't live in the neighborhood anymore still come back because I carry very unique items. We are also pretty well known because the store was featured in the movie Desperately Seeking Susan, *starring Madonna. This East Village neighborhood has changed so much over the years and is not really a neighborhood anymore as far as the people are concerned. There used to be lots of mom and pop stores in the area and neighborhood people would shop in them but most of the shops have been forced to close because rents have gotten really high. Now the East Village is more upscale and larger chain stores have opened. New people are constantly moving into the neighborhood and it's even become a tourist destination.*
— RICHARD HERSON *owner*

GEM SPA (‹Foldout) has been in business since the 1940's. The current owner, Ray Patel, bought the store in 1986. Gem Spa is famous for its egg creams, a quintessential New York beverage originally served in candy stores throughout the Lower East Side beginning in the 1920's. The egg cream does not contain eggs or cream but is a mixture of very cold milk, seltzer, and flavored syrup. The Gem Spa owners have always kept their milk in the ice cream freezer because one of the keys to making a great egg cream is to use extremely cold milk. It's also 'all in the way you stir it.' Because most of the original soda fountain locations have closed, true egg creams are rapidly disappearing. To this day, Gem Spa continues to make their egg creams using the same recipe and original soda fountain machine from the 1940's. The countermen learned to make egg creams from the previous owner who learned from the previous owner before him. The chocolate, vanilla, and coffee-flavored syrups were once made in the basement by the store's original owner. On a typical weekend night, Gem Spa sells about 70 egg creams.

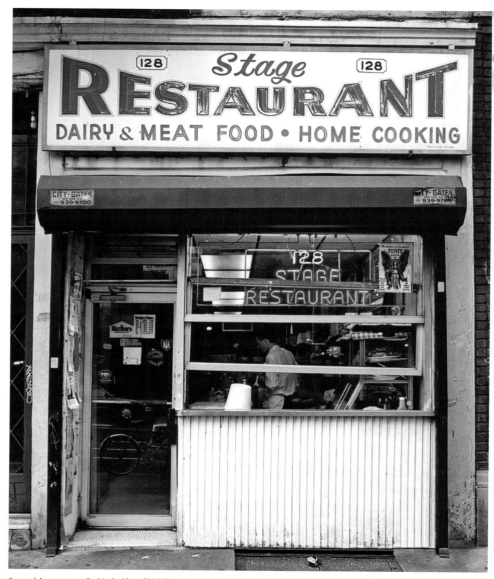

Second Avenue near St. Marks Place (2003)

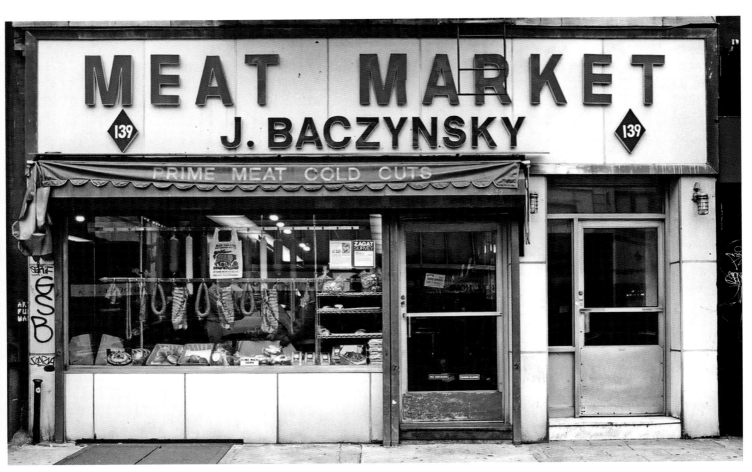

Second Avenue near St. Marks Place (2003)

EAST VILLAGE MEAT MARKET (‹Page 39) has been in business for over 44 years. Julian Baczynsky, the owner, came to New York from Ukraine in 1949 and went to work for a butcher in the area. He later opened his own butcher shop on Avenue B and in 1970, moved into a larger space on Second Avenue. Mr. Bazynsky is now in his 80's and has no children of his own who want to take over the business, so the store is currently being managed by Andrew Ilnicki.

I came to New York from Poland when I was a teenager to visit some relatives and I never left. I started working for Mr. Baczynsky in September 1980 and he taught me everything about the meat business. The most popular item we sell is the Eastern European Kielbasa. The recipe we use to make our homemade sausages is from Ukraine. We make them all by hand in the back of the store and we even have a smoker for the meat. We first select and trim the pork, then we marinate it for a week, grind it, spice it, and stuff it into casings. Finally, the sausages go into the smoker where they slow-cook over hardwood for 4–6 hours. What a lot of people don't know is that we are smoking and baking the sausages at the same time. All you have to do is heat the sausage up when you go home or you can even eat it cold. Our busiest times of the year are Orthodox Easter and Christmas. Many of our customers who have moved out of the neighborhood still come back to get their items for the holidays.

— ANDREW ILNICKI *manager*

BLOCK DRUG STORE is a second-generation family-owned pharmacy. Carmine Jr. Palermo is the owner and pharmacist along with his wife Beth.

This pharmacy originally opened in 1885 but the business was bought by the Block Drug Store chain in the 1920's and that is when the neon sign was installed as well as the cabinetry that we still use today. The Block Drug Store chain went independent in 1942 and my father, Carmine Sr. began working here as a pharmacist in 1962 and later bought the store. I started working behind the counter in 1975 as a 17-year old clerk. I became a licensed pharmacist and worked with my father until he physically retired from here in 2002.

This neighborhood has undergone a dramatic change since I've been working here. In the 1970's it used to be a neighborhood with lots of artists and poets and musicians. There were also a lot of Hispanics in the area. There were definitely more minorities living here than now. Our customer base is vast and many have been coming here for years. We even have customers that we mail prescriptions to in Florida. They don't want to leave us … it's so funny. I also have customers that regularly come here from every borough in New York. Even though they've moved away from the East Village, they come back because there's not too many independently owned drug stores anymore. The pharmacy business has changed a lot. Chain stores are in abundance and sometimes that improves the business of independent stores like mine because of the chain store's lack of ability to help customers personally. It's confusing for the customers at a chain store because there are so many different pharmacists working there all the time. If someone comes back into my store with a problem or complication, it's just me or my wife or even my father. We can talk amongst ourselves and find out what is going on with the customer and their medications. We are more familiar with the patient's background and history. But with chain stores, communication is probably scarce. So it's that attention to the customer that brings them back and also brings in new customers who have gotten fed up with the chain store's service and lack of personal attention.

— CARMINE JR. PALERMO *second-generation pharmacist*

PETER'S GROCERY STORE (›Page 42–43) has been in business since 1947. The storefront and sign are original. It is now being run by the second-generation owner, Pete Migliorini.

My father opened this store when the neighborhood was mostly Irish with some Italians and Polish immigrants. Over the years, the area has become a lot less residential. Many of the apartment buildings have been demolished and/or converted into office towers. I still have some customers that live around here and come in to shop for groceries but most of my business has shifted to office workers on break from their job. I've been working here since I was a kid and have seen many of my old-time customers grow up and have become friends with many of them. I'll even sign for their packages from U.P.S. when they are not home to get them. The delivery guy knows to just leave their stuff with me and that I'll give it to them the next time they stop in the store for something. My family owns this building so I don't have to worry about rent or anything. That's why I'm probably still in business. If I had to pay the going rental rate around here, I'd never survive.

— PETER MIGLIORINI *second-generation owner*

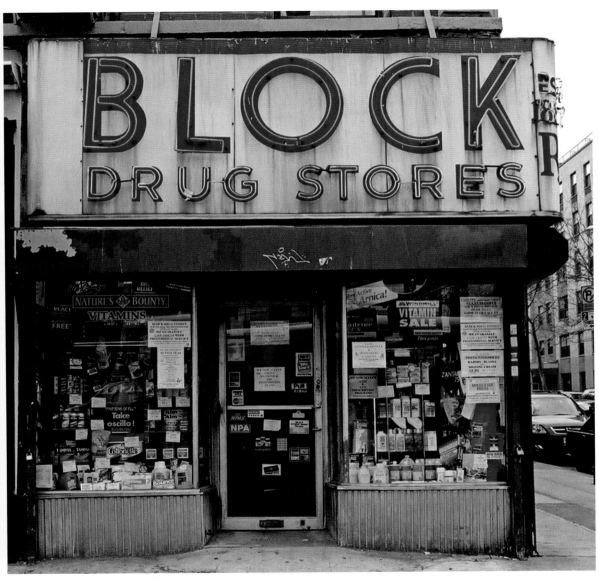

Second Avenue at East 6th Street (2004)

Madison Street near St. James Place (2008)

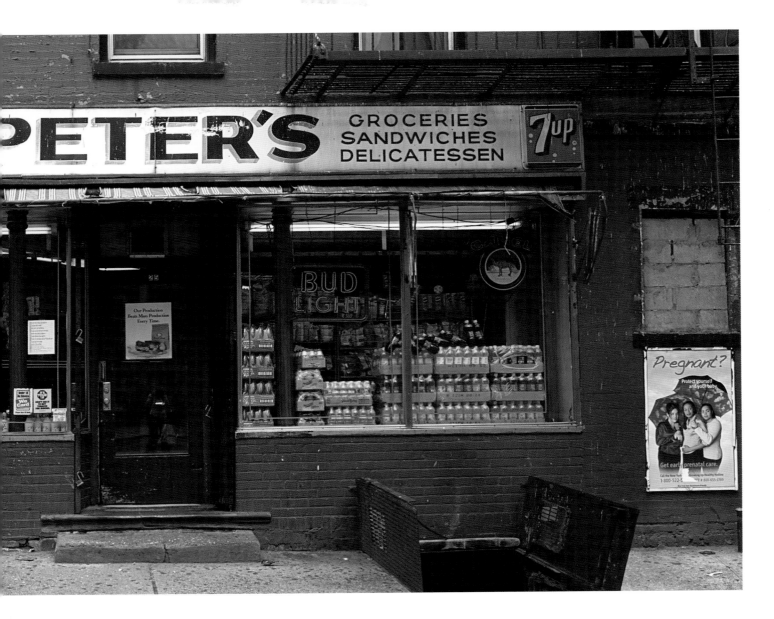

Second Avenue at East First Street (2005)

RAUL CANDY STORE located in Alphabet City has been in business since 1979. The area east of First Avenue between Houston and 14th Street is called Alphabet City because the lettered avenues are named Avenue A, B, C, and D. Until about 1998, this section of the East Village resisted gentrification.

I opened this candy store in 1979 when this neighborhood was really in trouble. Although things have changed for the better, I still care about the children who live around here and I've always tried to keep the neighborhood kids away from drugs. My sign and storefront are original.

— RAUL SANTIAGO *owner*

MOISHE'S BAKERY (›Page 48) has been in business since 1948. This popular kosher Jewish bakery is known for its rugelach, hamantaschen, and challah bread.

My father started this business on Suffolk Street by Grand Street on the Lower East Side in 1948. In 1977 he finally moved the bakery to this location in the East Village. The storefront and sign are all original from 1977. We still bake the same items we did back in 1948, using old family recipes from Romania. Everything is baked right here on the premises fresh every day. We don't use any preservatives of any kind.

— MOISHE *owner*

THE 2ND AVE DELI (›Page 49) opened in 1954 by Abe Lebewohl, a Jewish immigrant from Russia. Abe Lebewohl was murdered in 1996 during a robbery after the restaurant had closed for the night. Abe's brother Jack took over the deli after Abe's death, but had to close the business in 2006 because the rent on the 2,800 square foot space was raised from $24,000 a month to $33,000 a month. Jeremy Lebewohl, Abe's nephew, re-opened the business in 2007, on East 33rd Street at Third Avenue. He was able to revive the family's legacy by buying the building and opening at a slightly smaller location than the original. It's open 24/7 and now features a liquor license plus gratis gribenes (deep-fried chicken skin and onions).

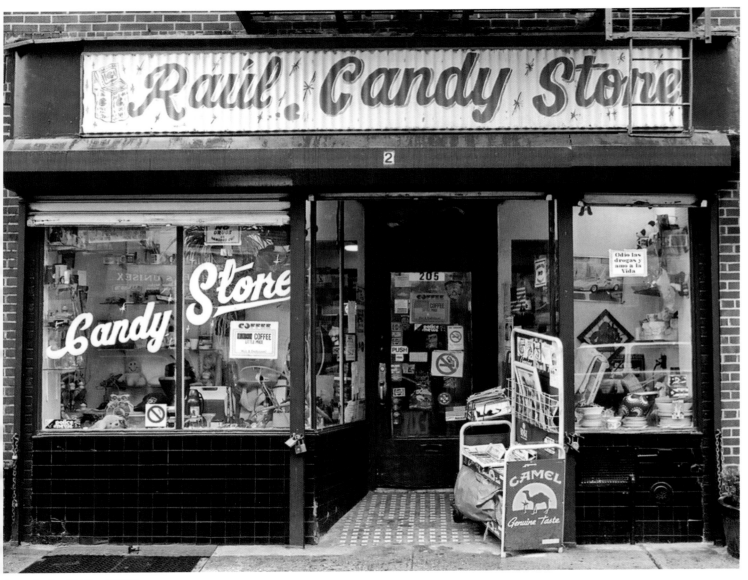

Avenue B at East 13th Street (2003)

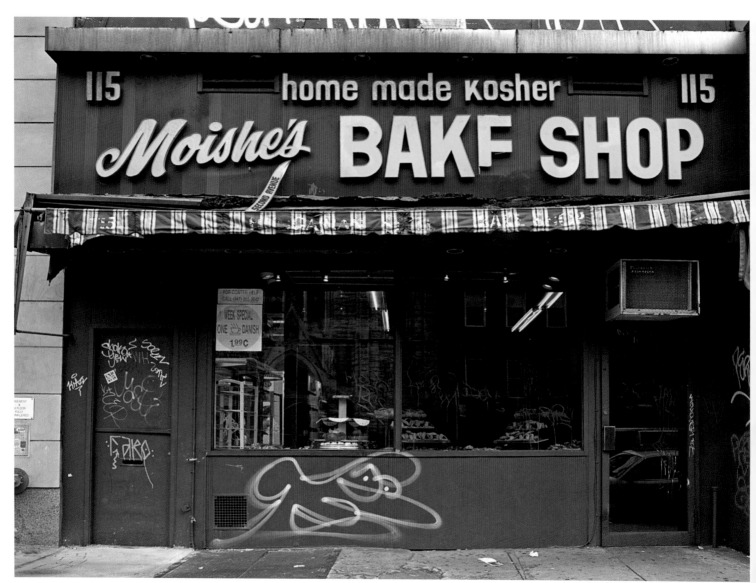

Second Avenue at East 7th Street (2004)

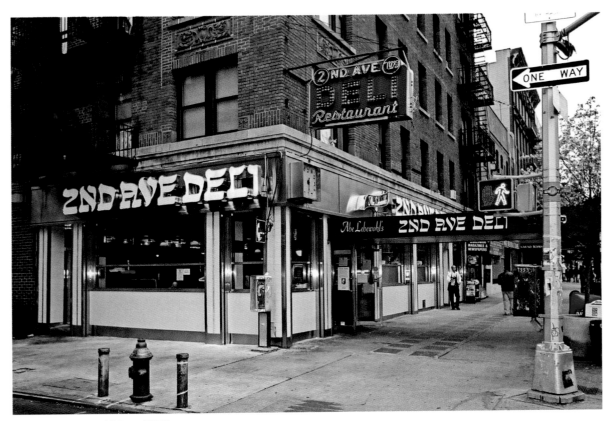

Second Avenue at East 10th Street (2005)

MANHATTAN *The East Village*

First Avenue between East 9th and East 10th Streets (2005)

JADE MOUNTAIN was in business from 1931 to 2007. Reginald Chan took over the store from his grandfather, 'Old man Chan,' who emigrated from Guangdong, China.

We serve the old style food here, like chop suey, chow mein, and egg foo young. We are the last traditional chop suey restaurant in New York City. The restaurant has been in my family for many years and we continue to use the same recipes. The menu has stayed the same and only the prices have changed. In 1931 we had 38-cent lunches. Around 75% of my weekend customers are middle-aged or elderly Italians and Jews who live nearby or can't find their old favorites in their neighborhood. The neon sign outside is from the 1940's. I want to keep it lit all the time but it takes so much effort to maintain it because every time rain hits it, a letter will go out and it costs me a few hundred dollars to replace it. The pagoda-style roof on the façade is newer. I put that up around twenty years ago because I thought it was nice and would make the restaurant have a very authentic Chinese-style.

— REGINALD CHAN *third-generation owner*

Reginald Chan was killed on 9/15/2006 while bicycling on Third Avenue at East 17th Street. He was delivering an order of food and was struck by a truck. His wife and son kept the business open until January 2007.

CBGB (› Page 54) opened in December 1973 and closed in October 2006, when it lost its lease. The club was owned by the late Hilly Kristal, who planned to re-open the club in Las Vegas, using much of the original interior fixtures, urinals and graffiti-covered walls. CBGB's became known as the birthplace of American punk rock, giving groups such as Television, The Ramones, Patti Smith, and Blondie their start. According to Kristal, CBGB stood for "Country, Bluegrass, and Blues, the kind of music I intended to have but not the kind that we became famous for. OMFUG stood for Other Music For Uplifting Gormandizers, Gormandizers being a voracious eater of, in this case, music."

RUSSO'S MOZZARELLA & PASTA (› Page 55) has been in business since 1908. Jack Camgime is the third generation owner of the store who took over the store from his uncle, Sevino, in 1983.

My great-aunt Rosalina started the business after she moved here from Naples, Italy. The store was originally across the street but we had to move to this location in 1956, when the City built the public school that is there now. Most of the recipes we use are old family recipes that have been handed down from generation to generation but we've expanded our menu over the years so a lot of the newer recipes are mine. But the original homemade mozzarella and marinara sauce recipes are all from my great-aunt. The mozzarella is still our best-selling item and we make it by hand all day long downstairs in our store. We now have about 40 different kinds of raviolis and 10 different kinds of sauces. This neighborhood has changed a lot over the years and we've changed with it. There used to be a lot more Italians living here but now we have many different ethnic customers. We try to cater to everyone and now sell raviolis filled with things like light cheese, broccoli, pesto, or lobster. Also, the size of families in the neighborhood has changed. There used to be lots of families with four or five kids but now it's mostly one-child families or just couples. People can't really afford to live in this neighborhood anymore, especially with more than one kid. We have many customers who have been coming here for years. Even if they move out of the neighborhood, they come back here to shop and they also recommend lots of new customers to us. We are a small storefront but we service a lot of people in this community and that's what keeps me in business.

— JACK CAMGIME *third-generation owner*

PRETTY DECORATING (› Page 56) was in business for over 50 years. The business survived the many changes of the neighborhood but was forced to close in 2005 due to a large rent increase. Pictured in the store's entrance is Kadette, the owner of Pretty Decorating.

GRINGER & SONS APPLIANCES (› Page 57) has been in business since 1918. The neon sign outside is original and unique because the neon tubes rest on oversize blue porcelain tiles.

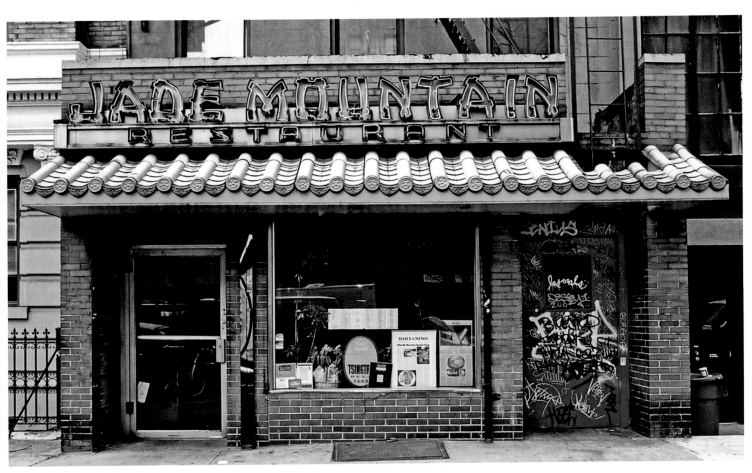

Second Avenue near East 13th Street (2004)

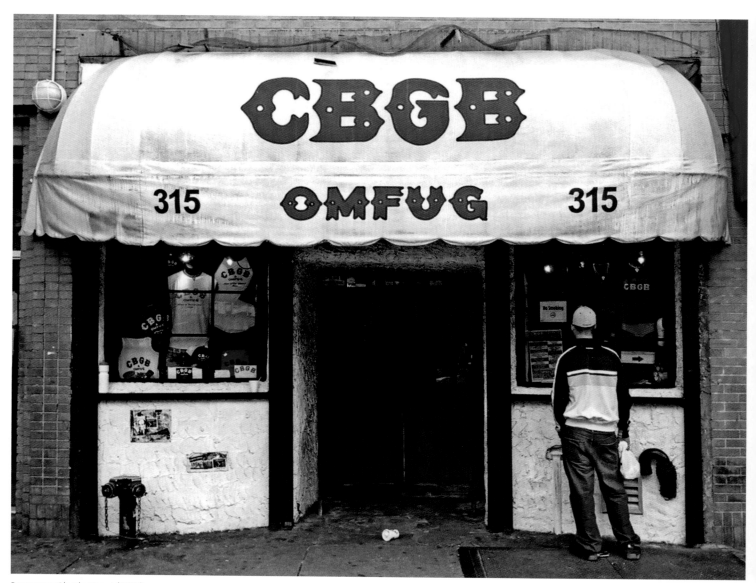

Bowery near Bleecker Street (2005)

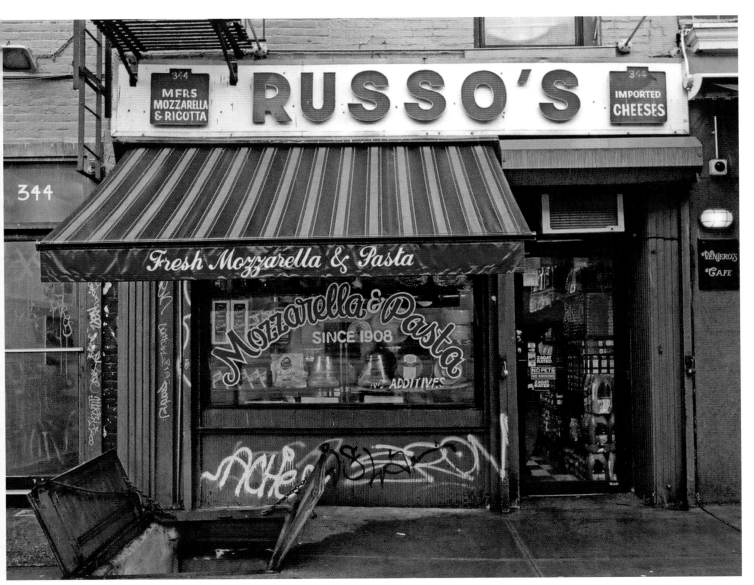

East 11th Street near First Avenue (2001)

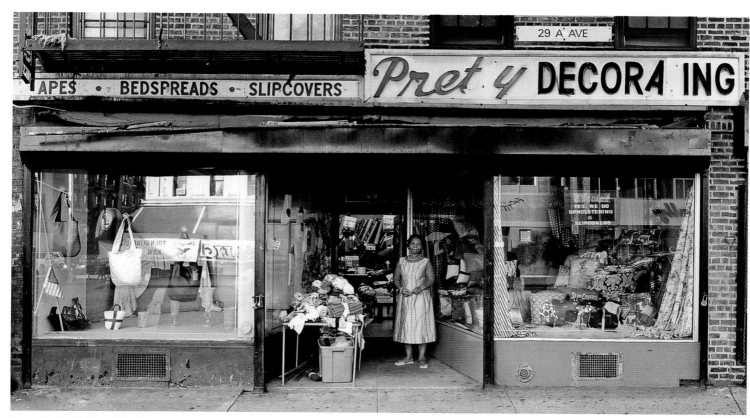

Avenue A at East 2nd Street (2004)

056.057

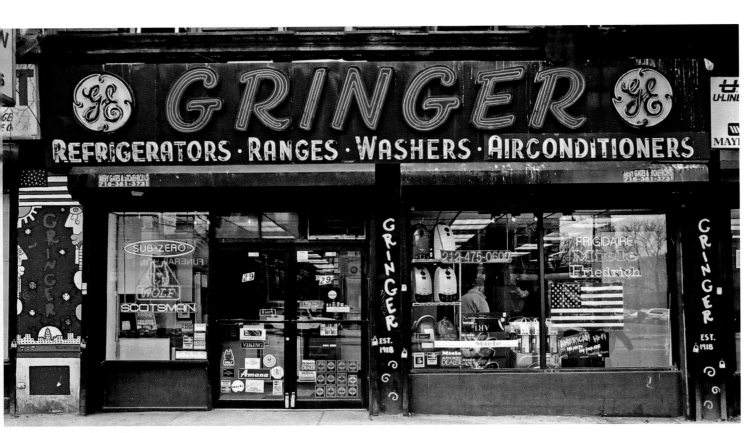

First Avenue at East 2nd Street (2005)

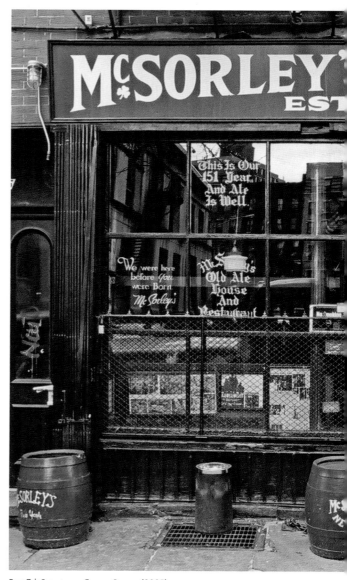

East 7th Street near Cooper Square (2005)

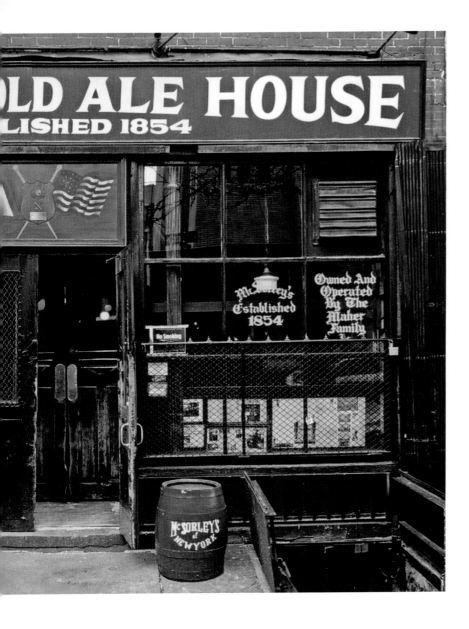

MCSORLEY'S OLD ALE HOUSE has been in the East Village since 1854. Originally, McSorley's was an all-male establishment known by its slogan, 'good ale, raw onions, and no ladies.' Female customers were admitted to most bars by about 1960, but McSorley's was the last bar in New York City to admit only men. Despite pressure from the women's movement, it fought to maintain its exclusivity, which was a common practice established long before the Prohibition. The women presented their case with a lawsuit in 1970, Seidenberg vs. McSorley, that resulted in 'McSorley's law,' prohibiting sex discrimination in bars, hotels, restaurants, airplanes, golf clubs, and other public accommodations. McSorley's still has the same bar taps, wooden bar, and the same pot-bellied stove since it opened in 1854. It serves just two kinds of beer, McSorley's own light and dark. McSorley's is now owned by Matthew Maher.

I'm not a McSorley native. I came in the back door. I had to buy the business but everyone else before me inherited it. I'm the sixth owner. At first, it was two McSorleys, father and son, and then their cousin inherited the bar. Then his daughter inherited it and passed it to her son and I bought the business from him. The big controversy with the women being allowed into the bar happened in 1970. I was working here then as a bartender. If it weren't for the controversy over the women, I'd never have owned the place. The McSorley family was very upset about the discrimination decision because the City didn't side with them. They got a kind of resentment towards the bar and decided they wanted to sell it. Everybody talked about how the minute the women would be able to come into the bar, the tradition would be broken and the place would go under. So I decided to buy it from the family. For me, the women paid the bills, you better believe it.

— MATTHEW MAHER *owner*

East 14th Street near University Place (2008)

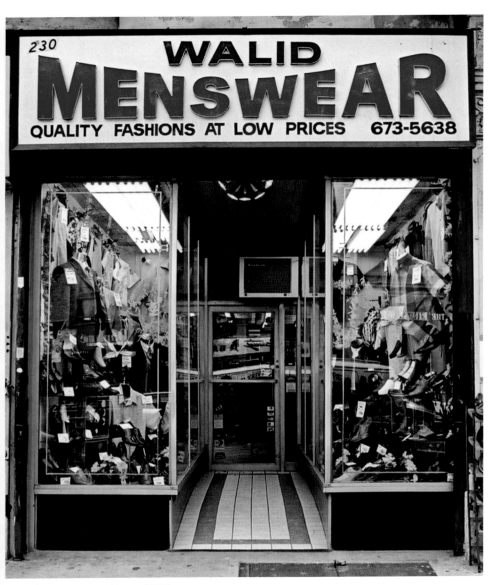

East 14th Street near Second Avenue (2004)

East 14th Street near Second Avenue (2004)

Canal Street near Essex Street (2004)

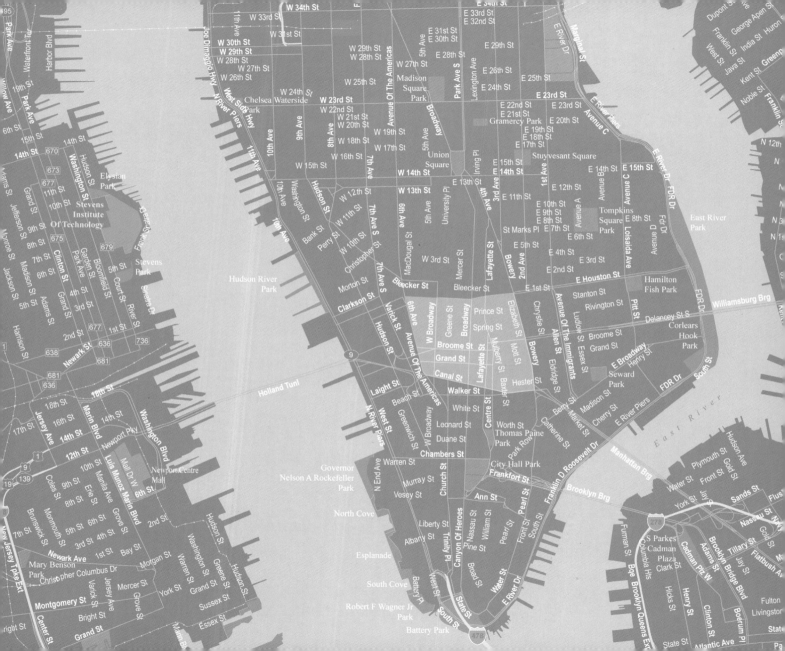

Little Italy

MANHATTAN

Little Italy is a neighborhood in lower Manhattan that was once known for its large population of Italian immigrants and is now centered on Mulberry Street between Broome and Canal Streets. Italians first settled in the area during the 1850's and by the 1920's the neighborhood occupied an area roughly bounded to the north by West 4th Street and Houston Street, to the east by the Bowery, to the south by Canal Street, and to the west by Greenwich Village, which also had a large Italian settlement. By the 1960's, wealthy Italians began to move out of the old 'Little Italy' neighborhood and Chinese merchants for the first time began to move north of Canal Street, the traditional boundary between Chinatown and Little Italy. Observing the changes in the neighborhood, Italian merchants and restaurateurs formed an association dedicated to maintaining Mulberry Street north of Canal as an all-Italian enclave, which it still remains. Much of Little Italy became part of Chinatown after 1968 and Italian businesses were forced to close. Many of the remaining landmarks have been in the same location for well over half a century.

C. DIPALO'S LATTERIA has been in business since 1925. Concetta DiPalo, who emigrated from Basilicata, Italy, and her husband, Luigi Santomauro, who emigrated from Montemelone, Italy, opened the dairy store after they got married. Today, Concetta's three grandchildren, Luigi, Salvatore, and Marie run the latteria and employ seven other family members. The store sells homemade mozzarella and ricotta, which are made daily, along with over 300 varieties of cheese imported from Italy. It also sells olive oils, prosciutto, and fresh pastas.

In November 2002, we moved across the street from our original location to a larger space. My grandmother and grandfather opened the original store at 206 Grand Street after they got married in 1925. At that time there were so many Italian immigrants in the community that my grandparents only serviced Grand Street and only the people who came from the area in southern Italy where they came from shopped at their store. It was a simple latteria, a dairy store that ladled milk out of cans into customer's pitchers and with what milk was left every day, they made fresh mozzarella and ricotta. That's basically what our families have always done. And the recipes we still use today to make our homemade mozzarella and ricotta are all from our family in Italy. This is the way it was done in Italy and we are just carrying on a tradition.

A lot of people make ricotta and mozzarella but as many people as there are, everybody makes it different. Even though I make mozzarella every day, and I think I make it pretty good, I can still taste my father's mozzarella in my mind. He's not with us anymore but I can still taste his mozzarella and I don't think I can beat him. It's in the hands. It's the love you have for it. Also, we have an ideal situation in New York City with the water. The water does change the recipe. If you leave New York and go somewhere else and try to make mozzarella, it will be different. Every day, just in the mozzarella, we make at least 500 pounds. We make mozzarella 7 days a week, all day long.

Many of our old customers who don't live in the neighborhood anymore still make a pilgrimage to Little Italy on special occasions and holidays to shop here. They might not shop every week but we are not forgotten by them. The one thing that is a problem for my returning customers is the parking problem here in Little Italy. There are no more lots left for our customers to park. And if they park on the street and run in for a minute, they'll get a $115 ticket, so that hurts us. And being in the City is tough anyway for a business because the City puts a lot of rules and regulations on the store owners. I can't even make a delivery anymore without coming out and finding a ticket on the window of my van because there is no truck parking or stopping allowed around here. It's money for the City. It's a hidden tax . . . that's what I call it. But my family plans to stay in Little Italy. We are going to stay as long as people keep coming to our store. We could have moved anywhere but we wanted to be here because here we are at home and the spirit of Italian immigrants lives in my store and in Little Italy.

— SAL DIPALO *third-generation owner*

ALBANESE MEATS AND POULTRY (› Page 68) has been in business on Elizabeth Street since 1923. Albanese Meats is the last Italian butcher shop in the neighborhood that was once part of Little Italy. Moe Albanese took over the business from his mother, Mary, who worked there until she died at age ninety-seven. The storefront and interior are all original and even the butcher block and scales have been used for over 80 years.

My mother knew nothing about the butcher business when she emigrated here from Sicily and opened up this store with my father when she was only 18-years-old. But she slowly learned all about it and took over the store when my father died at age 55. At one time there were five Italian butcher shops on the block, including one owned and operated by my mother's parents called, 'Moe's Meats.' She taught them the meat business too. The neighborhood is very different now. It's gotten very trendy. There are very few of my older customers left. There is a young crowd here now and they don't cook. And they don't know how to cook! So the restaurants are doing all the business in the neighborhood now.

— MOE ALBANESE *second-generation owner*

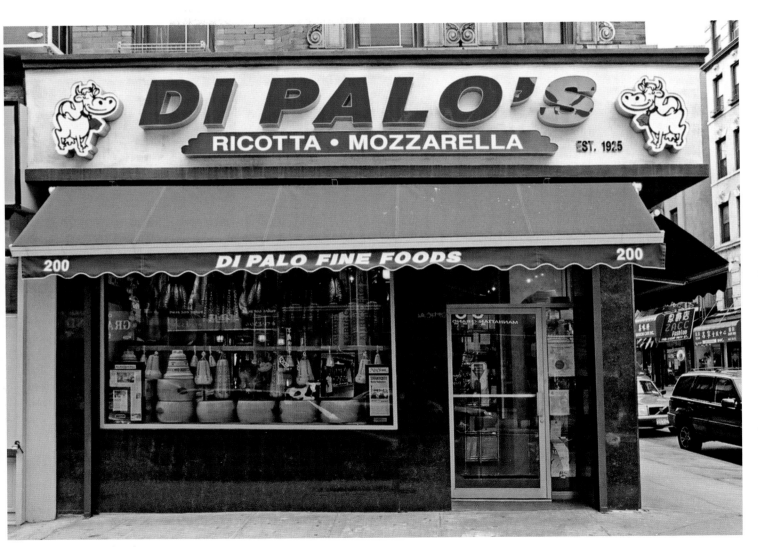

Grand Street at Mott Street (2005)

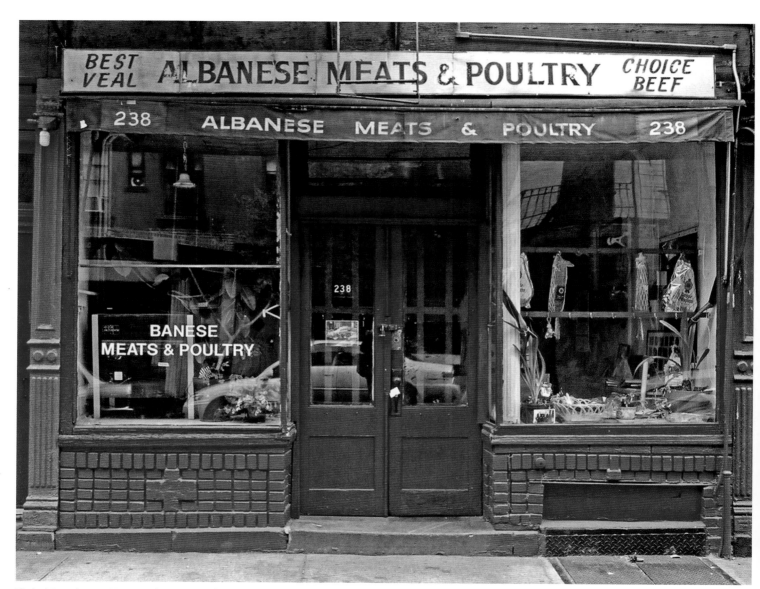

Elizabeth Street between Houston and Prince Streets (2003)

Prince Street near Thompson Street (2004)

JOE'S DAIRY is in a neighborhood that was once considered the western half of Little Italy. It's been a dairy store for over 83 years and was originally called Frank and Al's Dairy. The current owner, Anthony Campanelli, bought the store in 1977. The storefront is original but the sign was installed in 1972.

The recipe we use to make the homemade mozzarella is the original recipe from when the store was opened over 83 years ago, but what happens is that the recipe slowly changes a tiny bit as the person who has taken over the store follows it. We have all added our personal touches over the years. There's more to making mozzarella than you would think. I could show you how to make it step by step but you still wouldn't be able to do it, because it's all really in the technique. The main ingredient for mozzarella is the milk curd. I use like 25–30 bundles of curd delivered every day from New Jersey. And there's 45 pounds in each bundle. So it's the curd and the water and the knowledge. That's the only ingredients you got. The water is also very important to the recipe.

There's a lot of hardness in different waters and here in New York the water is great for making mozzarella. If you go to Florida or California, it's a completely different thing. I know people who went out there and tried to make mozzarella and what they are doing now is having water tanked out to them from New York because they can't make the mozzarella the same way without it. It breaks down. It's like the chemicals. It sounds strange but there is a chemical imbalance with the water everywhere else that turns the cheese different. Everything that we make here has to do with mozzarella. That's what we are known for. We even have a smokehouse outside at the back of the store where we do all our smoking. I don't own this building. I only rent the store. When I'm ready to retire, it will probably be a lost art in my family because I have a daughter but I won't allow her to do this. It's a lot of hard work. It's

not that a woman couldn't do it, but you have to get up really early and work long hours.

Many people who have moved out of the neighborhood come back here just to buy fresh mozzarella from me. Their roots are here but the neighborhood has really changed. There are not too many Italians living here anymore. The old-timers are dying and their children are moving out so the traditions of years ago are being lost. We've lost most of the Italian families in the neighborhood but we've gained new people, like New York University students. The University has been buying many of the buildings in the neighborhood to use as dormitories and classrooms and big developers are buying old buildings and turning them into co-ops. So basically, it's a lost neighborhood as far as family goes. Its not family-orientated anymore.

— ANTHONY CAMPANELLI *owner*

ALLEVA DAIRY (› Page 72) is an Italian cheese store, which has been in business since 1892. Francesco Alleva emigrated from Italy and opened the store and worked alongside his eight sons until he died. The business is now owned by the Robert Jr., a fourth-generation Alleva.

We are the oldest Italian cheese family in the United States. This store is the first and oldest cheese shop. My great-grandmother and great-grandfather started the business in 1892, next door at 190 Grand Street. We moved to this larger store on 188 Grand Street after the Prohibition in the 1920's. I am the fourth-generation Alleva to run the store and my son John, who works here with me, will be the fifth generation if he decides to stay. My family and I love the business and that's why we've been here so long.

The recipe we use to make our homemade mozzarella and ricotta is an old family recipe from Italy that my great grandmother used and has been passed on from generation to generation. We make ricotta and

mozzarella every day by hand starting at about 7:00 AM right here in our store. We get the basic milk curd from upstate and we process it down here. We even have a smoker in the back of the store, which vents to the roof to smoke our cheeses. I've been working here for about 25 years and the neighborhood really hasn't changed much except that Chinatown has gotten larger. Most of our old customers who have moved out of town still come back to Little Italy to shop here. During the holidays, it's especially busy and on the weekends. We also ship as many items as we can and even have a website to keep up with the times.

— ROBERT ALLEVA JR. *fourth-generation owner*

PIEMONTE RAVIOLI COMPANY (› Page 73) was originally founded in 1920 by the Piemonte family from Genoa, Italy. In 1955 Mario Bertorelli, who emigrated from Parma, Italy, took over the store.

I took over this business when I was 19 years old. When I came here from Parma, I met my wife and she was working at this ravioli store. We decided to get married and take over the business from the current owner, who had bought the business from the Piemonte family. The recipes we use today to make all the pastas are the original ones from the Piemonte family. We make everything we sell, right here in the back of the store. The most popular item we sell is the tortellini. We get the cheeses we use to fill all the different pastas next door from the Alleva family. We also sell homemade pasta sauces and those recipes we use are all from my mommy. I don't live in the neighborhood myself anymore but I can say from working here for years that Little Italy has changed a lot. Most of the Italian families have moved out but many still come back here to shop.

— MARIO BERTORELLI *owner*

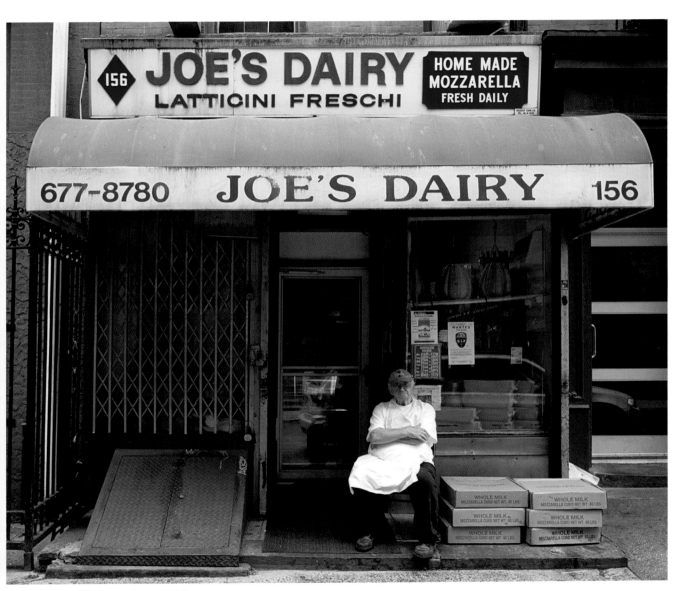

Sullivan Street near West Houston Street (2008)

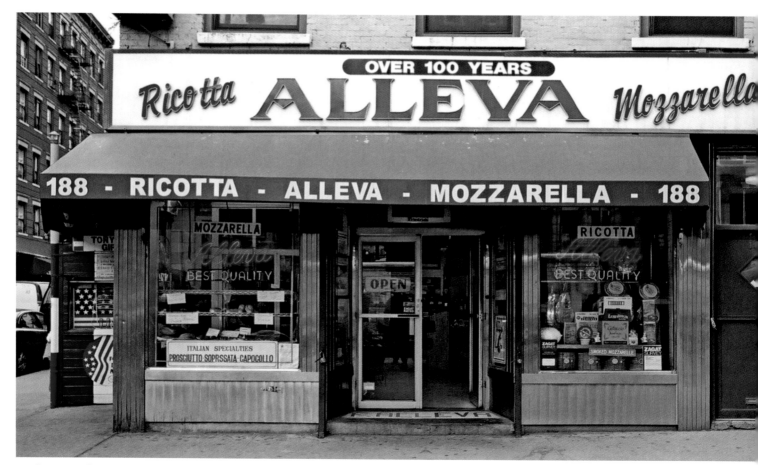

Grand Street at Mulberry Street (2005)

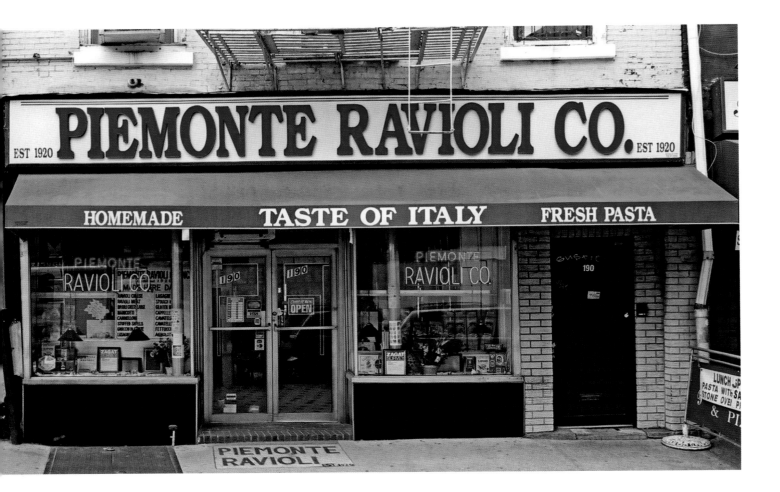

Chinatown

MANHATTAN

Chinatown is a neighborhood in the Lower East Side covering about 35 blocks, bounded to the north by Kenmare and Delancey Streets, to the east by Allen Street, to the south by East and Worth Streets, and to the west by Broadway. Chinatown was originally a very small protective enclave bounded by Pell, Doyers, and lower Mott Street and was almost entirely male due to Chinese exclusion acts, which prohibited new immigration and prevented most men from bringing their families to the United States. The population also remained small due to immigration quotas that were in place until the 1960's. The neighborhood became known as the 'bachelor society.' Doyers Street, which is very short and has a sharp curve, became an infamous criminal hangout and was once called the 'bloody angle,' because enemies were often lured there and ambushed by gang members. After 1965, the population grew rapidly and by 1980, Chinatown had expanded beyond its traditional boundaries absorbing much of the Little Italy neighborhood as well as parts of the Lower East Side, and became the most populous Chinese community in the Western hemisphere.

TING'S GIFT SHOP Ting Yu Hong and his wife opened this shop, which sells many Chinese gifts, in 1977.

We decided to open this store after working long hours in the restaurant business after first emigrated to New York City from China. My uncle in Hong Kong sends us the Chinese merchandise to sell. In 1977 our rent was only $35 a month and now it's $3,000 a month. I remember when we first opened, I used to buy lunch for 25 cents and still get change back. Business isn't as good as it used to be because there is so much more competition in the neighborhood now but I can't imagine doing anything else.

— MRS. TING YU HONG *co-owner*

NOM WAH TEA PARLOR (›Page 78–79) has been in business since 1920. The façade and interior are original. The present owner, Wally Tang began working at Nom Wah when he first came to this country from China in 1950. At that time, Tang's cousin, who had worked in teahouses in China, owned the store. Wally Tang learned everything from him and eventually bought the business in 1975. Many of Tang's family members worked in the tea parlor over the years, but most of them have moved on to other professions. They still come back to help out when needed. Nom Wah sells more than 20 varieties of tea, all stored in old, multi-colored tins. Full-bodied oolong tea is the most popular.

NISSUN SEAFOOD (›Page 81) is a wholesale seafood store, which has been in business in Chinatown since 1976.

I opened this business in 1976 and started supplying seafood to local residents and restaurants in the area. I also supply fresh seafood to many high-end midtown restaurants and large supermarkets. That is where the bulk of my income comes from. The storefront and large shrimp sign are original but unfortunately I will have to remove the old shrimp sign soon. I have to put up new siding on the building and when I do that the shrimp sign has to be removed.

— BILL LO *owner*

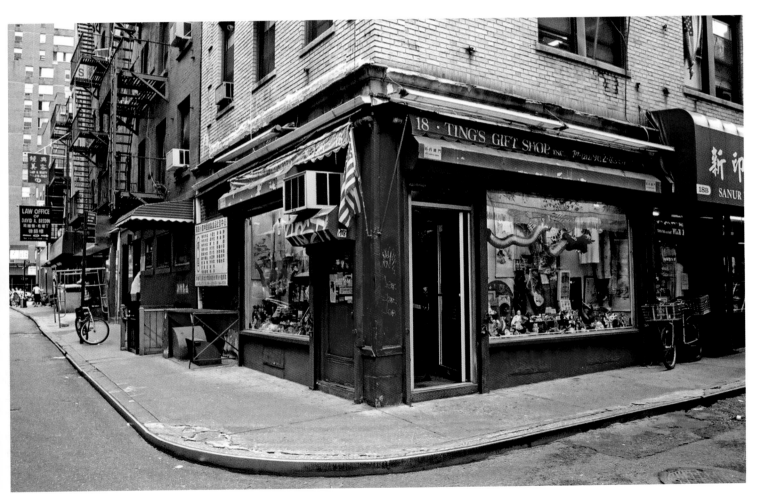

Doyers Street at Pell Street (2005)

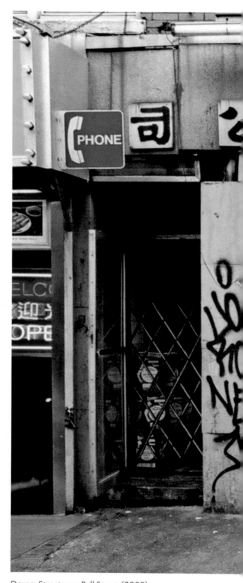

Doyers Street near Pell Street (2005)

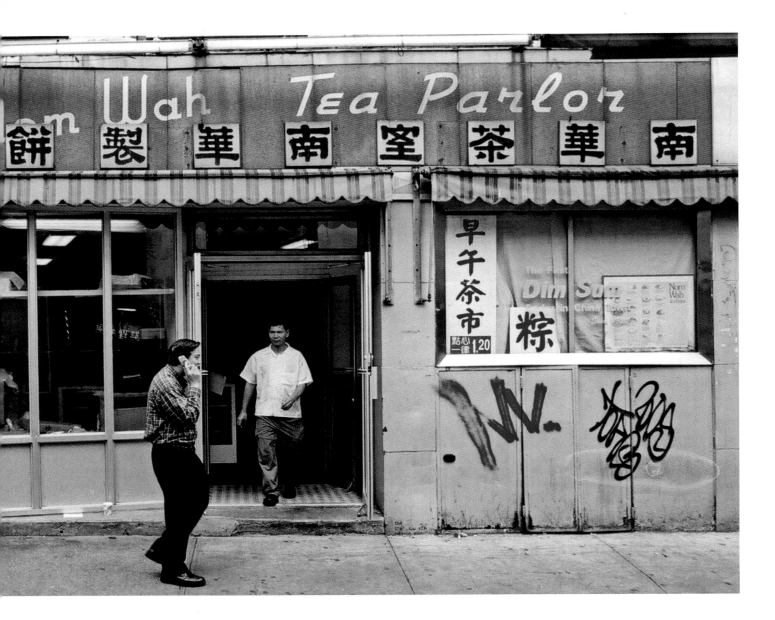

MANHATTAN *Chinatown*

Division Street at Orchard Street (2006)

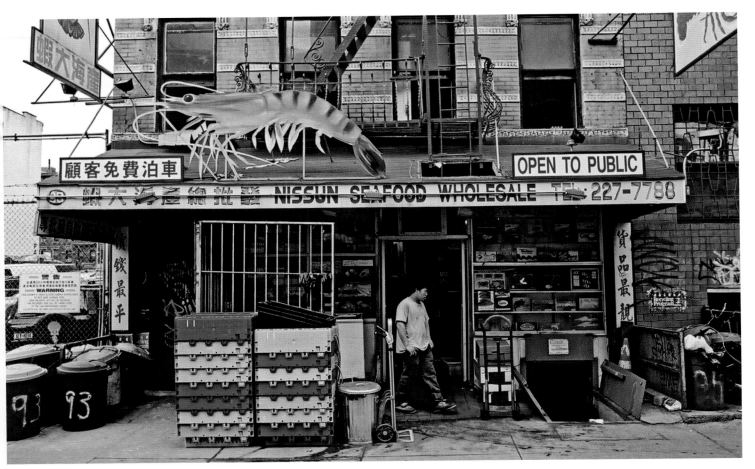

Madison Street near Catherine Street (2005)

Gramercy & Vicinity

MANHATTAN

Gramercy is the neighborhood on the East Side of Manhattan, bounded to the north by 23rd Street, to the east by 3rd Avenue, to the south by 18th Street, and to the west by Park Avenue South. Dutch settlers once called the area Krom Moerasje 'little crooked swamp,' and the English changed the name to Gramercy. The land was part of Peter Stuyvesant's farm in the late 1600's and was later bought by the developer Samuel Ruggles in 1831. Mr. Ruggles drained the swamp, laid out streets in an English style around a private park and offered lots for sale where many luxury townhouses were built. The neighborhood declined after the extension of the Third Avenue elevated line to the area and the onset of the Depression. Many townhouses were remodeled and converted into apartments or replaced by high-rise apartment buildings. In the 1970's and 1980's, the neighborhood became very desirable again and many original townhouses were restored. Gramercy Park remains the only private park in the city and is locked to all non-residents. In order to obtain a key to the park, a resident of the area must live in a building with windows overlooking the park.

Kips Bay is the neighborhood adjacent to Gramercy, bounded to the north by 34th Street, to the east by the East River, to the south by 27th Street, and to the west by Third Avenue. It is named for Jacobus Kip, who owned a large farm in the area in the 1600's. By the early 1900's, elevated rail lines were built along 2nd and 3rd Avenues and many estates were replaced by tenements. Starting in the 1960's, many large apartment complexes were built, including Kips Bay Plaza, which contained the first exposed concrete structures in the city.

EMEY'S BIKE SHOP has a facade made of zinc, which dates back to around 1900.

The building was originally a barn on Peter Stuyvesant's farm and the original silo is still standing in the basement of the store. Time *magazine's initial headquarters were once located at this address.*

— EMEY HOFFMAN *former owner*

CLOVER DELI (› Page 86) is owned and operated by Frank and Chris Cuttita. Frank and Chris are cousins and are the third-generation of the Cuttita family to own the deli.

Our store is like the American dream. We are a very close family and we work very hard. We are open 6 days a week from 7:00 AM – 11:00 PM. We are closed on Sundays because that's what my grandfather always did and he wanted us to do the same. We've been in this same location since 1957 and the neon signs and storefront are all original. My grandfather chose the name Clover Deli, because he thought it was easy for people to remember. He originally opened the deli on 31st and Second Avenue in 1948 but was forced to leave that location when Kips Bay Plaza was being built and that's when he moved to this location. In the 1950's, it was more of a grocery store than a deli. It was a real family neighborhood and the customers got very personalized attention.

My grandfather would take things off the shelf for his customers and package them up nicely and even deliver them personally. He even had a pushcart to sell goods in the street, which is still in the basement of the store today. Today, it's more of a commercial and transient neighborhood and business is more cash and carry. We've evolved over the years but we still have a customer base from the neighborhood and some people who no longer live or work in the area still come by just to say "Hi" and make sure we are still here. I worked in the store as a very young boy and people remember that and some customers even remember my grandfather. My father still comes in from time to time too. To me the name 'Kips Bay' is just a name for this neighborhood. I live here too and the people are what make the area. Our business has been successful over the years because we are very courteous and respectful and we try to 'keep it simple.'

— FRANK CUTTITA *third-generation owner*

LA DELICE PASTRY SHOP (› Page 87) is a family-run business that has been open since 1935. George and his wife Demetra took over the store from George's father when he retired. The storefront is original but the sign was replaced in the early 1960's.

We are known for our black and white cookies because they are not the 'cakey' kind. The neighborhood has changed so much over the years but we still have a lot of customers who've been coming here forever – and some that have moved out of the area but still travel back just to buy their favorite things here. There used to be a homeless shelter down the block and the area got a little seedy for a while but now the shelter has closed and things are better.

— DEMETRA *second-generation owner*

East 17th Street near Third Avenue (2003)

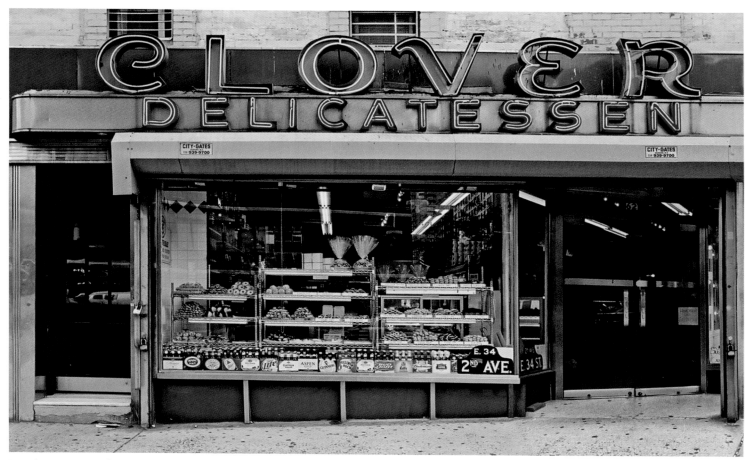

Second Avenue at East 34th Street (2004)

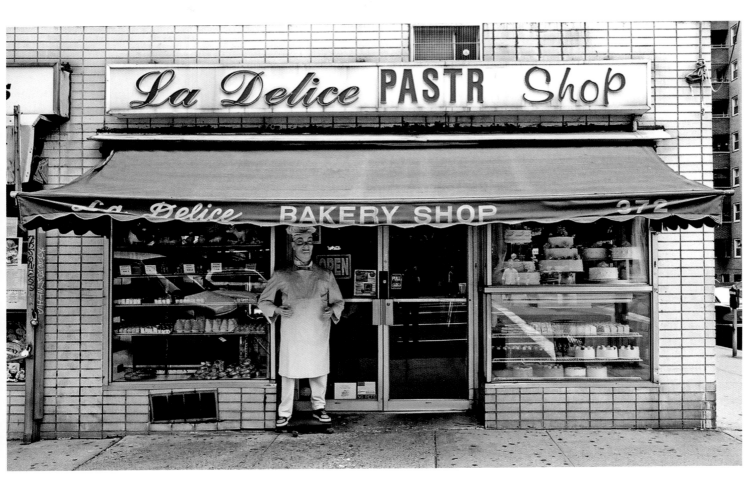

Third Avenue at East 27th Street (2004)

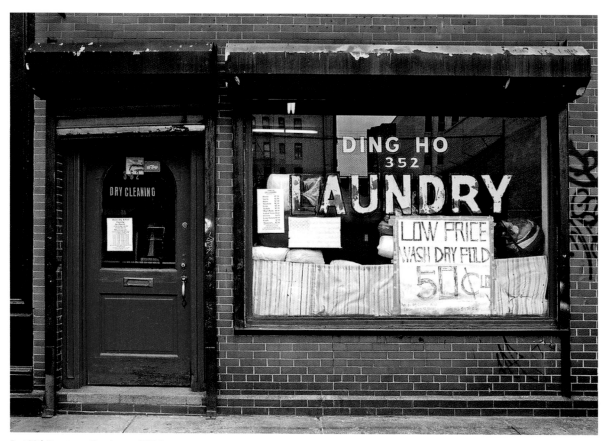

East 20th Street near First Avenue (2004)

East 27th Street near Lexington Avenue (2004)

Greenwich Village

MANHATTAN

Greenwich Village is the neighborhood in lower Manhattan bounded to the north by 14th Street, to the east by 4th Avenue and the Bowery, to the west by the Hudson River, and to the south by Houston Street. The English first designated the area as a country hamlet called 'Grin'wich' in 1713. In the 1800's, residents of Greenwich Village mounted efforts to preserve the crooked colonial lanes of their neighborhood and as a result much of the area was exempted from the rigid symmetry of the grid plan of 1811 that imposed a waffle-iron system on the streets of Manhattan north of Houston Street. Many of the neighborhood streets are narrow and curvy and are typically named rather than numbered.

New York University opened buildings on the east side of Washington Square starting in 1836 and the neighborhood soon became filled with art clubs, literary salons, libraries and theaters. By the beginning of the First World War, Greenwich Village was a bohemian enclave with many colorful and artistic residents who had a tolerance for radicalism and nonconformity. During the 1950's, Greenwich Village became the center for the Beat Generation. A loose collection of writers, poets, artists, actors, musicians and student dissidents, many from San Francisco, moved into the southern and eastern portions of the neighborhood and set up galleries, coffee houses and avant-garde theaters. Although many of Greenwich Village's historic structures have been preserved, its bohemian days are long gone, due to the extremely high housing costs in the area.

PORTO RICO IMPORTING CO. is a fourth generation family-owned business that was founded in 1907.

The original location of the business was on 195 Bleecker Street and was founded in 1907 and sold coffee, tea, dried mushrooms, and olive oils to the many Italians who lived in the neighborhood. My grandfather bought the building at 201 Bleecker in 1895 and that's where Porto Rico stands today. He opened a bakery on the ground floor alongside a shoemaker business before getting into the coffee business. My family has lived above the store ever since and my mother, who is in her 90's, still lives on the top floor. Years ago we used to roast our own coffees in the back of this store but because of stricter pollution codes we are no longer able to do that so we do all our roasting at our warehouse in Williamsburg, Brooklyn.

Greenwich Village has really changed tremendously over the years. The rents are much, much higher and many of the artists and musicians have moved out of the area. But the biggest change that I see is that when I was growing up in the 1950's, Greenwich Village was a huge Italian community. Everything except church was closed on Sundays and it gave a rhythm to the week. Monday through Friday I went to school. Saturday was a day for chores and Sunday was church day and was very quiet. The streets were very pleasant to walk around and cars were even allowed to park on all the streets with no restrictions. As the years went by, most of the Italians moved out of the neighborhood and NYU replaced the Italian community. Stores are no longer closed on Sunday, everything stays open late and the streets are continuously busy. Most of the

specialty stores, which catered to Italian customers, have gone out of business and the whole Village has lost its ethnicity and character.

— PETER LONGO *third-generation owner*

MCNULTY'S TEA & COFFEE COMPANY (›Page 94) has been in business since 1895. The store was originally located down the street and was moved to its present location in the 1920's.

The McNulty family owned the business until the 1920's. My parents were the fifth or sixth owners and my brother even worked for the previous owner. We don't roast our own coffees anymore because there is no roasting allowed in New York City. Now we get our beans from different roasters in New Jersey and Long Island and we also carry over 100 different kinds of teas, either in loose form or tea bags or different combinations of both. All the large metal tea bins and coffee bins we use are from the 1920's and were especially made for this store. This Greenwich Village neighborhood has changed a lot since I've owned this store, not necessarily for the better or worse, but its gotten more expensive. Many of our old customers who have been coming here for years but have now moved out of the area still come back to shop or we ship items to them. Our customers bring us with them wherever they go.

— DAVID *owner*

O. OTTOMANELLI & SONS PRIME MEAT MARKET (›Page 95) is a family-owned business founded by Ononfrio Ottomanelli in 1935 and now run by his

four sons, Jerry, Frank, Peter, and Joe. The store specializes in prime meats, wild game, and fancy birds.

I learned everything I know about the meat business from my father, uncle and my older brothers. My father was a butcher in Bari, Italy before he came here and settled in this neighborhood. My brothers and I all started working for my father when we were young boys. My brother Frank was cutting meat in the store by the time he was 14. But my father wouldn't ever let any of us use the machines to cut the meat. He wanted us to cut everything by hand before he would let us use the machines you see here. Because that's how you learn. It's the only way you can really feel the meat! We had to learn how to cut every different piece of meat by hand. All of us worked together and we all had a different job to do learning from the bottom up.

Years ago, this was mostly an Italian neighborhood and we catered to them, offering things like our own Italian pork and lamb sausages. Nobody else around here knew how to make the sausages like my family, and even today, nobody can make them like my brother Frank! But the secret to the longevity of our business is that we do most of the buying of the meat ourselves, break it down and age it in our meat lockers downstairs. When you buy meat from us, you're not just buying a piece of meat. It's been hand-selected by us and aged properly to bring out the flavor. We also help our customers by giving them recipes and tips in preparing the meat they purchase. Many of our long-time customers do not live in the neighborhood anymore but make a special trip into the City just to buy their meat here.

— PETER OTTOMANELLI *second-generation co-owner*

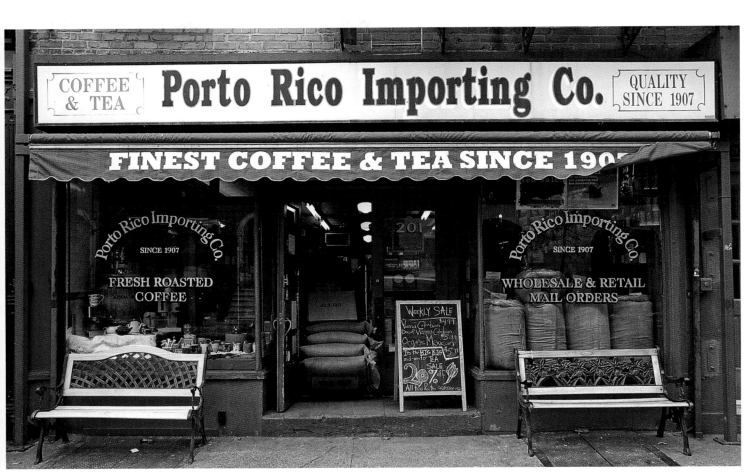

Bleecker Street near Sixth Avenue (2007)

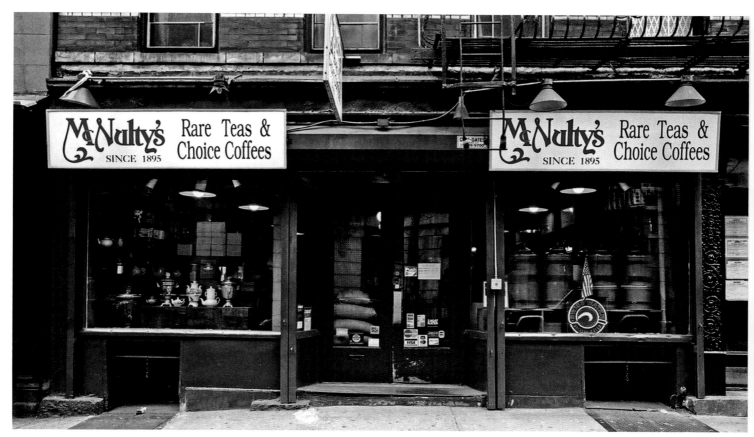

Christopher Street near Bedford Street (2005)

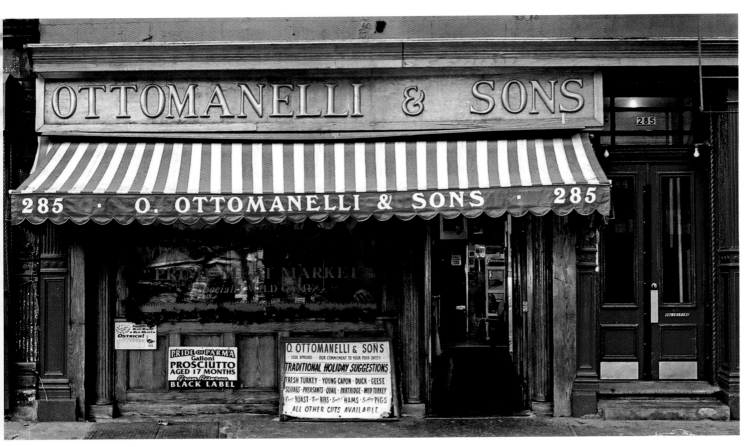

Bleecker Street near Seventh Avenue (2005)

MURRAY'S CHEESE SHOP (›Foldout) was founded in 1940 by Murray Greenberg. The original Murray's was located around the corner on Cornelia Street and primarily sold milk, eggs, and butter. Murray's later added pasta, olive oil, Parmesan cheese, and provolone cheese to serve its many Italian neighborhood customers. In 1990, Robert Kaufelt bought the store, moved around the corner where he expanded its cheese offerings and continued to run the business until 2004 when he moved to an even larger location directly across the street. Mr. Kaufelt even constructed masonry caves in the basement of the store in which to store and age cheese. These unique caves can be viewed from outside through a glass panel in the sidewalk and are the only ones in the country precisely modeled after ancient cheese caves in France. The store also supplies cheese to many of the leading restaurants in the City and its wholesale division accounts for half of its yearly business. Murray's Cheese carries more than 250 different kinds of cheese from countries all over the world and sells between 10,000 to 12,000 pounds of cheese per week.

ZITO & SONS BAKERY (›Foldout) was open for 80 years and was the longest continuously occupied store on Bleecker Street until its closure in 2004. Antonino Zito, who emigrated from Sicily with his wife, opened their first bakery on West Broadway in 1919 and then moved to Bleecker Street in 1924. The family lived in an apartment behind the bakery and raised three sons, who took over the business when Antonino died in 1963. At the time of its closure, Antonino's son Julio and grandson, Anthony managed the bakery. The closing was prompted by a combination of rising costs including energy and supplies. The price of coal for their coal-fired ovens doubled, flour prices rose, and gasoline and insurance costs for their delivery trucks increased. The popular low carbohydrate diet also hurt their retail and wholesale business.

CAFFÉ REGGIO (›Foldout) has been open since 1927 and is famous for its espresso machine, which was imported from Italy by the original owner, Domenico Parisi. Mr. Parisi spent his life savings of $1,000 to import the chrome and bronze espresso machine to his café. The machine was made in 1902 and was the first of its kind and has a base formed by dragons and an angel sitting on its top. When filled with hot water, the machine makes a cup of espresso in just about three seconds. Mr. Parisi is credited as being the first person to introduce the cappuccino to the Unites States. Caffé Reggio originally only served coffee, all made by Mr. Parisi himself using the espresso machine. In the 1960's, Mr. Parisi sold the business to Hilda and Niso Cavallaci, and their son Fabrizio now runs the café.

MATT UMANOV GUITARS (›Foldout) has been in business since 1965. The store sells only guitars, new, used, and vintage as well as parts and accessories. They also specialize in guitar repairs. They have had many famous customers over the years, including Patti Smith, who calls Matt Umanov's Guitars her second home in New York. In 2006, Matt Umanov sold a vintage Stratocaster that once belonged to Bob Dylan for $75,000.

Bleecker Street near Jones Street (2001)

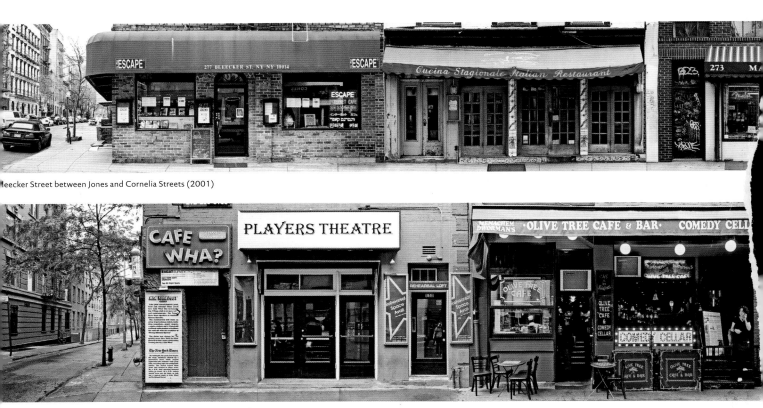

Bleecker Street between Jones and Cornelia Streets (2001)

MacDougal Street between Minetta Lane and West 3rd Street (2005)

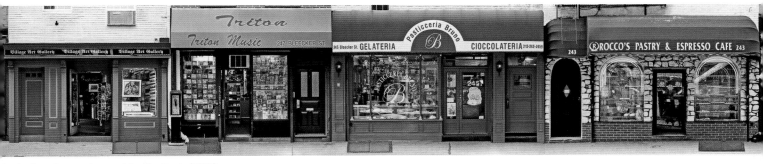

Bleecker Street between Leroy and Carmine Streets (2001)

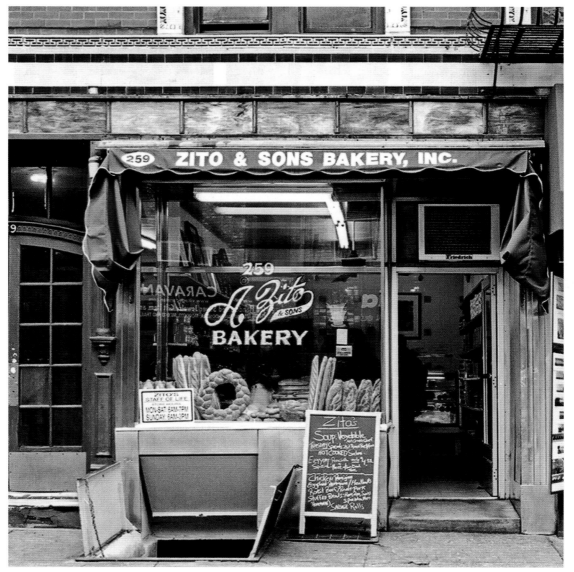

Bleecker Street near Cornelia Street (2001)

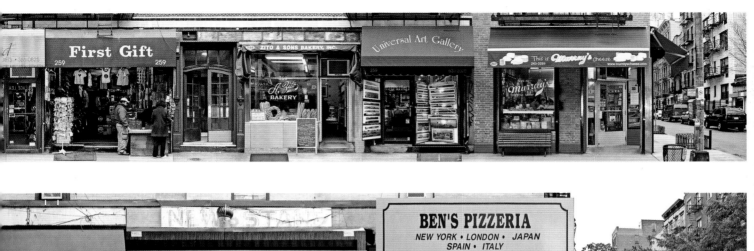

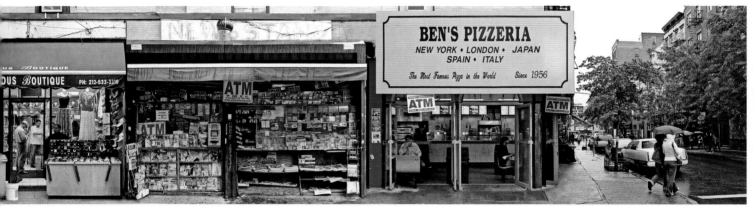

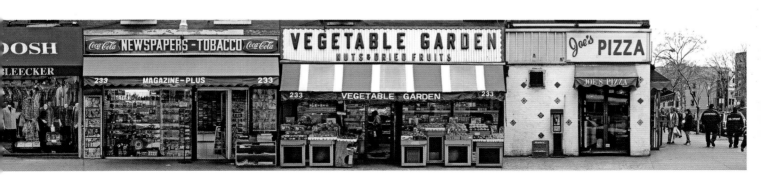

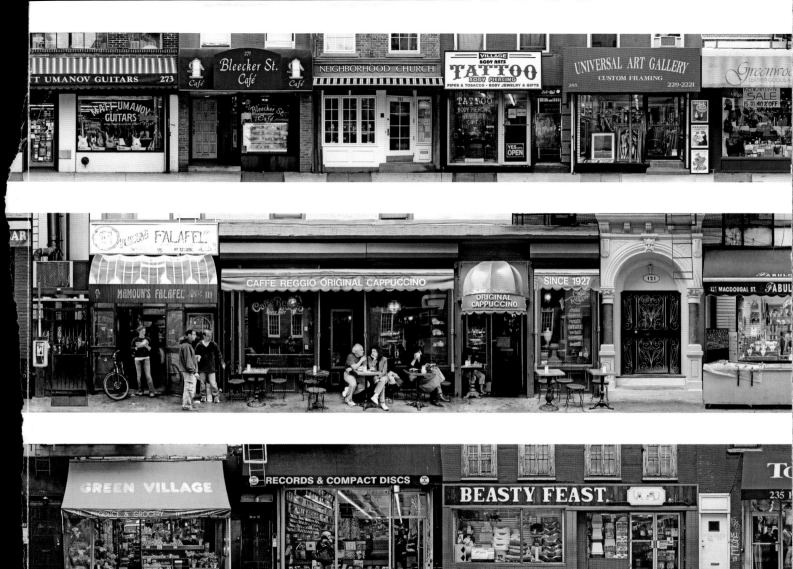

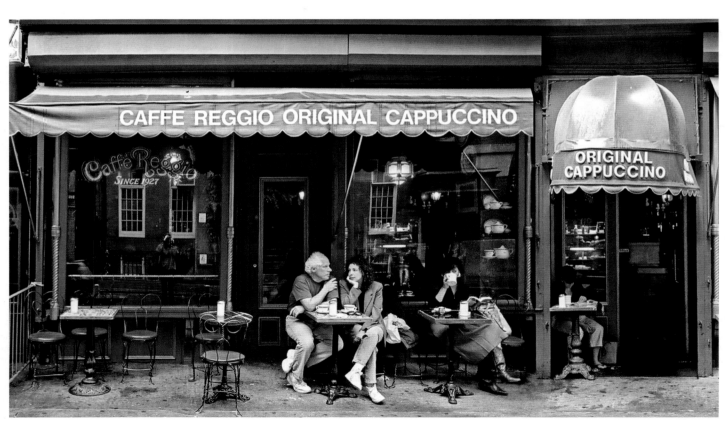

MacDougal Street near Minetta Lane (2005)

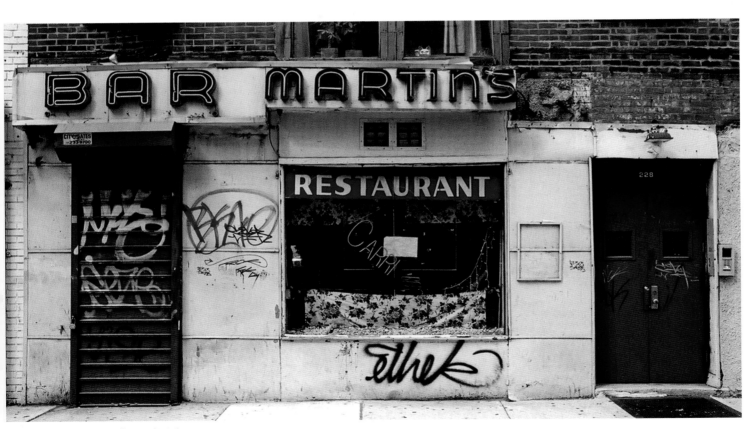

West Houston Street near Varick Street (2004)

Sixth Avenue at Waverly Place (2004)

STRAND BOOKSTORE is an independent bookstore founded in 1927 by Benjamin Bass. It was originally located on 4th Avenue's Book Row. Benjamin Bass's son Fred took over the business in 1956 and Fred's daughter Nancy is now co-owner of the store.

I started working at the Strand, with my father Ben Bass, when I was 13 years old. I took over management of the store in 1956. Book Row was such a community back in its heyday . . . 48 booksellers lined the streets on Fourth Avenue, from Union Square to Astor Place. At the time there was a lot of foot traffic, thanks to Wanamaker's department store, so the men would drop their wives off at Wanamaker's and then come by and browse the book carts in front of each of the bookstores. When Wanamaker's closed in the mid-1950s, traffic on Fourth Avenue began to subside and rents started to increase. A lot of bookstores went out of business, unfortunately. When my dad and I lost our lease, around 1956, we moved the store over to a 4,000 square foot space on the corner of Broadway and 12th Street. Broadway had much more foot traffic so we were able to grow over the years.

The Internet was one of the most significant changes we made to our business. In the late 90's, we catalogued every book in the store for our website and now the Internet comprises about 30% of our annual sales. We have also changed the appearance of the store in the last few years; we now have air conditioning, an elevator, four sales floors and one of the largest art book departments in NYC. We offer incredible discounts on all of our books and we offer the largest selection of art books in New York City.

The neighborhood has also changed dramatically over the years. Book Row is long gone and so are a lot of the small businesses. Union Square is cleaner than it has been in years and Greenwich Village has become a destination for all ages to enjoy the various cultural events and restaurants.

We own the building. It certainly helps to not have to worry about rent increases!

— FRED BASS *second-generation co-owner*

Broadway at East 12th Street (2008)

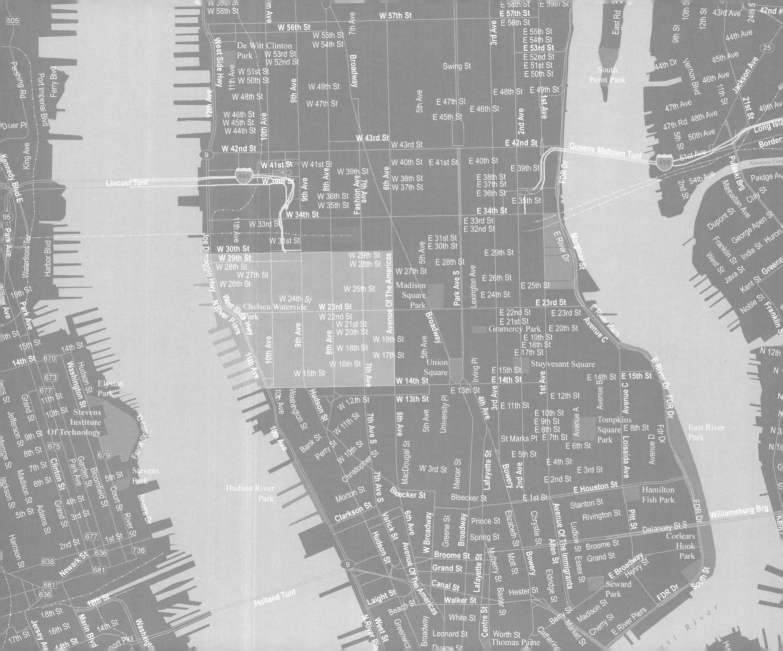

Chelsea

MANHATTAN

Chelsea is a neighborhood on the West Side of Manhattan bounded to the south by West 14th Street and to the west by the Hudson River. The northern and eastern boundaries are difficult to define but correspond roughly to 30th Street and 6th Avenue. In the early 1800's, Chelsea was settled by Scots, Germans, Italians, and the British. A Chelsea theater district, which extended along 23rd Street from 6th Avenue to 8th Avenue, began in the late 1800's. Many performers stayed at the popular Chelsea Hotel on West 23rd Street which was built in 1883 as a private apartment cooperative and opened as a hotel in 1905. Early residents of this historic 12-story brick structure included many artists. Andy Warhol's film *The Chelsea Girls* was made here.

Freight handling and warehousing became important industries in the neighborhood and west of 10th Avenue became the site of lumberyards, breweries, factories, rail yards, and piers. Tenements were built to accommodate workers and houses were converted into apartments. Greeks developed the fur business centering around 7th Avenue and by 1950 they were the largest group of white immigrants in the neighborhood. After the Second World War, Puerto Rican immigrants moved into Chelsea and some areas became crowded as townhouses were divided into apartments. In the 1980's and 1990's there was an influx of gay residents who helped revitalize the neighborhood, refurbishing townhouses and opening new businesses.

D'AUITO BAKERY is a family business that opened in 1924. Mario D'Aiuto took over the business from his father in 1977.

My father emigrated from Italy and opened up this bakery with my mother after they settled in this neighborhood. I grew up two blocks from the store and I remember my father baking in the back while my mother served customers in front. When I took over the bakery and decided to specialize in cheesecake manufacturing, my buyers persuaded me not to use the D'Auito name on the product because they said it was too hard to pronounce. So I chose 'Watson' as an American name and added the 'Baby' because 'everyone loves babies.' Nowadays, the Baby Watson Cheesecake is in such demand that we start baking at 4:00 AM and bake around 40,000 cheesecakes a day and then flash-freeze them and ship them out worldwide. We use over 40,000 pounds of cream cheese and 3,000 gallons of heavy cream delivered every other day to make our cheesecakes.

— MARIO D'AUITO *second-generation owner*

CAPITOL FISHING TACKLE (›Page 106) at this Chelsea location from 1964 to 2006, is now located on West 36th Street.

Capitol was originally a cutlery shop opened by a German immigrant in 1897. He also began to sell his own handmade fishhooks and over the years the store evolved into a tackle store. Before 1964, Capitol Fishing Tackle was located on Seventh Avenue between West 22nd and West 23rd Streets. The neon sign that is outside the store today was taken from the old location and therefore dates back to before 1964.

— TOM HOBBS *manager*

CHELSEA GUITARS (›Page 107) opened in 1989 but has been a music store since the 1940's.

I opened this store in 1989 but this location has always been a music store since the 1940's. It was called 'Interesting Records'and the guy who owned it is pretty notorious among musicians because before he would sell anybody sheet music, he would quiz them about the composer or musician. And if they didn't answer his questions correctly, he wouldn't sell them the music. Many famous musicians have shopped here over the years so this is a pretty well known store. The Allman Brothers used to live in a van parked right outside the store and would come in here all the time and hang out. This store and the tackle place next door were once part of the restaurant located inside the Chelsea Hotel and we still have the original marble floors from the restaurant in our store. This Chelsea neighborhood has really changed over the 25 years that I've lived here and what worries me is that the very people that have made Chelsea a vibrant area aren't here anymore. They can't afford to live here. I wouldn't have this store if I had to open up today. I couldn't afford the rent.

— DAN COURTENAY *owner*

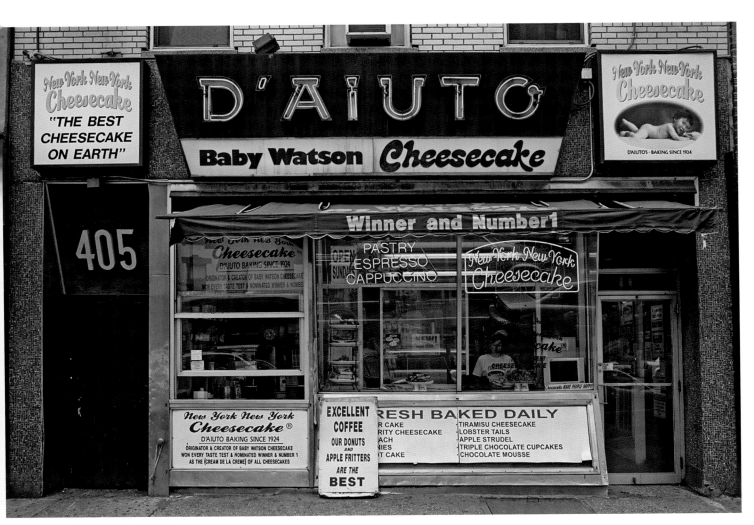

Eighth Avenue near West 30th Street (2008)

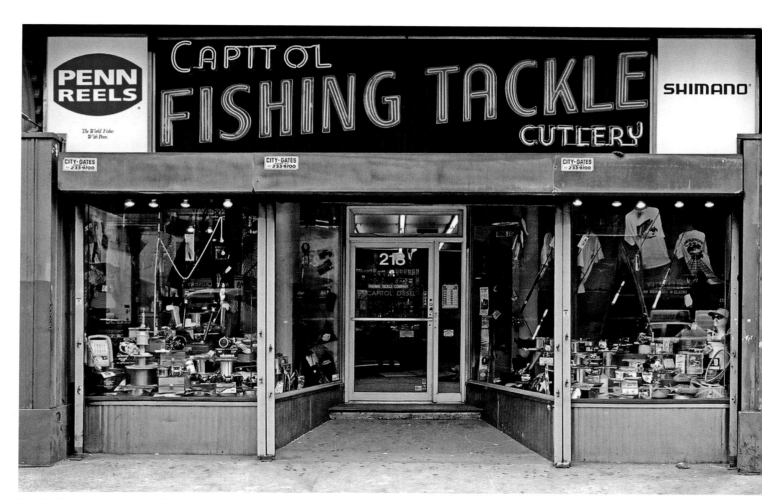

West 23rd Street between Seventh and Eighth Avenues (2004)

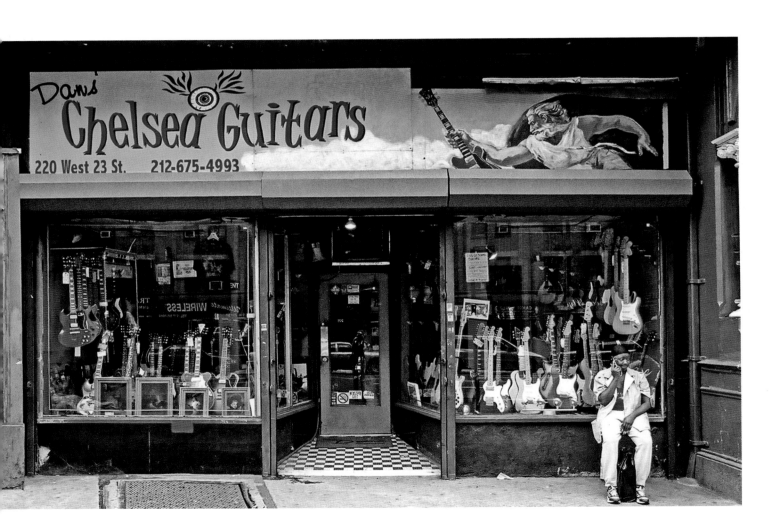

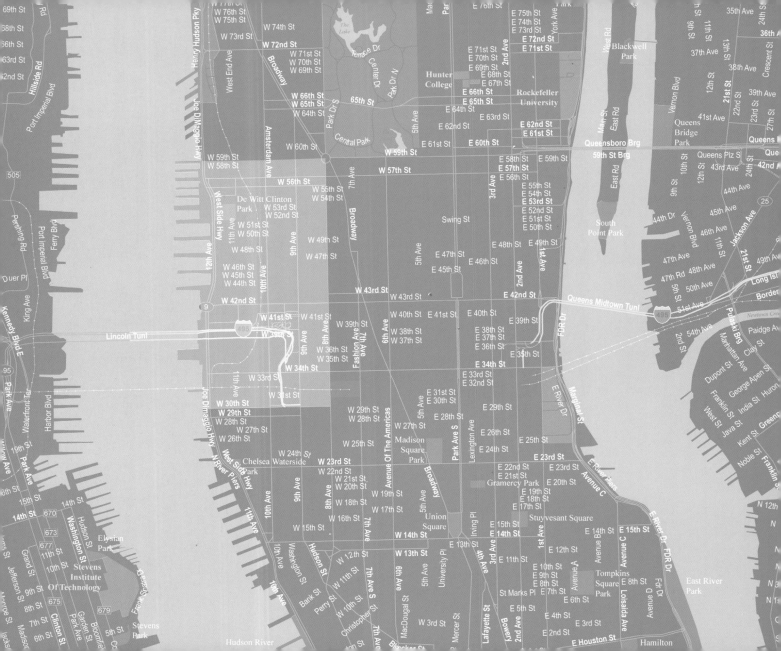

Hell's Kitchen

MANHATTAN

Hell's Kitchen is a largely disused name for the neighborhood on the West Side of Manhattan, having once been known for its dangerous gangs. It is bounded to the north by 59th Street, to the east by Eighth Avenue, to the south by 30th Street, and to the west by the Hudson River. By the end of the Civil War the area was one of the worst slums in the city. The moniker Hell's Kitchen was most likely acquired from the name of a notorious neighborhood gang. The Irish were the largest ethnic group residing in Hell's Kitchen in the 1880's but there were also Scots, Germans, and African Americans. Most Greek immigrants, who came to New York City after the First World War, settled along 8th Avenue between 14th and 45th Streets. African Americans from the South as well as Puerto Ricans settled in Hell's Kitchen in the 1940's. After two children were killed in gang wars in 1959, local organizations sought to improve the image of the neighborhood by promoting the area using its current name 'Clinton' after the DeWitt Clinton Park. When the Elevated train line ran down Ninth Avenue, the street was filled with an army of outdoor pushcart vendors, known as Paddy's Market. When Mayor Fiorella H. La Guardia banned all pushcarts in 1938, food stores were all moved indoors, a number of which survive today.

SMITH'S BAR AND RESTAURANT has been open since 1954. The neon signs outside are all original. Smith's serves breakfast, lunch and dinner from 7:00 AM to 4:00 AM and has a full bar. This old Irish pub also recently added live music performances.

GIOVANNI ESPOSITO & SONS PORK SHOP (›Page 112) is a third-generation family business that has been open since 1932. The storefront and sign are from 1971. Giovanni Esposito founded the business after he and his wife arrived from Naples, Italy in the 1920's. When his son Teddy was 12 years old, he began learning the business and took over after his father's death at age 91. Continuing the family tradition Robert Esposito, Teddy's son, took over the family business from his father in 1986. They sell homemade Italian sausages and all types of quality meats, poultry and game. They supply meat to many noted restaurants in the city.

We are known for our homemade Italian sausage, made from a family recipe almost a century old. Sausages are like handwriting. When somebody tries to copy them, they just don't come out right. When I started to run the business in 1986, one of the first things I bought was a Rolodex. For years, all of the important phone numbers were written on the walls and only my father knew where they were. Christmas is one of the busiest times of year and we sell more than 400 hams in that week. We get our hams from Gwaltney of Smithfield in Virginia and every ham we sell is accompanied by a recipe. I'll give a customer a recipe on one trip, and the next time they'll bring me one of theirs. I'd say that 85 % of our customers are regulars. We even send things to Florida when our customers retire and move down there.

— ROBERT ESPOSITO *third-generation owner*

HOWARD JOHNSON'S (›Page 114–115) opened in Times Square in 1959 and remained in business for 46 years. Howard Johnson's was a franchise restaurant, owned by the Rubinstein family. The original owner, Morris Rubenstein indicated in his will his wishes for his 'pride and joy' of restaurants to stay open forever but his son ignored his wishes and the building was sold in July 2005. Inside the restaurant were vintage Formica tables, rows of brownish-orange leather booths, and an old soda fountain serving 28 flavors of ice cream. In the 1970's there were over 1,000 Howard Johnson's Restaurants in the United States. With the closing of the Times Square Howard Johnson's in 2005 there are only five restaurants remaining.

MANGANARO GROSSERIA ITALIANA (›Page 116) has been in operation since 1893. It's a family business, currently run by Linda R. Dell'Orte. The store still has old-fashioned tin ceilings and vintage showcases stocked with Italian specialties like prosciutto, sausages, olive oil, and pastas. The provolone and smoked mozzarella are the best selling cheeses. There is a restaurant with seating in the back of the store where you can order Italian sandwiches, antipasto, or hot foods such as veal and peppers and pasta dishes.

This was originally a liquor store in the 1880's and then a family took over the space and started an Italian grocery store and restaurant in 1893, which was called Petrucci's. My family acquired the store in the 1930's and we haven't changed what we sell since we've opened and we are not going to. I am the only one left in the family who has an interest in the business but I am hoping that my niece or nephew will eventually take over the store.

— LINDA R. DELL'ORTE *third-generation owner*

THRIFT & NEW SHOPPE (›Page 117) has been in business since 1952. The present owner, Minas Dimitri took over the store in 1984.

When I bought this store it was more like a secondhand clothing shop that also sold some antiques. I decided to concentrate more on selling pottery, vases, and collectibles as well as gold and silver jewelry. Business picked up after I made the inventory change. The sign that is pictured was the original sign, but in 2005 a bus hit the store and the whole side of the store needed to be replaced so we had to put up a new sign too. I'm not sure how the bus lost control but it's definitely a hazard being located next to the bus stop. Luckily nobody inside the store got hurt.

— MINAS DIMITRI *owner*

Eighth Avenue at West 44th Street (2004)

Ninth Avenue at West 38th Street (2004)

Broadway near West 32nd Street (2004)

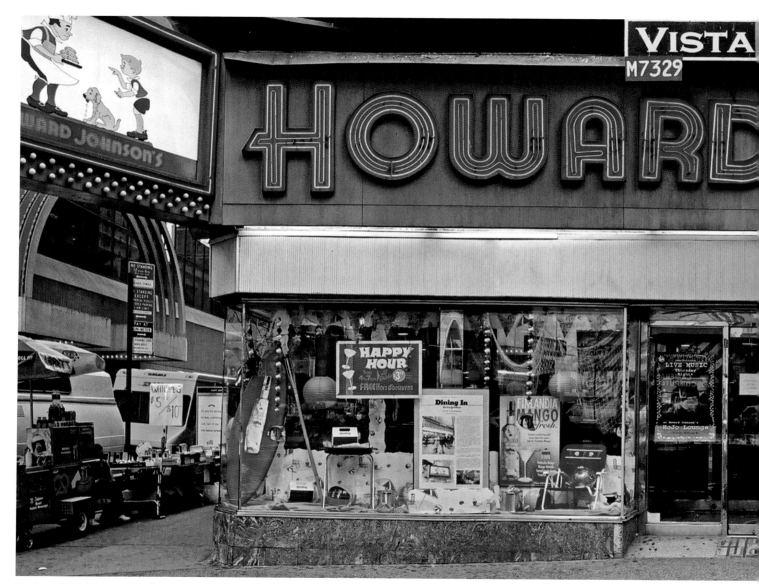

Broadway at West 46th Street (2004)

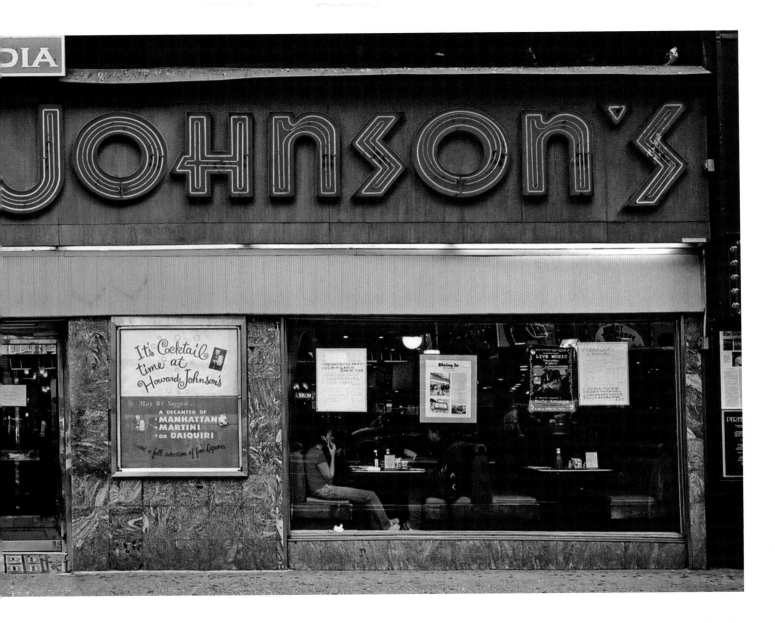

Ninth Avenue near West 37th Street (2004)

Ninth Avenue at West 43rd Street (2004)

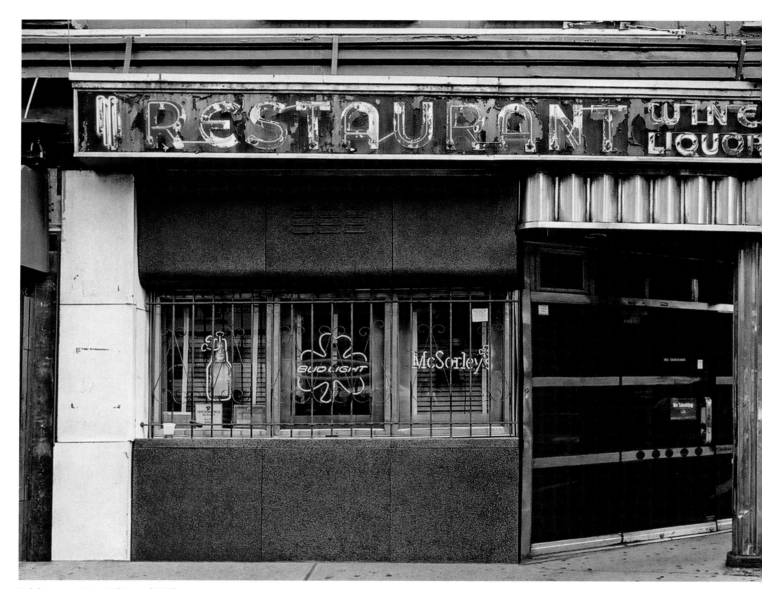

Eighth Avenue at West 46th Street (2004)

Ninth Avenue at West 33rd Street (2004)

Ninth Avenue near West 44th Street (2001)

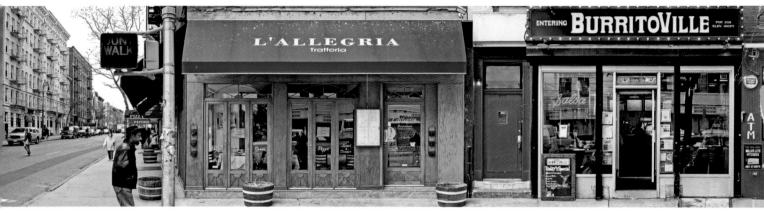

inth Avenue between West 44th and 45th Streets (2001)

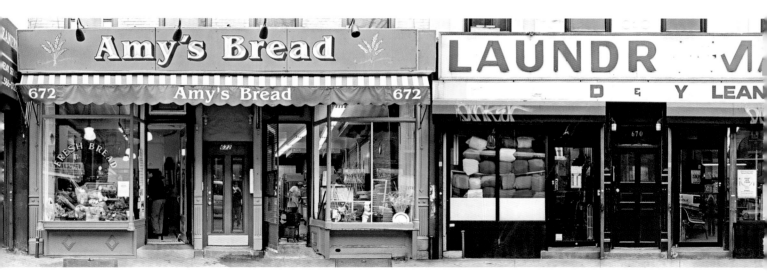

inth Avenue between West 46th and West 47th Streets (2001)

Ninth Avenue near West 45th Street (2001)

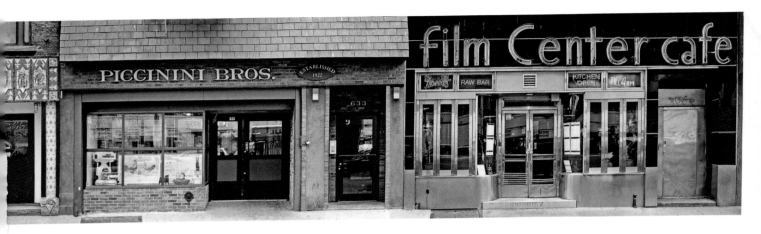

PICCININI BROS. ESTABLISHED 1922

633

film Center cafe

SAMUEL ADAMS RAW BAR | KITCHEN OPEN TILL 4AM

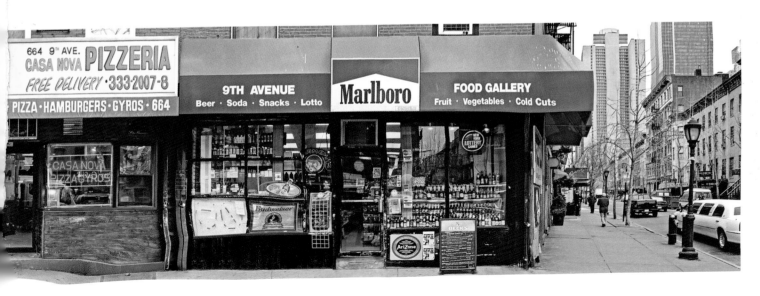

664 9TH AVE. CASA NOVA PIZZERIA
FREE DELIVERY · 333·2007·8
PIZZA · HAMBURGERS · GYROS · 664

CASA NOVA PIZZA GYROS

9TH AVENUE
Beer · Soda · Snacks · Lotto

Marlboro

FOOD GALLERY
Fruit · Vegetables · Cold Cuts

Budweiser

AriZona

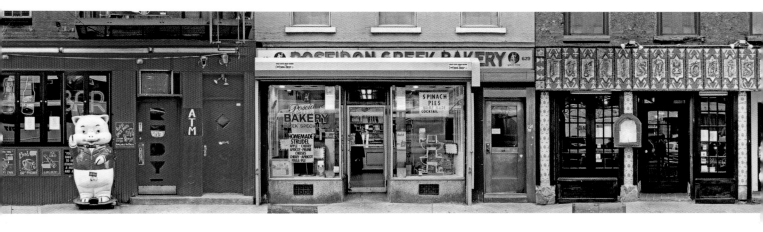

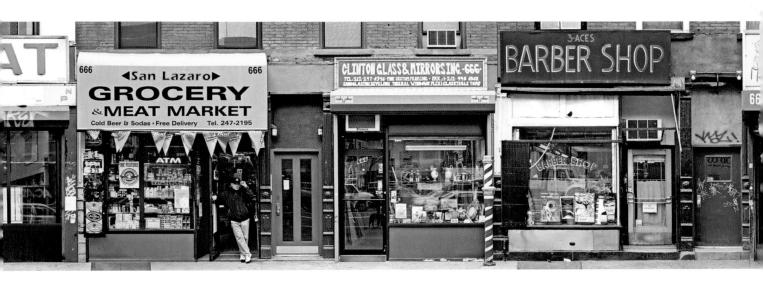

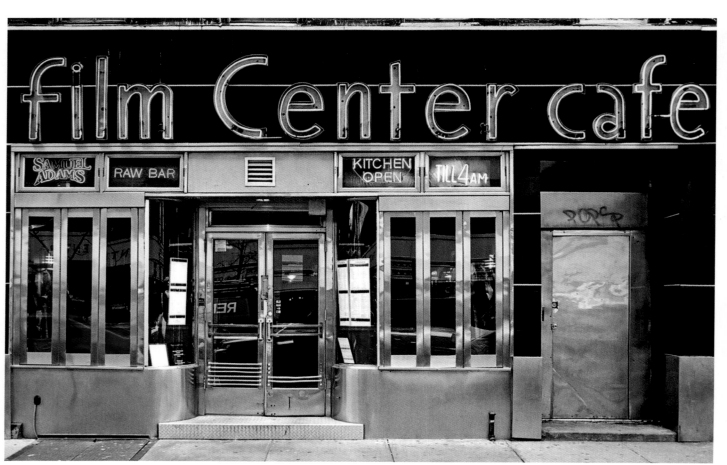

Ninth Avenue near West 45th Street (2001)

CHEYENNE DINER (‹Page 120) was in business from 1940 until April, 2008. The stainless steel and glass diner was forced to close when the owner, Spiros Kasimis, lost his lease on the property in order to make way for a nine-story apartment building. Mr. Kasimis sold the structure to a new owner who plans to move the diner and re-open at a new location in Red Hook, Brooklyn.

PICCININI BROTHERS PRIME MEAT, POULTRY AND GAME (‹Foldout) has been in business since 1922. It is now being run by third-generation family members.

My father, Guido Vaccari, and my uncle, Mauro Piccinini, started this meat business in 1922 and called it Piccinini Brothers because Mauro was the oldest brother. They both were from Milano and my uncle had even been a butcher in Italy. I started working in the store when I was 14 years old. I learned from the bottom up. I lived down the block on W44th Street and went to school right here too. After school and on the weekends I swept sawdust on the floors of the store and ran errands for my father. Eventually I began to apprentice behind the counter and learned the butcher business. The store was located down the block at 647 Ninth Avenue back then and had the city's first walk-in freezers. It had white marble counters, custom made wood-paneled walls, sawdust floors, and white enameled Toledo scales. The theater district was really bustling and we had a wide variety of customers from local housewives to famous actors like Walter Matthau and Jimmy Durante. We also supplied meat to many of the fancy restaurants in the city.

My father passed away in 1960 and I took over the business fully. My oldest son, Richard, joined me in 1971 and I taught him everything I knew. We kept expanding the business and when we heard that the City was going to build housing projects on Ninth Avenue between 45th and 49th Streets, I decided to buy a building down the street for $40,000 so the store could have a new home. The City never did build those projects but by then our rent had gotten too high and we wanted to expand our business even more, and get bigger refrigeration areas, so we decided to move in 1974 to this new store. In the 1980's my other two sons, Peter and Paul, joined the business and we widened our retail and wholesale clientele even more. Now we are no longer able to conduct a retail business here because the United States Department of Africulture (USDA) changed the regulations regarding wholesale and retail business practices. You cannot operate both from the same location so we only do wholesale now and supply many of the City's finest restaurants. That makes me sad because I really enjoyed seeing my old neighborhood customers come in every week but sometimes they still stop by and say hello anyway.

— RUDY VACCARI *second-generation owner*

POSEIDON GREEK BAKERY (‹Foldout) is a family-owned store that has been in business since 1923. Andy Fable and his wife Lillian currently run the bakery along with their youngest son who is now the fourth-generation family member in the business.

The original Poseidon Bakery was on 41st Street between Eighth and Ninth Avenues. It was on the south side of the street where the Port Authority bus terminal is now. When the City started to build the bus terminal, they kicked my father-in-law, Michael Anagnostou out. They put a summons on his door and said you have six months to get out. In those years, and that was 1952, no one knew how to fight City Hall because all of the properties around Ninth Avenue were rented by immigrants. So my father-in-law said, "This is never going to happen to me again!" He walked around the neighborhood and he saw this building for sale. He bought the building and he secured a future for himself and for us and his grandchildren. He would never be evicted again. My grandfather-in-law is the one who first opened the bakery on 41st Street, so it goes back four generations now. There are just a few businesses left that are generational and usually it's a food business too.

All the recipes we use here are from the family and we've never changed anything. Everything is made as it was 85 odd years ago in Greece and we don't use any preservatives or additives, just the pure ingredients. We live above the store and so does my youngest son. He has one floor and he's married and has a little boy now. All my three children have lived here and worked in the store pushing pastry until they were ready to marry and move on to other places. Having this apartment over the store is the best thing because it enabled Andy and myself to be at the store the irregular hours demanded and still have time with the family. We can run downstairs at 5:00 AM, start flouring the boards and rolling the baklava without leaving home. We're keeping up the tradition. We are the only shop in the U.S.A. that makes phylo pastry dough by hand. It's a very involved process and takes two people 8 or 9 hours a day to make phylo and we sell it fresh every day.

I think the thing that saved a lot of the small mom and pop stores like mine on Ninth Avenue is that the businesses were owned by the families that sometimes lived in the buildings and even owned the buildings they worked in. Customers are often afraid and anxious when they come into a small store like mine that it's going to close soon. They ask me, "How long are you going to be here?" And I reassure them that we live here and that our son has come into the business too. I cannot imagine not having this bakery.

— LILLIAN FABLE *third-generation owner*

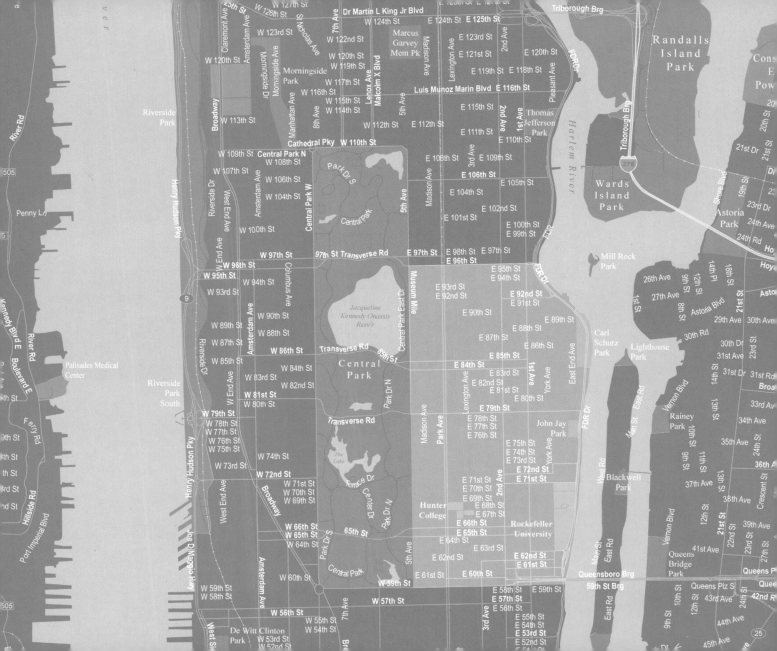

The Upper East Side

MANHATTAN

The Upper East Side is the neighborhood in Manhattan bounded to the north by 96th Street, to the east by the East River, to the south by 59th Street, and to the west by Fifth Avenue. The neighborhood of Yorkville within the Upper East Side, centered around 86th Street and 3rd Avenue, became predominantly a German neighborhood by 1850 after prosperous German families left their old neighborhoods on the Lower East Side and the East Village and settled further north. When the elevated rail lines on 2nd and 3rd Avenues were built in 1878 and 1879, the area became congested and more ethnically diverse as many Irish, Hungarians, Jews, and Italians moved in. After Second World War the neighborhood began to lose its ethnic character. The demolition of the Third Avenue El in 1955 hastened the gentrification of the neighborhood and many Central and Eastern European residents were forced to move. Real estate prices continued to rise over the years and in 1990 the postal zone, 10021, was the wealthiest in the United States.

GLASER'S BAKE SHOP has been in business in Yorkville since April 2, 1902. John and Justine Glaser established the bakery when they settled in 'German Town' and ownership was passed down to their son, Herbert, when he was 18 years old. He worked in the shop well into his seventies, using many of the family's old German recipes his parents had originally used. The third generation of Glasers, John and Herbert Jr., currently own the business and continue to make many of the same products that were introduced close to 100 years ago.

I am the third-generation owner of this store. My grandfather started this business after he emigrated here from Bavaria. He initially settled somewhere else in the city but very shortly after, he came up to this neighborhood and bought this building. Thank God, he bought it because that's why we are still here over 105 years later. Our whole family has lived upstairs from the bakery and I still do. I live in the family apartment. My brother is an owner of the business too but he's moved out of the city and he comes in and does the night shift. The storefront was last renovated in 1965. When I was a kid and it was redone, I thought it was really neat but now I wish that we had kept the original storefront because it had beautiful stained glass up top and marble down at the bottom. I actually am using the original door from the store in my apartment upstairs. We still have the original tin ceiling and the old-fashioned blue and white tile flooring. I'm glad that we never ripped those out.

All of our wooden showcases are pretty original too. They were put in around 1918. My grandfather had a bakery in Bavaria before he came to the United States and we still use some of his old recipes but we've had to adapt to the changing times because there are not too many Germans in the neighborhood anymore. It used to be heavily German. And our 'black and white' cookies are still a favorite. The original black and white cookie is derived from the German drop cake, which basically has the same ingredients. It's a big soft cookie with half vanilla and half chocolate icing. Our bakery has always made black and white cookies as far as I can remember. Everything we sell is baked right here fresh every day, using all natural ingredients.

When I retire I'm not sure who will take over the family bakery. My brother has two children but as of now, they don't want to go into the business. So I'm not sure what will happen to the bakery. I don't have any kids. It's hard work and long hours. There are easier ways to make a living I guess, but I love it and I'm glad my family has this bakery. And we have lots of loyal customers who are glad that we are still here too. We have many customers who grew up around here but have moved away and still come back to get birthday cakes and things for the holidays.

— HERBERT GLASER JR. *third-generation owner*

SUBWAY INN (›Page 126) has been open since 1943. It still has its original neon sign and an original 'Art Moderne' glass-block storefront. One of its most famous customers was Marilyn Monroe, who between takes of *The Seven Year Itch*, dropped in for drinks. Many photos and paintings of Marilyn line the back walls of the bar. In 2007 the building that houses Subway Inn was sold to a developer for $6.3 million and its future is uncertain.

LEXINGTON CANDY SHOP (›Page 127) has been in business since 1925. It's the oldest continuously operating luncheonette in Manhattan. The present owner is John Philis, grandson of the founder.

My grandfather opened this luncheonette on Lexington Avenue in 1925 and the last time it was renovated was in 1948. That's when the sign outside and all the interior seats and counters were installed. Unfortunately, I had to change the exterior slightly and put new granite up in 1995. But other than that, everything else has been here since 1948. We still use my grandfather's recipes for chocolate syrup drinks, malteds, rice puddings, and we even use the same combination of blends for the salads we sell. The Hamilton Beach mixer we use to make malteds is from the 1940's and we still make them the old-fashioned way with malt powder rather than syrup. We also continue to make coffee using an old gas-fired coffee urn.

We have some third-generation customers who live in the neighborhood and still come in with all three generations of their family together to dine here. I started working here as a young boy, when I was only 12 years old. This neighborhood has always been one of the nicer and better neighborhoods in New York City. I would say that the people living here have gotten younger since the 1980's but it's always mostly been a neighborhood full of people in their 30's and 40's. Wealthy people live here, like professionals and Wall Street types. The hanging neon sign outside that says, 'Lexington Candy Shop' was put up around 20 years ago because the original one got blown down in a windstorm. We kept the permit for the sign going and eventually replaced it because those permits . . . the City does not give them out anymore. That's why you don't see overhanging signs that much anymore. These kinds of overhanging signs are grandfathered. It's an asset that we thought we could use again. It helps visibility and visibility always helps in business.

— JOHN PHILIS *third-generation owner*

GOLDBERGER'S PHARMACY (›Page 128–129) has been in business since 1898.

I took over the pharmacy in 1986 when my former partner retired. He was the grandson of the original owner, Aaron Goldberger. Aaron Goldberger's actual license from the Board of Pharmacy in New York still hangs on the wall above the entrance to the pharmacy. His pharmacy license is dated March 21, 1898 and it has a license number of 144 proving that Aaron Goldberger was truly one of the first pharmacy licenses to be issued in the state of New York.

— PAUL FEINGERTZ *owner*

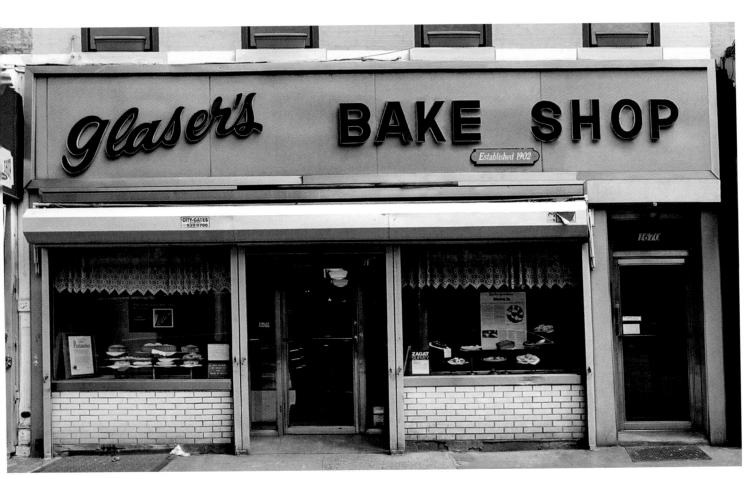

First Avenue near East 87th Street (2004)

East 60th Street near Lexington Avenue (2004)

Lexington Avenue at East 83rd Street (2005)

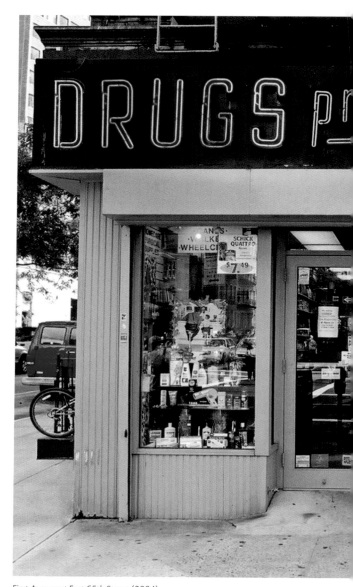

First Avenue at East 65th Street (2004)

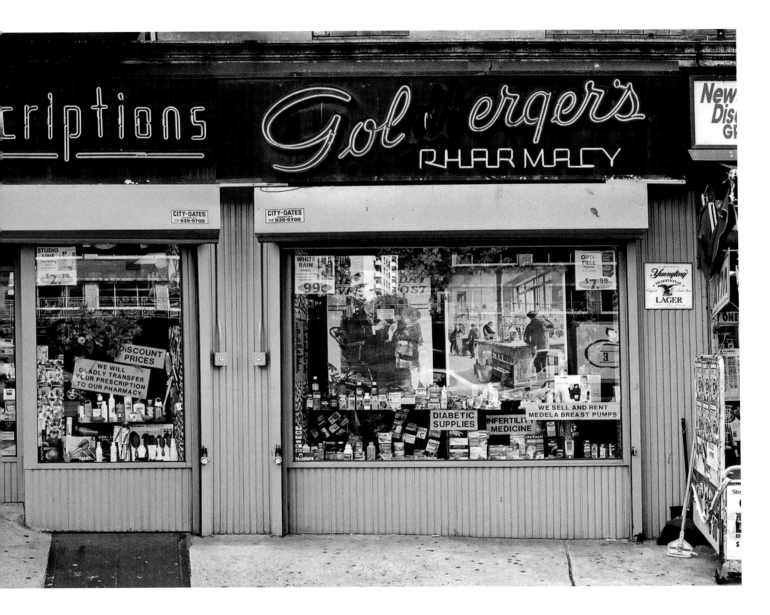

MANHATTAN *The Upper East Side*

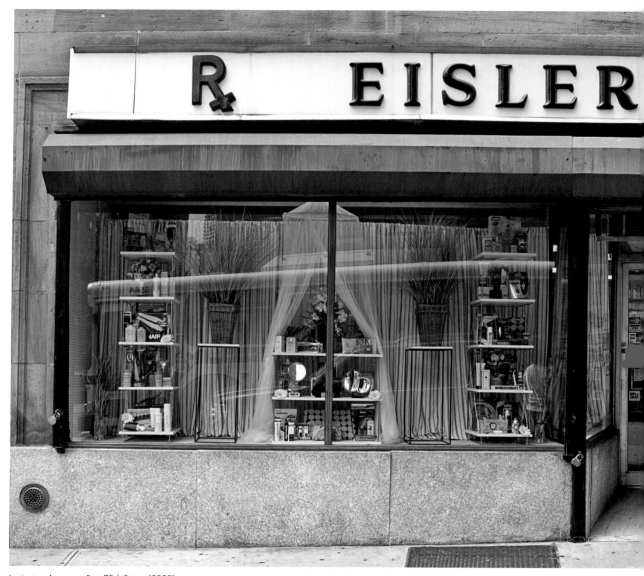

Lexington Avenue at East 79th Street (2008)

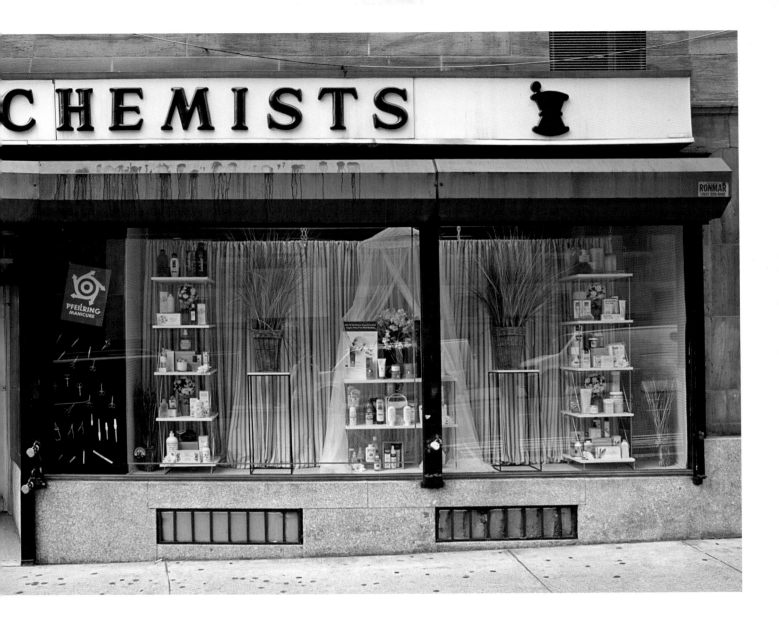

Randalls Island Park

Wards Island Park

Central Park

Jacqueline Kennedy Onassis Res'vr

Riverside Park

Riverside Park South

Morningside Park

Marcus Garvey Mem Pk

Thomas Jefferson Park

Mill Rock Park

Carl Schurz Park

Lighthouse Park

John Jay Park

Blackwell Park

Queensbridge Park

Rainey Park

Astoria Park

Hunter College

Rockefeller University

Palisades Medical Center

Harlem River

Harlem River Dr

FDR Dr

Henry Hudson Pkwy

Joe DiMaggio Hwy

Broadway

Amsterdam Ave

Columbus Ave

West End Ave

Riverside Dr

Central Park W

Central Park East Dr

Park Dr S

Park Dr N

Center Dr

Terrace Dr

Museum Mile

5th Ave

Madison Ave

Park Ave

Lexington Ave

3rd Ave

2nd Ave

1st Ave

York Ave

East End Ave

Pleasant Ave

Manhattan Ave

Morningside Dr

Claremont Ave

St Nicholas Ave

7th Ave

8th Ave

Lenox Ave

Malcolm X Blvd

Adam Clay

Malcolm X

Dr Martin L King Jr Blvd

Luis Munoz Marin Blvd

Cathedral Pky

Central Park N

97th St Transverse Rd

Transverse Rd

Triborough Brg

Triborough Brg

Queensboro Brg

59th St Brg

Queens Bridge

Queens Plz

Vernon Blvd

Main St

East Rd

West Rd

Shore Blvd

Astoria Blvd

Hoyt

Boulevard E

Kennedy Blvd E

River Rd

Ferry Rd

Hillside Rd

Port Imperial Blvd

Penny Ln

Undercliff Ave

Consolidated Edison Power

New York

St Nicholas Park

The Upper West Side

MANHATTAN

The Upper West Side is the neighborhood in Manhattan, which lies on a rugged plateau, bounded to the north by 125th Street, to the east by Central Park, to the south by 59th Street, and to the west by the Hudson River. The area was called 'Bloemendaal,' 'flowering valley,' by early Dutch and Flemish settlers. Country estates were built by the wealthy in the early 1800's and Central Park was constructed during the 1850's. After the 9th Avenue (Columbus Avenue) elevated rail line was finished in 1879, row houses were built along West End Avenue and Riverside Drive. In the 1980's, Columbia University moved from 49th Street and Madison Avenue to its present location on the Upper West Side at 116th Street and Broadway.

Tenements were built and businesses opened on Columbus and Amsterdam Avenues and large residential hotels lined Central Park West. The extension of the IRT subway line to the neighborhood in 1904 spurred the construction of high-rise apartment buildings, which developers hoped would attract members of prominent families, but instead attracted mostly the middle and working class. Crime, poverty, drugs, and disease were rampant in many sections of the neighborhood.

Starting in the 1950's through the 1980's, several projects were undertaken to clear the slums, and the opening of Lincoln Center for the Performing Arts helped establish the neighborhood as a center for the arts. Fashionable restaurants and boutiques opened along Columbus and Amsterdam Avenues and as real-estate prices rose, developers built luxury apartment towers. Today, the Upper West Side has both wealthy and poor sections, but is inhabited by mostly middle-class families. Columbia University has continued to expand its campus over the years and remains one of the city's finest learning institutions and research facilities.

P & G CAFE is a third-generation family-owned bar that has been in business since 1933. Tom Chahalis bought the bar in 1942, and re-named it P & G after his two sons, Pete and George. During Prohibition the bar was a gambling parlor and speakeasy. The neon sign is from 1946.

We have no business cards, no napkins, no matches. We don't need them. This neighborhood has changed so many times over the years. First it was great, then it was lousy, and now it's good again because the city got rid of all the single occupancy hotels in the area. Unfortunately, my lease is up at the end of 2008 and I'll probably be forced to leave because the community leaders don't really want to have a bar here. They want this street to be another Madison Avenue.

— TOM CHAHALIS *third-generation owner*

BARNEY GREENGRASS – THE STURGEON KING (› Page 136–137) is a third-generation family-owned business, which specializes in smoked fish such as sturgeon, salmon, and lox as well as caviar. They also have a restaurant serving all of their smoked fish, pickled items, salads, and fresh bagels and breads. Barney Greengrass founded the store in 1908. Since the early 1980's, Gary Greengrass, his grandson, has run the business.

The busiest time of year for us is Yom Kippur when it's like a war room in here. I work two days straight without going to sleep. My older brother Barney, who was blessed with the name of the family business, decided not to be a part of it and instead became a financial consultant. Our family joke is that one brother went to stock, the other to sturgeon. Our original store was at 113th Street at St. Nicholas Place but we moved to this Amsterdam and 86th Street location in 1929. The display cases and the counters inside the store are all original, dating back to 1908. The current sign is from the 1960's.

— GARY GREENGRASS *third-generation owner*

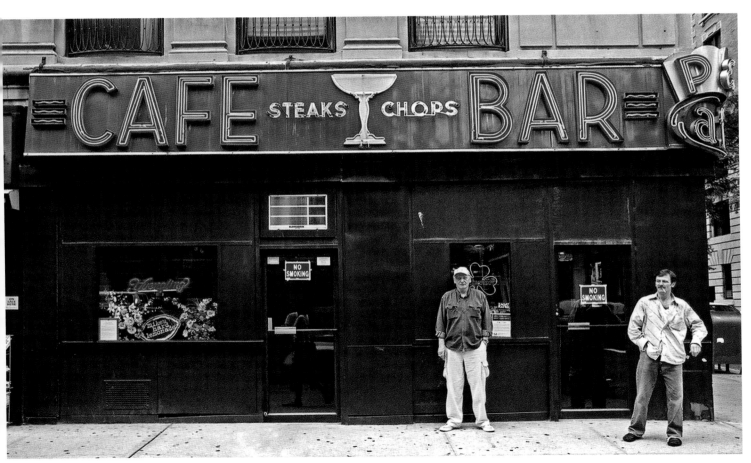

Amsterdam Avenue at West 73rd Street (2004)

Amsterdam Avenue near West 86th Street (2004)

Amsterdam Avenue at West 87th Street (2004)

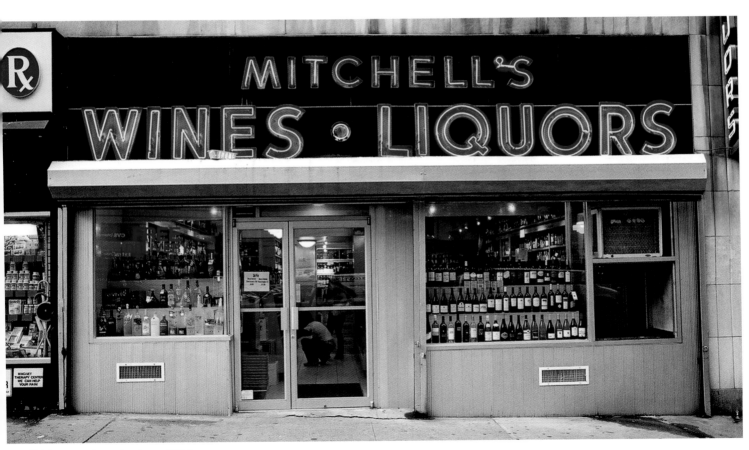

West 86th Street near Amsterdam Avenue (2004)

Harlem

MANHATTAN

Harlem is synonymous with many neighborhoods in the northern part of Manhattan, including East Harlem, El Barrio, Hamilton Heights, and Sugar Hill. When a railroad was built down Park Avenue in 1837, Harlem was divided into east and west sections.

The neighborhood in the western half of Harlem is bounded to the north by the Harlem River, to the east by Fifth Avenue, to the south by 110th Street (Central Park North), and to the west by Morningside and St. Nicholas Avenues. In the early 1900's the neighborhood had a very large Jewish population, but by 1930 the Jewish population declined and the number of African Americans increased to more than 200,000. African Americans from all over the country were attracted to Harlem because of its economic opportunities and vibrant musical and cultural life, including the literary and artistic movement known as the Harlem Renaissance. The Depression devastated the local economy, ending Harlem's golden period. In the 1990's the population remained almost entirely African American. The entire area is benefiting from a second revival, with new shops and restaurants and visitors arriving to tour significant sites of African American culture.

East Harlem has imprecise boundaries, but correspond roughly to East 96th Street in the south, East 142nd Street in the north, and from the East River to Park Avenue in the west. By the mid 1880's, most streets were lined with tenements, which initially housed poor German, Irish and Jewish immigrants. At its height in 1917, the Jewish population in East Harlem was 90,000. There was also an influx of Italians into East Harlem in the early 1900's and by the 1930's as many as 110,000 Italians lived in an enclave east of Lexington Avenue. Puerto Ricans first began moving there in the 1920's and by 1930, most of the city's Puerto Rican residents lived in East Harlem. During the 1940's and 1950's, due to severe overcrowding in the neighborhood, Italians moved out and Puerto Ricans became the dominant group.

As the Puerto Rican population of East Harlem increased, the neighborhood between 96th and 120th Streets, east of 5th Avenue became known as Spanish Harlem (El Barrio). Although a large number of Puerto Ricans were forced to move to other parts of the city during the construction of urban renewal public housing projects in the 1950's, they maintained ties to the neighborhood and continued to visit and shop there. Today, East Harlem and El Barrio remain racially diverse neighborhoods in which more than a third of the population is Puerto Rican.

LENOX LOUNGE has been in business since 1939. The current owner, Alvin Reed has restored much of the club's interior to its original decor. Many famous jazz musicians have played at the Lenox Lounge, including Charlie Parker, Billie Holiday, and Miles Davis.

M. FUTTERMAN CORP. (›Page 144) has been in business for over 100 years. It is a wholesale candy, tobacco, and paper goods family business, being run by the third-generation family member, Bruce Futterman. The storefront and signage are from 1950.

My grandfather started this business in Harlem over 100 years ago and we moved to this location in 1950. I grew up around here and this neighborhood has always been on the tough side, especially in the 1980's and early 1990's. We have always kept the door locked and buzz customers in. Our basement is lined with metal cages and we even have sophisticated motion detectors set up to monitor the merchandise. Most of our clients are bodega owners and movie theaters. They buy candy and cigarettes in bulk from us at a much cheaper price than they could negotiate from the vendors directly.

— BRUCE FUTTERMAN *third-generation owner*

CLAUDIO'S BARBERSHOP (›Page 145) has been in business since 1950, but the shop itself dates back over 110 years.

I've worked here since 1950, when I moved to Harlem from Campania, Italy. I come from a family of barbers, including my father and brother. I was only 20 years old when I began working for Sal, the former owner. When he was ready to retire, I bought the business from him. I never changed a thing about the store since I bought it. I still use the same porcelain and leather barber chairs and even have my original straight-edge razor with its leather strop for sharpening. I can't use it anymore because the health codes have changed and I have to use disposable razors. I also have not raised my prices much over the years. I try to keep them low because many of my customers are on Social Security and don't have much money. I keep my price reasonable and that's why I'm still here.

When I first started working here this was a big Italian neighborhood but now most of the Italians are gone. I even moved my family to the Bronx but still come here to work 6 days a week. I am Italian but have learned to speak Spanish because I've picked it up from so many of my customers over the years. Some of my customers have been coming to me for so long that they now bring their grandchildren in for haircuts. That's why you see all these pictures hanging. My customers bring me pictures of their kids and grandkids and wedding pictures and everything. They all want me to stay here forever and I'm going to try my best.

— CLAUDIO CAPONIGRO *owner*

BRAND'S WINE & LIQUORS (›Page 146–147) has been in business since the 1920's. Moon Lee, the current owner, bought the store in 1980 from the original owner's grandson.

This liquor store dates back to before the prohibition. The wooden showcases are from the 1920's and the big marquee sign is from the 1950's. Over the past few years, the City has been trying to get me to take the sign down because there is a new law that says that storefront signs can't stick out from the building more than 18 inches. But I don't want to take it down because I realize the historical importance of the sign. So I am fighting the City to keep it. This sign is the last of its kind on the block. West 145th Street was once lined with old stores with big marquee's like this one, but little by little the City has forced the owners to remove the signs by giving us summonses and tickets. Every time the city needs money, they start pressuring me and issuing more tickets, but I won't give in.

(In late 2005, Moon Lee lost his battle with New York City and was forced to remove the sign and replace it with a new flat version.)

I lost the battle with the City to keep the marquee sign when they decided to fine me for the sign retrospectively from the time I bought the store. The fine amounted to over $50,000 and I couldn't afford that so I agreed to remove the sign and replace it with a flat version they approved of. The removal of the sign was a kind of harbinger of the neighborhood changing. Down comes the past along with the entire character of the neighborhood and in comes gentrification. This area was once the outer rim of a ghetto area and now luxury condos are being built and rich people are moving in. This block is going to look like 96th Street with chain stores and expensive housing. It's good for my business but I still feel terrible about the loss of the neighborhood's character.

— MOON LEE *owner*

BRITE LITE BARBER SHOP (›Page 148) has been in business since the 1940's. The barber pole located outside the shop with the traditional red and blue stripes is original. It is no longer functional but when the stripes on the pole moved, it indicated that the shop was open.

MISHKIN'S DRUG STORE (›Page 149) has been in business since 1890.

This pharmacy has been in business since 1890. I am the third owner and I bought this store in 1985. This neighborhood has really changed over the years. When I bought this store, the neighborhood was pretty bad and there was a lot of crime and many apartment buildings were abandoned. Now many new people have moved in and the area has gotten more expensive. Unfortunately, many of the smaller older stores like mine have disappeared and have been replaced by big name franchises.

— SEUNG YOO *pharmacist and owner*

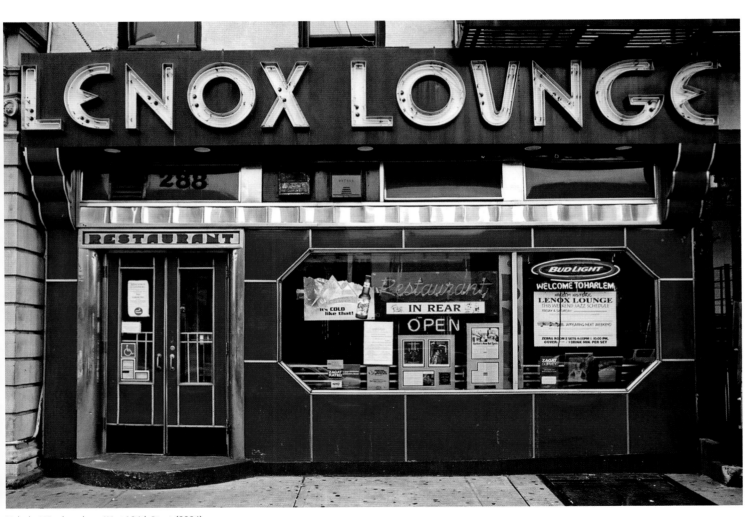

Malcolm X Boulevard near West 124th Street (2004)

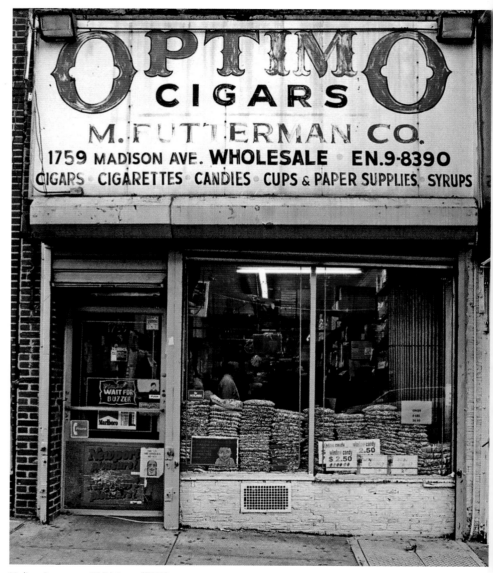

Madison Avenue near 116th Street (2007)

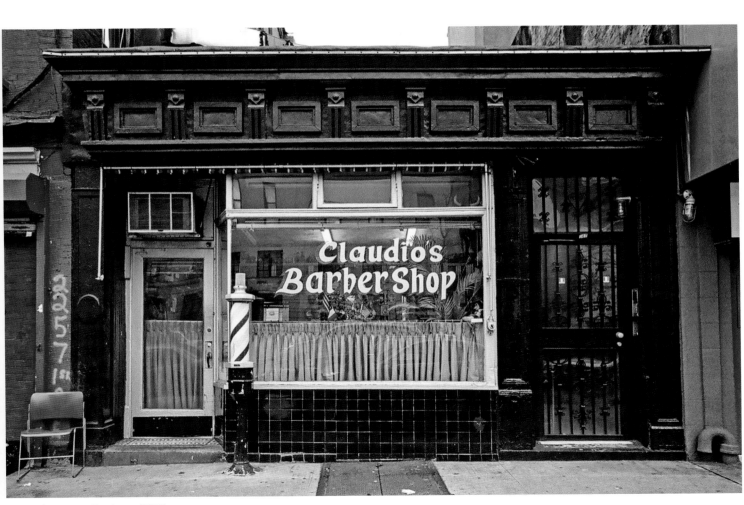

East 116th Street near First Avenue (2007)

West 145th Street near Broadway (2004)

MANHATTAN *Harlem*

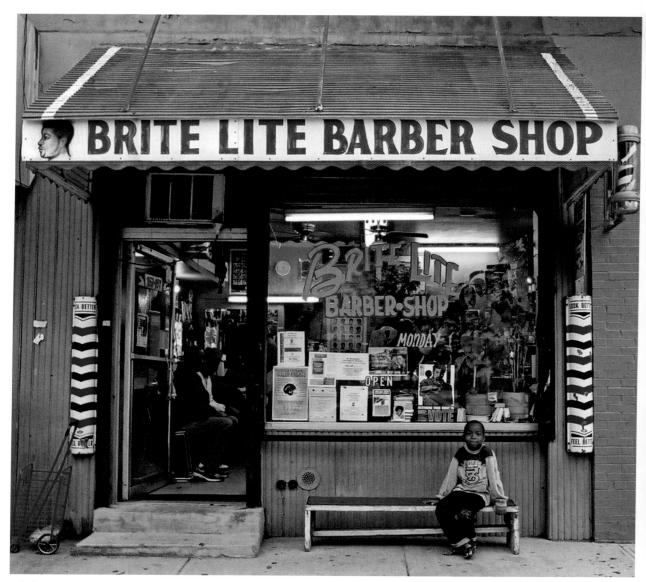

Malcolm X Boulevard near West 118th Street (2004)

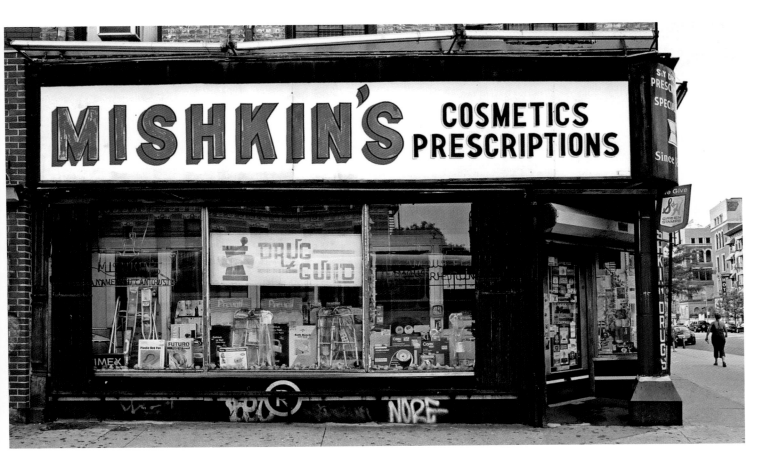

Amsterdam Avenue at West 145th Street (2004)

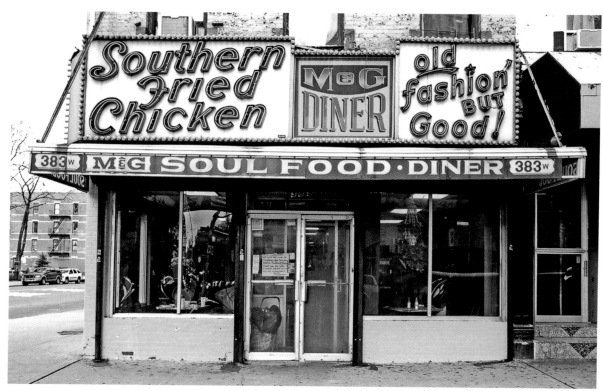

West 125th Street at Morningside Avenue (2007)

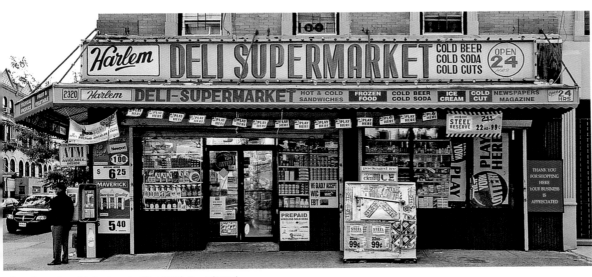

Adam Clayton Powell Jr. Boulevard at West 136th Street (2004)

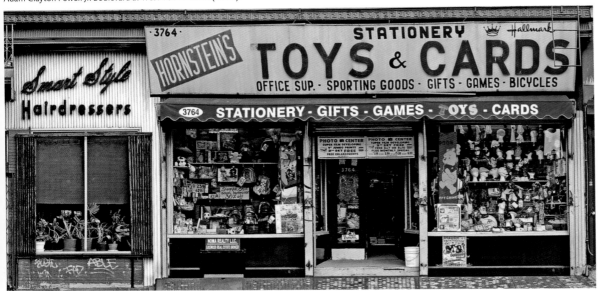

Broadway near 156th Street (2004)

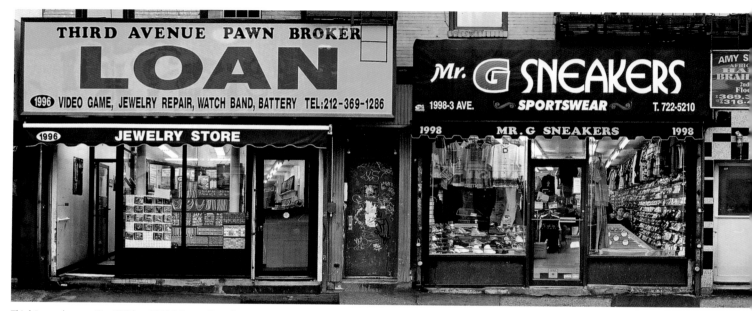

Third Avenue between East 109th and 110th Streets (2001)

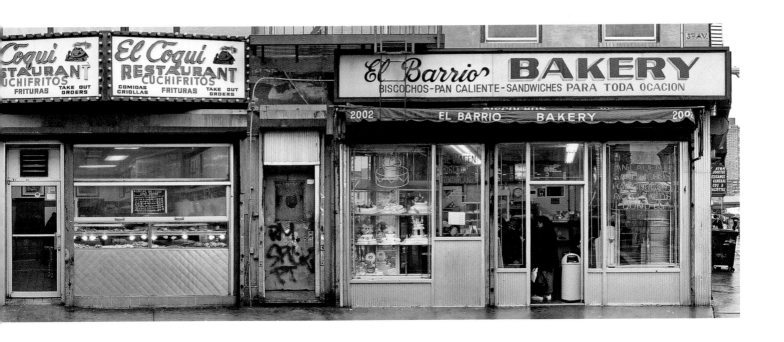

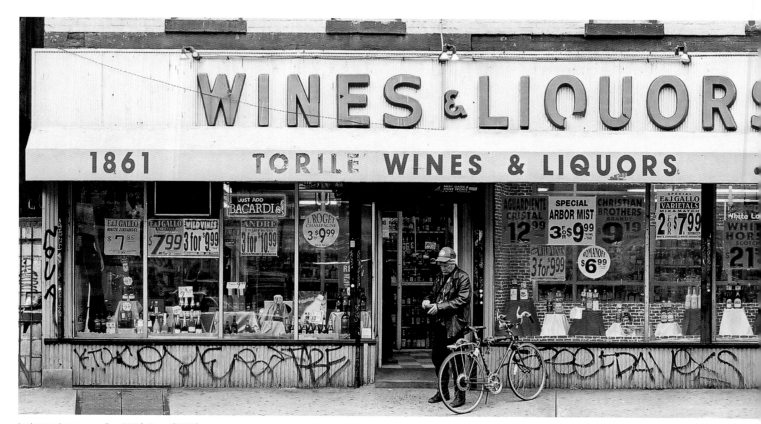

Lexington Avenue near East 115th Street (2001)

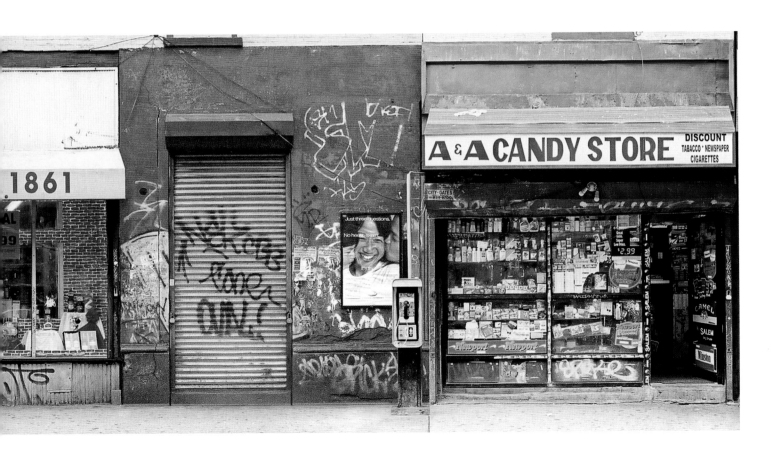

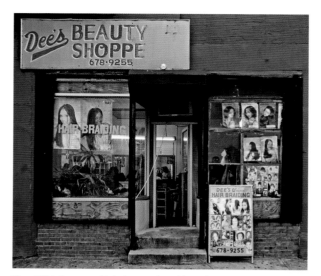

West 127th Street near Malcolm X Boulevard (2004)

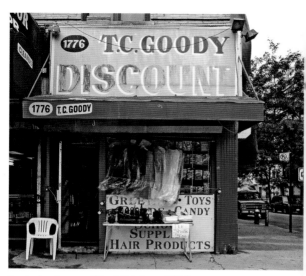

Amsterdam Avenue at West 148th Street (2004)

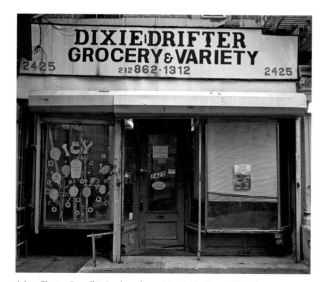

Adam Clayton Powell Jr. Boulevard near West 141st Street (2008)

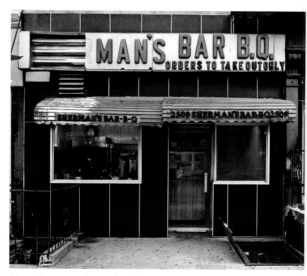

Adam Clayton Powell Jr. Boulevard near West 145th Street (2004)

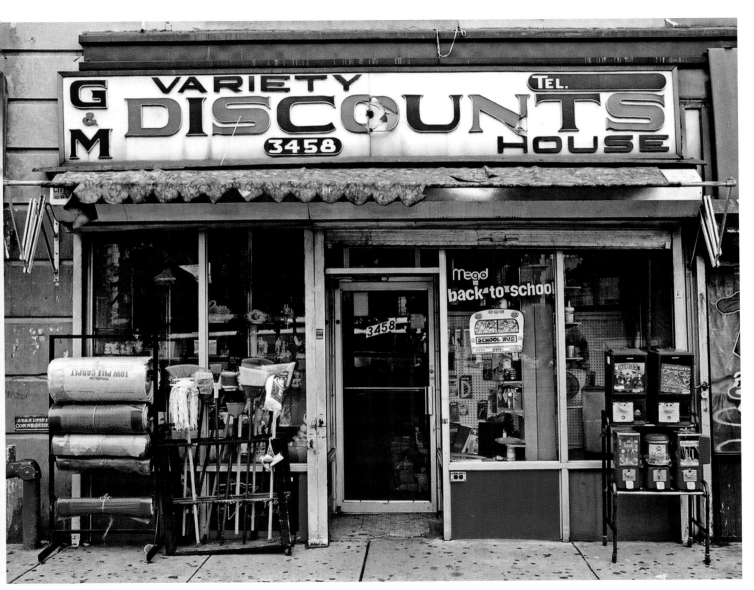

Broadway near West 142nd Street (2004)

First Avenue near East 116th Street (2003)

Malcolm X Boulevard near West 131st Street (2004)

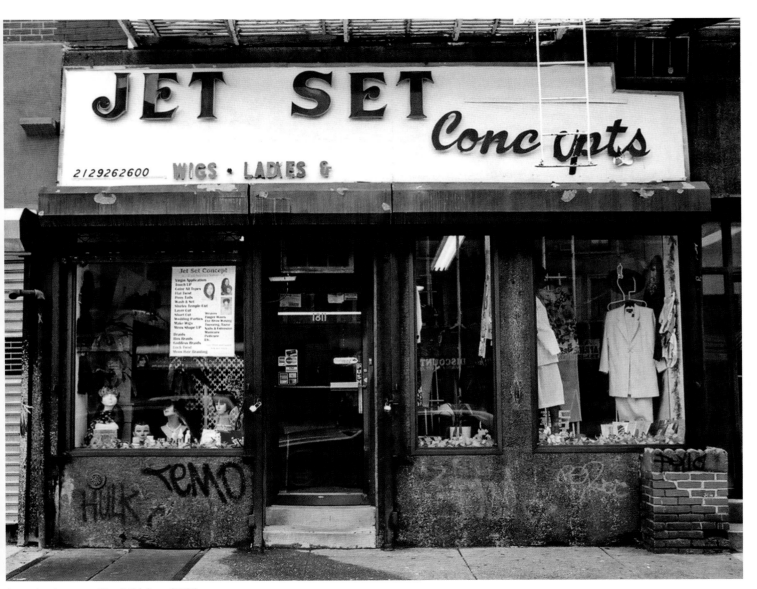

Amsterdam Avenue near West 148th Street (2004)

Inwood Hill Park

Columbia Univ- Baker Field W 218th St

W 216th St
W 215th St

Kingsbridge Rd

Poe Park

Decatur Ave

Fordham University- Rose Hill

Boston Rd

White Plains Rd

Bronx Park E

Bronxdal

Lyd Cruger Ave
Antin Pl
thews Ave
Bigar

9th Ave
Broadway

Bailey Ave
Sedgwick Ave
Major Deegan Expy

Jerome
Creston

Marion Ave

E Fordham Rd

3rd Ave

E 189th St
E 188th St
E 187th St

Crotona Ave

Southern Blvd

Jungle World Rd

Rhinelander Ave
Van Nest
Victor St
Morris Park Ave
Hunt Ave

Bronx River Pky

St James Park

Dr Martin L King Jr Blvd

Celia Cruz Blvd

E 188th St

Bronx Park

Webb Ave

Devoe Park

W Fordham Rd

E 184th St

River Ave

Davidson Ave

University Ave

Aqueduct Ave E

E 184th St

Tiebout Ave

Valentine Ave

Lorillard Pl

Arthur Ave

E 183rd St

Garden St

Park Ave

Webster Ave

E 183rd St
E 182nd St
E 181st St
E 180th St

Hughes Ave
Lafontaine Ave

Mapes Ave

Bronx Park S

Crotona Pkwy

Vyse Ave

E 180th St

Seaman Ave
Payson Ave
Cooper St
Vermilyea Ave
Park Ter

Isham St
Isham Park

W 207th St

W 204th St

Dyckman St

Henry Hudson Pky

9

Bronx Community College

W 180th St

Roberto Clemente State Park

Long Pl S

Sedgwick Ave

Phelan Pl

Morris Ave
Creston Ave

E 181st St

Anthony Ave

Washington Ave

Quarry Rd

Batgate Ave

Clinton Ave

Firefighters Blvd

Clinton Ave
Prospect Ave

E 179th St
E 178th St

Wyatt St

E 177th St

E Tremont Ave

Cross Bronx Expy

Harrod Ave

Academy St
Sherman Ave
Nagle Ave
9th Ave
10th Ave

Ellwood St
Hillside Ave

Fort Tryon Park

Bennett Ave
Fort Washington Ave
Amsterdam Ave
Audubon Ave

Fort Washington Park

Riverside Dr
Margaret Corbin Dr
Park Dr
Cabrini Blvd

9

Harlem River Dr

Undercliff Ave

Popham Ave
Andrews Ave E
University Ave

Grand Ave
Harrison Ave

Aqueduct Ave

Walton Ave

E 179th St
E 177th St
E 176th St

Jerome Ave

E 174th St

E 173rd St

Macombs

Selwyn Ave

Morris Ave

Clay Ave

Bathgate Ave

Park Ave

E 175th St
E 176th St

Fulton Ave

Crotona Park N

Crotona Park

E 174th St

E 172nd St
E 173rd St

Boston Rd

Hoe Ave

Longfellow Ave

E 174th St

Vyse Ave

Charlotte St

Wheeler Ave

Elder Ave
Boynton

E 172nd St

Evergreen Ave

Bronx River Ave

Claremont Park

Claremont Pkwy

Crotona Park E

E 171st St

Clinton Ave

Close Ave

W 181st St
W 182nd St

87

Newton Ave

Jesup Ave

Edward L Grant Hwy

Townsend Ave

Walton Ave

Teller Ave

E 170th St
E 170th St

Webster Ave

Park Ave

3rd Ave

Jennings St

Freeman St

Home St

W Farms Rd

895

Simpson St

W 179th St
W 178th St

1

University Ave

Shakespeare Ave

E 170th St

College Ave

Washington Ave

E 169th St

E 168th St

Franklin Ave

Forest Ave

E 167th St

Southern Blvd

Kelly St

Intervale Ave

Rev James A Polite Ave

Bryant Ave

Falle St
Longfellow Ave
Falle St

W 176th St
W 173rd St

J Hood Wright Park

St Nicholas Ave

High Bridge Park

Ogden Ave

Elliot Pl

E 169th St

Gerard Ave

Sheridan Ave

Morris Ave

Findlay Ave

Clay Ave

Washington Ave

Trinity Ave

Union Ave

Prospect Ave

E 165th St

E 163rd St

Barretto St

Beck St

W 168th St

Columbia Presbyterian Medical Ctr

Haven Ave
Amsterdam Ave
Edgecombe Ave

McClellan St

John Mullaly Park

E 166th St
E 165th St

Grant Ave

Sherman Ave

Cauldwell Ave

E 164th St

Eagle Ave

Trinity Ave

E 163rd St

E 164th St

Elton Ave

Melrose Ave

Brook Ave

St Anns Ave

3rd Ave

Prospect Ave
Union Ave

E 160th St

Longwood Ave

Fox St
Dawson St

Tinton Ave

Lafayette Ave
Tiffany St

Kelly St

Wor then St

W 165th St
W 164th St
W 161st St
W 160th St

Roger Morris Park

Riverside Dr

Woodycrest Ave

Summit Ave

Joyce Kilmer Park

E 162nd St

Grand

E 161st St

Walton Ave

E 163rd St

Washington Ave

Elton Ave

E 161st St
E 160th St

Westchester Ave

Bruckner Blvd

Garrison Ave

Barry St

Whitlock Ave

Sheridan Expy

W 158th St
W 157th St
W 156th St

8th Ave

W 155th St

Macombs Dam Park

Henry Hudson Pky

Harlem Heights Dr

Harlem River Dr

E 161st St

Gerard Ave

River Ave

E 158th St

Sheridan Ave

Courtland Ave

3rd Ave

E 156th St

Elton Ave

Cortland Ave

E 153rd St

E 151st St

Franz Sigel Park

Eugenio Maria De Hostos Blvd

Bergen Ave

Brook Ave

Timpson Pl

Dawson St

Truxton St

Kelly St

Austin Pl

Bruckner Expy

E 149th St

E 147th St

Trinity Cemetery

W 153rd St
W 152nd St
W 150th St

St Nicholas Pl
imble Ave
thurst Ave

Frederick Dougl

Exterior St

Gerard Ave

E 157th St

Walt

Concord Ave

FDR

Washington Heights & Vicinity

MANHATTAN

Washington Heights is the neighborhood in northern Manhattan, bounded to the north by Dyckman Street, to the east by the Harlem River, to the south by 155th Street, and to the west by the Hudson River. Initially, large number of Greeks, Irish, and Jews settled in the area but by the early 1960's many of them left and African Americans, Puerto Ricans, and Cubans moved in. After the mid 1960's Dominicans increased in number and by 1980, more than three-quarters of the population of Washington Heights was Dominican. In the mid 1990's poverty, overcrowding, and drug trafficking overtook the neighborhood, but many businesses still flourished. Broadway has long divided the poor and working class sections of Washington Heights to the east from the middle-class areas to the west. This division is still evident today, even though the ethnic composition of the neighborhood has changed dramatically.

In the early 1900's many Jewish and Irish immigrants moved into Inwood, which is the neighborhood at the northern tip of Manhattan, bounded to the north and east by the Harlem River. Over the years the demographics changed, many Latin Americans and African Americans settled in the area and Dominicans accounted for almost 80 percent of the recent immigrants who settled in Inwood in the 1980's. By 1990, the Dominican community in Washington Heights and Inwood combined was the largest in the United States.

REYNOLD'S BAR has been in continuous operation since 1932. The neon sign is from 1964.

This bar has been here since 1932. It was called Bill's Café back then and the owner was an ex-cop who ran the place for 32 years. When he retired, he sold the bar to Jim Reynolds in 1964 and he put up the neon sign that you see today. The interior, however, is still the same, and dates back to Prohibition. This is the last of the old Irish bars in the whole neighborhood. There were dozens of them at one time. But this is the last one left around here. I started working the bar here 32 years ago when the neighborhood was mostly Irish.

Now the neighborhood has totally changed and most of the Irish and Jewish people have left and lots of Dominicans have moved in. There used to be a lot of problems in the area around ten years ago with drugs and crime but now the neighborhood has really improved. Most of our business is Spanish-speaking customers, especially at nighttime, but we have no problems and haven't been robbed or anything. We plan to stay here for many more years to come.

Although Jim Reynolds doesn't own the building and there are only two and a half more years left on the lease, we aren't worried. We recently spoke with the landlord and he said that we can have this place for as long as we want. That really makes us feel better because rents have really been on the rise. Around the corner from here on West 181st Street there was an old Jewish bakery that recently went out of business because the landlord tripled their rent up to $10,000 a month. They couldn't afford to stay in business anymore and we hope that never happens to us but you never know.

— PAT SMITH *manager/bartender*

OLYMPIA FLORIST (›Page 167) has been in business since 1905. Gus Pappas, the owner, took over the business from his father, Peter, when he retired. The neon sign is from the 1930's.

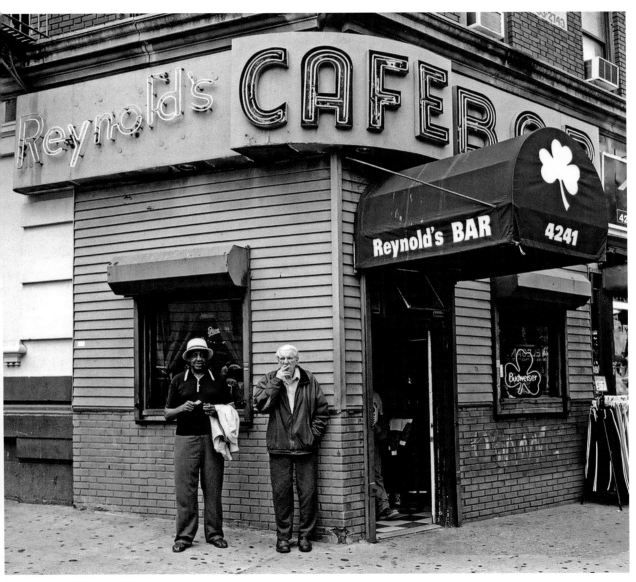

Broadway at West 180th Street (2004)

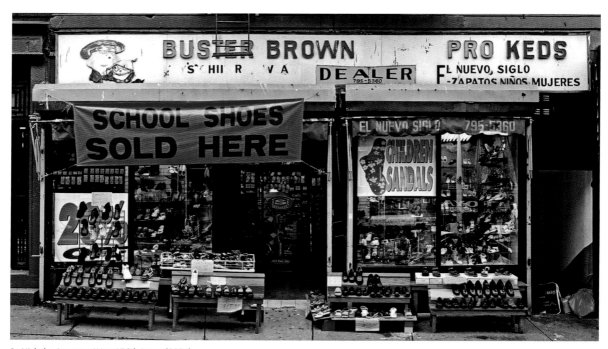

St. Nicholas Avenue at West 176th Street (2004)

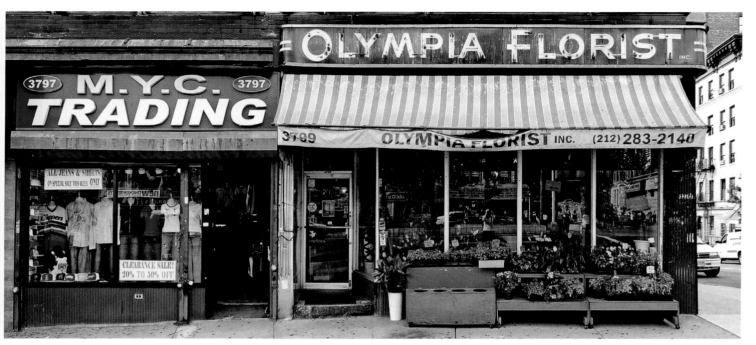

Broadway at West 158th Street (2004)

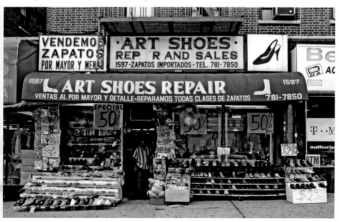

St. Nicholas Avenue near West 192nd Street (2004)

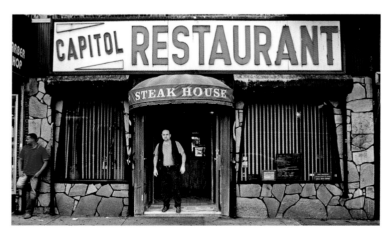

Broadway at West 207th Street (2004)

MANHATTAN *Washington Heights & Vicinity*

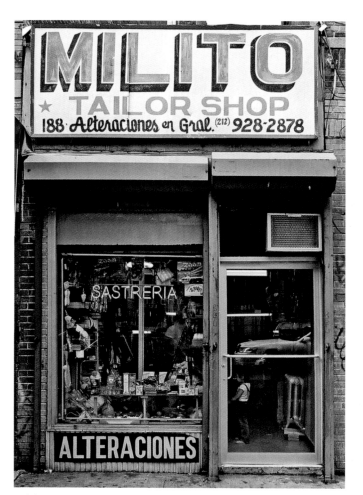

Audubon Avenue near West 176th Street (2004)

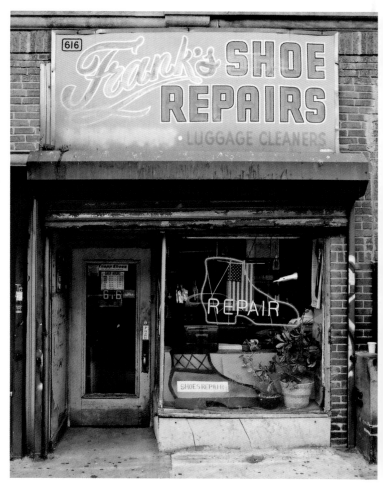

West 207th Street near Broadway (2004)

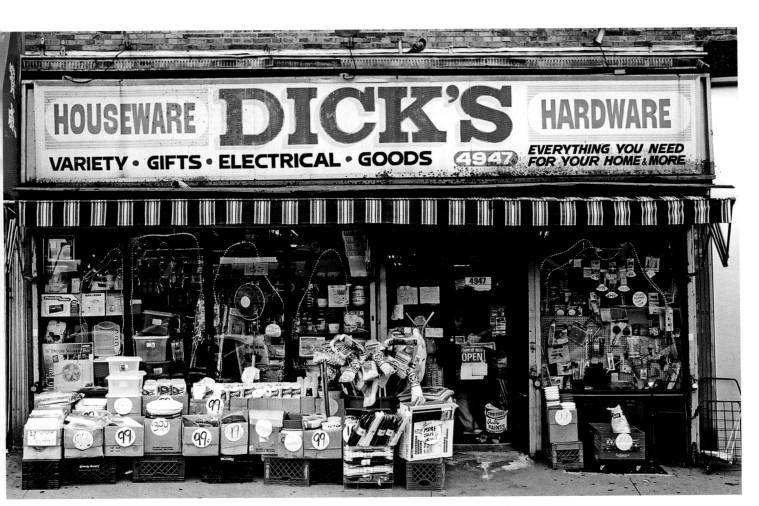

Broadway near West 207th Street (2004)

THE BRONX

is the northernmost borough of New York City and was annexed by the city in the late 1800's. During the early part of the 1900's, after the first subway connecting the Bronx to Manhattan was built, thousands of immigrants moved from their overcrowded tenements in Manhattan to spacious new apartments in the Bronx. Large numbers of Irish and German immigrants moved to southern neighborhoods, including Mott Haven and Morrisania.

After the Second World War, longtime Irish, German, Italian, and Jewish residents moved from older housing in the southern neighborhoods into privately-built housing in the northern Bronx, or to other boroughs and suburbs. At the same time, about 170,000 people displaced by slum-clearing in Manhattan, mostly African Americans and Puerto Ricans, moved to neighborhoods in the southern Bronx including Hunts Point, Morrisania, Melrose and Tremont. Many neighborhoods became poverty-stricken and buildings fell into disrepair. There was a period of rampant arson in the late 1960's and early 70's in southern sections of the Bronx. Buildings were set afire by corrupt landlords, or by tenants trying to take advantage of the city's policy regarding burned-out tenants. The policy then in existence gave these tenants priority for city housing. Since the early 1990's, much redevelopment has taken place in several Bronx neighborhoods.

Belmont, the 'Little Italy of the Bronx,' is one of the few neighborhoods which has retained its original ethnic character. The Bronx Zoo and The New York Botanical Garden began construction in the late 1890's and required many workers to landscape the grounds and construct the buildings that would house the animals. Real estate developers encouraged Italians, who were drawn to the construction industry, to settle in Belmont. Even though many Italian families have moved out of the neighborhood, it still draws new immigrants from Italy, and many who have moved away often return to shop and dine.

Potters
Field

Eastchester
Bay

C & N EVERYTHING STORE is a family-owned business run by Cobert and Novil Seward that has been in operation since 1956.

The sign is the original one taken from our old store on 165th Street and Teller Avenue. We moved to this location in 1977 because the landlord raised the rent so high at the other store that we were forced to move. My husband and I ended up buying this whole building so that would never happen again to us. We took with us all our shelving, cabinetry, and merchandise so the inside of the store still looks very much like it did in 1956 except that maybe it's a bit more crowded with merchandise now. We literally sell everything in here from candy to pipe-fittings. We are open 7 days a week, every day of the year except for Christmas Day. I really don't have a most popular item, I just sell what I can. We used to sell more food items like milk and eggs but business is slower now so I don't stock perishables anymore and I've cut back on the amount of newspapers I carry. I used to sell every New York paper including the New York Times *but now I only carry the* Daily News *and the* Post *because they are the only ones that let me buy only a few a day, otherwise you've got to buy in bulk and I can't afford that.*

I've been in this neighborhood so long that I've watched many of my customers grow up and now some of them even bring in their grandchildren. I know most everybody by name and I treat all of them like family. One of the biggest things happening in this neighborhood lately is that there's lots of new construction. I don't know who can afford the rents they are charging. Most of these new buildings are empty and you'd think the owners would lower the rents instead of them staying empty but I guess they'd rather leave them unoccupied. If we didn't own this building we would have been out of here long ago.

— NOVIL SEWARD *owner*

FRANK BEE 5 ¢ TO $1.00 STORE (›Page 176–177) has been open since 1957. Douglas Bee, Frank's son, has run the store since his dad's retirement.

This store was already a '5 and 10' that had opened in 1930, and when my dad took it over in 1957, all he had to do was just the change the name on the sign. But he didn't have any money for a new sign so he just rearranged the letters from the previous owner's sign to spell his own name. He told me that it looked totally crazy because he didn't have all the letters he needed so he ended up cutting the letters he had into new shapes and that the sign looked like it was written in Chinese when he was finished. Finally, he saved enough money to put up his own new sign in 1960 and that is what still stands today.

The storefront is original and all the wooden shelves inside the store with glass dividers are also original. We are one of the only original '5 and 10' stores left in the United States. Woolworth's was the big '5 and 10' in New York City but they went out of business around 1997. When my dad opened this store he purposely called it Frank Bee's 5 and $1.00 because everything we sold was priced from 5 cents to one dollar. And that competed with Woolworth's slogan that everything they sold was between 5 to 10 cents. We still sell many of the same kind of items we sold in 1957, but we cannot make a living from selling those inexpensive things anymore, so we added a costume shop and we also do party supply rentals of games, inflatables, tents and tables.

— DOUGLAS BEE *second-generation owner*

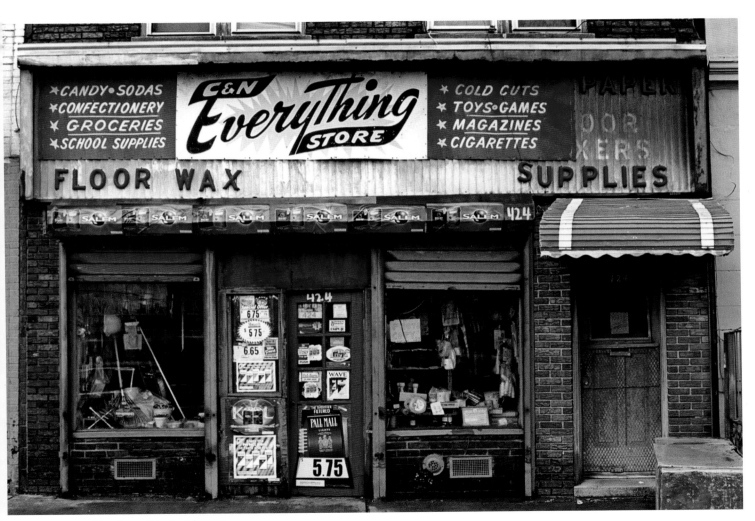

East 161st Street near Fulton Avenue [*Morrisania*] (2003)

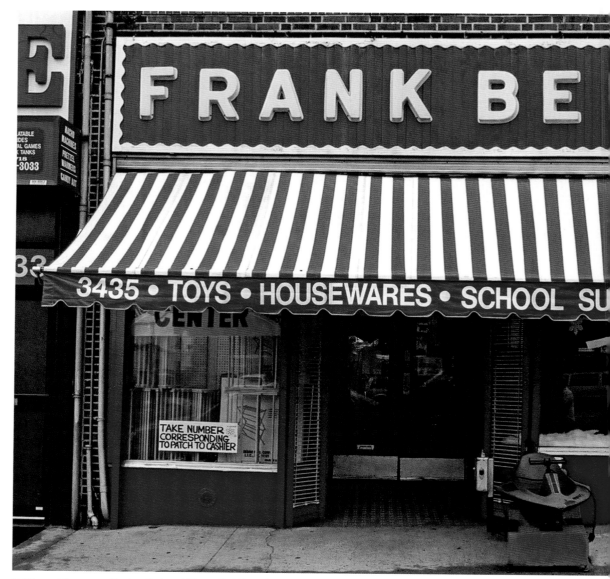

East Tremont Avenue near Bruckner Boulevard *[Throgs Neck]* (2005)

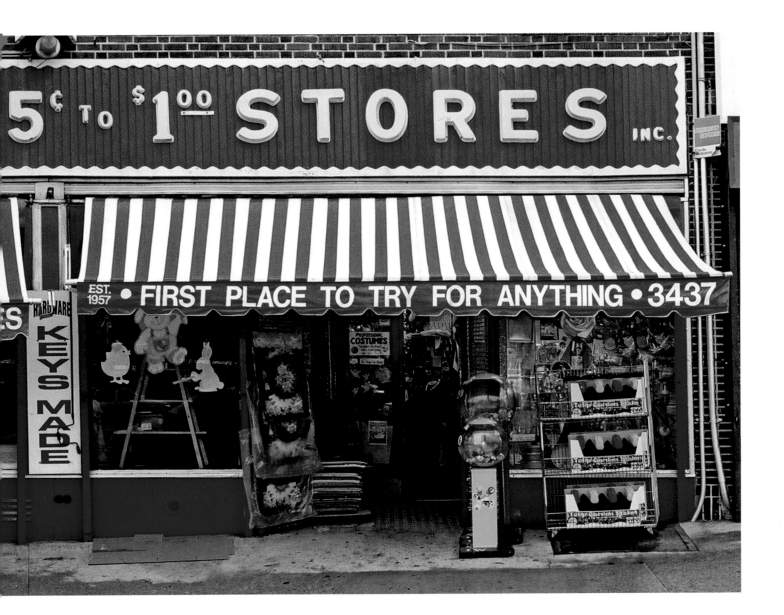

5¢ TO $1.00 STORES INC.

EST. 1957 • FIRST PLACE TO TRY FOR ANYTHING • 3437

HARDWARE KEYS MADE

PROFESSIONAL COSTUMES

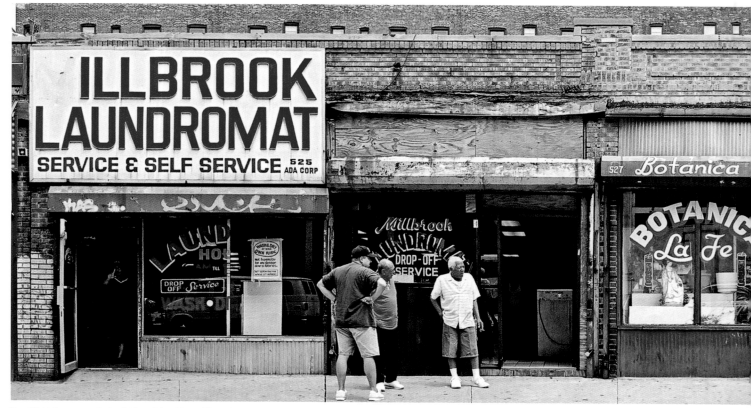

East 137th Street near St. Ann's Place *[Mott Haven]* (2001)

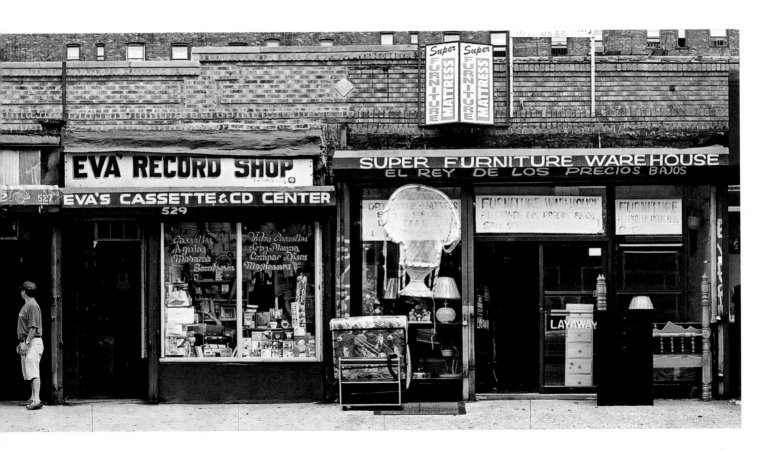

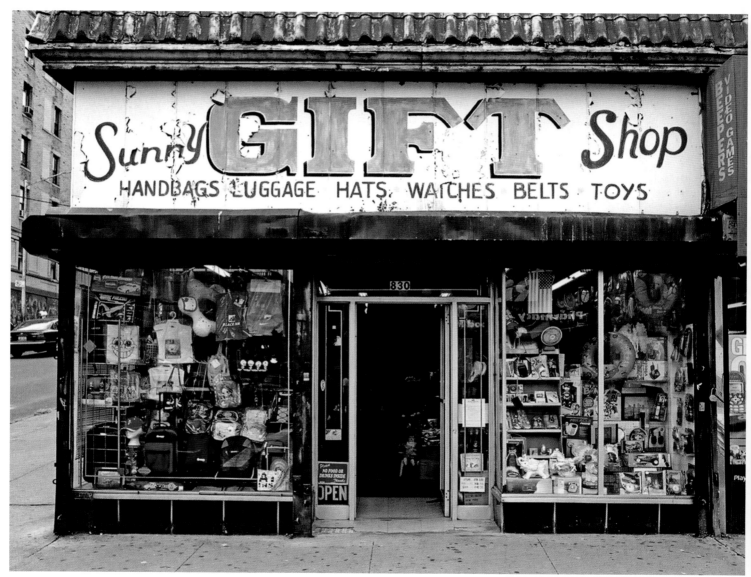

East Tremont Avenue at Marmione Avenue *[East Tremont]* (2004)

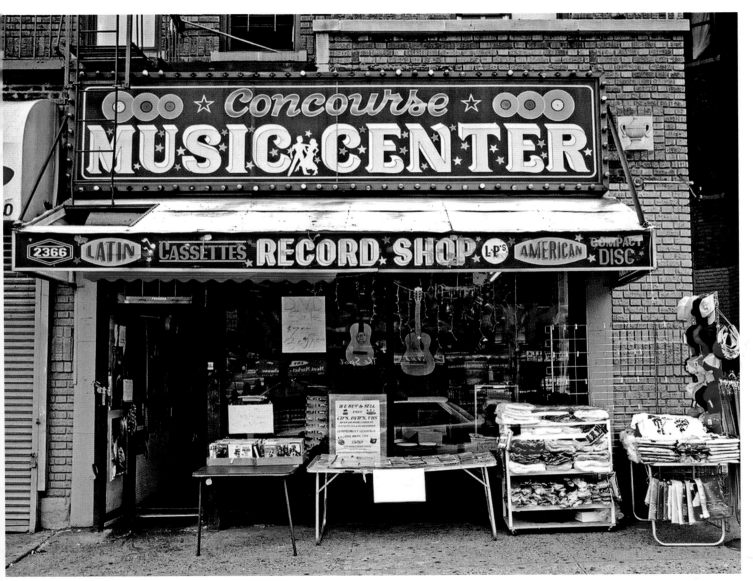

Grand Concourse at East 184th Street *[University Heights]* (2004)

LA PASTORA BAKERY has been in business for 27 years. The storefront and sign are original. The bakery is now being run by the third-generation owner, Chris Garcia.

My grandfather started this business and my father still works alongside me today. He taught me everything I know about baking and we still use my grandfather's family recipes. This store was a bakery before my grandfather bought it and we even still use some of the equipment that was in the original bakery.

— CHRIS GARCIA *third-generation owner*

FRANK'S SPORTING GOODS (›Page 184) has been a family-owned and -operated business since 1922. Frank's is the oldest sporting goods store in the Bronx. Frank Stein founded the store, which is now owned by his son Moses. It is a multi-million dollar business that has exclusive contracts with professional, novice and school sport teams supplying their uniforms and other needs. They also supply uniforms for the U.S. Postal Service, New York Police, Corrections and Sanitation Departments.

RIVIERA RAVIOLI & PASTA CO. (›Page 185) has been in business since 1946. This pasta business is now run by Joseph Giordano, the second-generation owner.

My father-in-law opened this store after he moved here from Italy. His family owned a pasta business in Italy near Monte Carlo, the 'Italian Riviera' and he continued to use those old family recipes when he opened this store. We make everything we sell here, pastas and sauces on the premises, fresh daily. We've expanded our line over the years and have added things like lobster ravioli and whole-wheat pastas for the health-conscious customers. We also sell imported cheeses from Italy. The storefront and sign we have outside has been in place since 1975.

— JOSEPH GIORDANO *second-generation owner*

MARYLAND FURNITURE (›Page 187) has been in business since 1962.

I bought this store in 1962 and put up the neon sign that is still out there today. I don't keep it lit anymore because it got too expensive to maintain and believe it or not, I almost lost my entire business because of that sign. It used to be a very small fee the City charged in order to keep an illuminated neon sign on your business. I remember paying about $76 a year and then they slowly raised it and when it reached over $200, I wrote a letter to the City that I would not be renewing the permit, but in the early 1980's I got a letter from the City saying that they had foreclosed on my business because I hadn't paid my neon sign permit fees. I was so upset because my whole life is this store and they were going to take it away from me. I had to hire a lawyer and go to City Court and fight to get my store back. I ended up having to pay the City $1,200 in order to own my business again.

— EDDIE UNDA *owner*

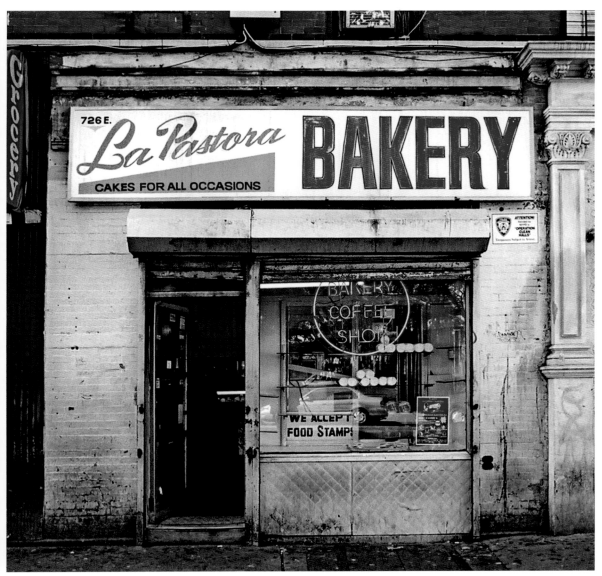

East 152nd Street near Concord Avenue [Mott Haven] (2006)

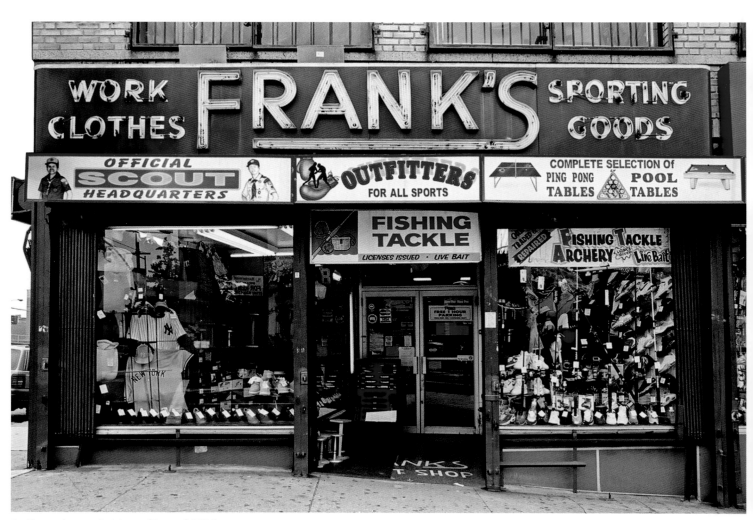

East Tremont Avenue at Park Avenue [*Tremont*] (2004)

Morris Park Avenue at Unionport Road *[Van Nest]* (2005)

Morris Park Avenue near Haight Avenue [Westchester] (2004)

East Tremont between Honeywell and Daly Avenues *[East Tremont]* (2007)

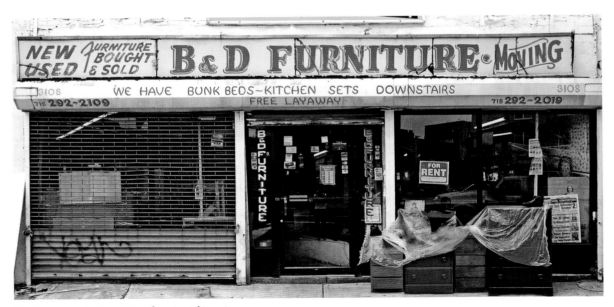

Third Avenue near East 159th Street *[Morrisania]* (2004)

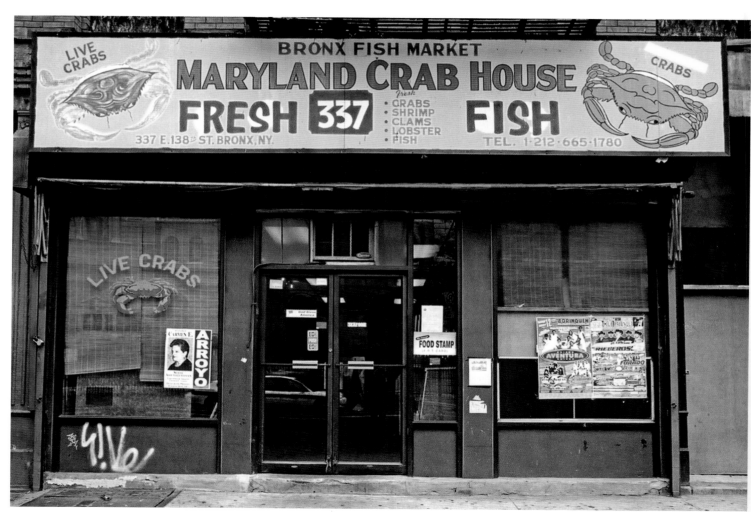

East 138th Street near Third Avenue [*Mott Haven*] (2004)

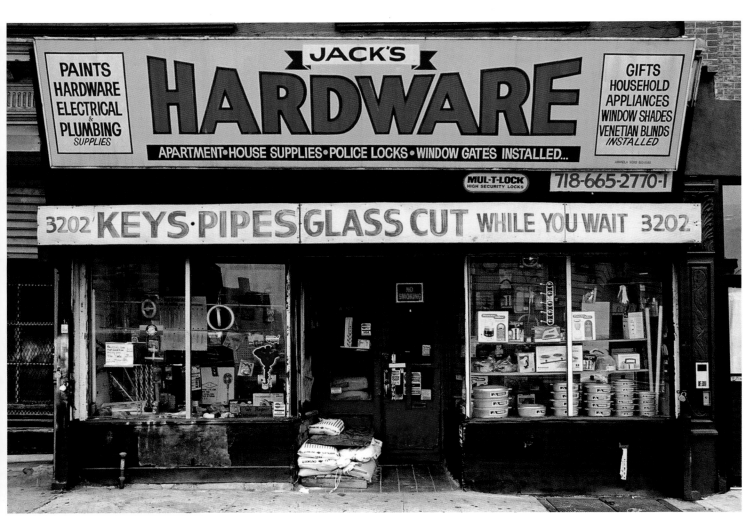

Third Avenue at East 162nd Street *[Morrisania]* (2004)

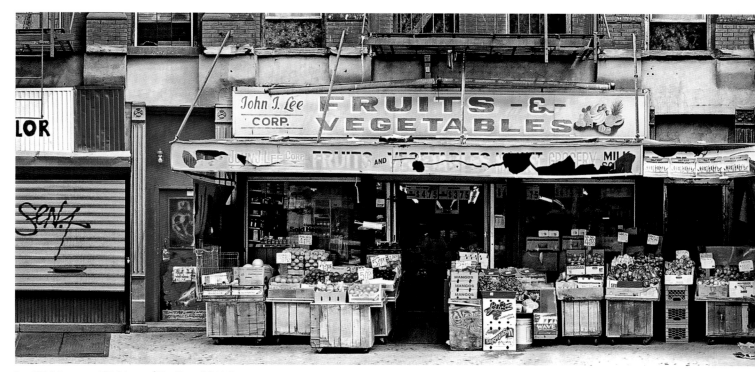

East 138th Street near Third Avenue [Mott Haven] (2004)

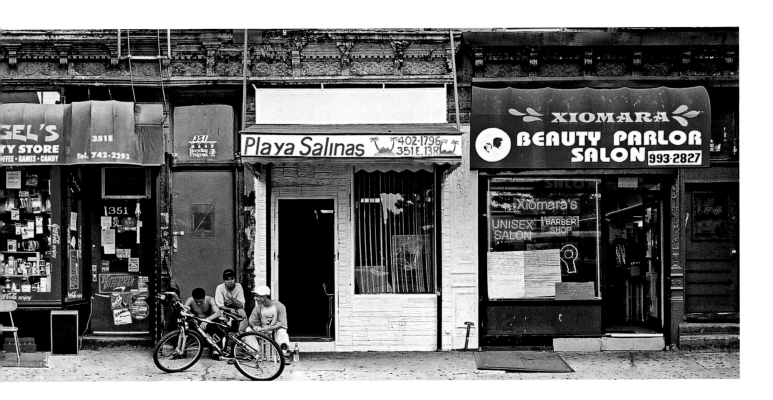

Grand Avenue near West Fordham Road *[Fordham]* (2004)

Third Avenue at Claremont Parkway [*Morrisania*] (2004)

D. D'AURIA AND SONS PORK STORE was a family business that was in operation from 1938 to 2006. The second-generation owner, Mike D'Auria took over the store from his father Dominick, who emigrated to the Bronx from Naples, Italy in 1921.

All of the pure pork sausages and salami we sell are made by hand using an old family recipe my father taught both me and my younger brother Dominick. The sausages are either sweet or hot, with or without fennel seeds, and sometimes made with paprika, which turns them bright red. What makes my family's sausages and salami different is the TLC [tender loving care] because we have always made them in small batches so we can control the seasonings. Everything is very fresh because we don't use any preservatives or additives and that's what makes them taste so good. The busiest time of the year is Christmas and New Year's, followed by Palm Sunday and Easter.

My younger brother, Dom, used to work in the store with me but he retired a few years ago. I am 76 years old and I don't have any children of my own to take over the family business. I'm worried about how the store will continue after I am gone because I'm not the marrying type and my brother Dom's children are all professionals, doctors and lawyers, and don't want to take over the business. Also, the neighborhood has changed so much over the years. It's not really a Little Italy anymore . . . it's more like a United Nations.

— MIKE D'AURIA *second-generation owner*

ADDEO BAKERS (› Page 197) is a family-owned business that has been in operation since 1929. The store has original tin ceilings, tile floor, and many of the machinery is from the early 1940's. The store is now being run by the third generation brothers, Laurence and Tommy Addeo.

My grandfather was not a baker. He became a baker because when he moved here from Italy people told him that it would be a good business to get into. That was when there were over 50,000 Italians living in this neighborhood, mostly Neoplolitans. That's a lot of people living in one neighborhood. And at that time there were as many as 14 bread bakeries in Belmont and there are still 5 of them all within a few blocks of us. So even though there are still a lot of bakeries here, I guess the secret to our longevity is tender, loving care. My grandfather didn't use some secret family recipe for the bread. He got some people together who were experienced bakers and they put together a recipe. Even the best baker doesn't make his own recipe. Bread has been around for years and years but the only really important thing in bread baking is time. It's all about time. You can't rush anything. Time is flavor in bread. If you give it time, you'll make a great-tasting bread. More commercial bakers and larger shops will not let the dough proof for at least 5 hours like we do. They can't afford to do that. They have to make the bread faster. So whether they put in additives or more yeast to make it move faster, you can taste the difference in their bread.

Our most popular bread is our Pane di Casa, an oval, white Italian bread that comes in three sizes and can be as big as 16 inches. And that bread is made from what we call a long-term dough. It has a low yeast content and a very long fermentation time. It takes as much as 8 hours of preparation in fermentation, scaling, and proofing before it even goes into the oven to bake. Also, all our round bread is hand-rolled. Then the pane di casa bakes anywhere from an hour and 10 minutes to an hour and a half depending on the size of the loaf. The whole process starts at 6:00 PM the night before we sell it. On a slow, slow weekday we sell about 440 loaves of just Pane di Casa and on a busy Saturday we might sell as much as 1,120 loaves. On a holiday like Christmas, which is our biggest day of the year, we sell about 2,160 loaves of just Pane di Casa.

We also sell many other types of bread including standard white, whole wheat, semolina long loaves, friselle or pepper biscuits, lard bread and pizza dough.

During the weekday, the majority of my customers are people who either live or work in this neighborhood or who pass through here on their way home from work. And a lot of our customers are people who have grown up with our bread. It's a really big part of our business, people who are multi-generational just like we are.

— LAURENCE ADDEO *third-generation owner*

East 187th Street near Cambreleng Avenue *[Belmont]* (2004)

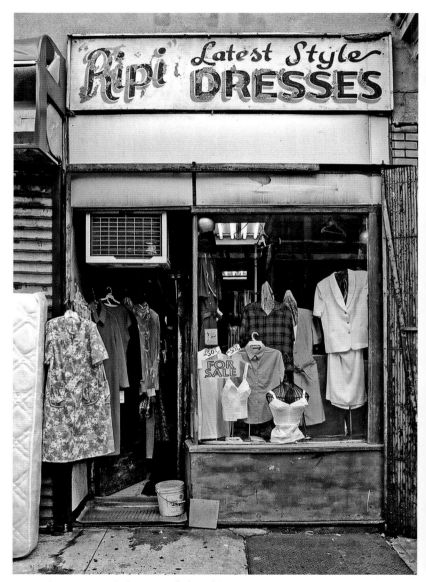

East 187th Street near Cambreleng Avenue *[Belmont]* (2004)

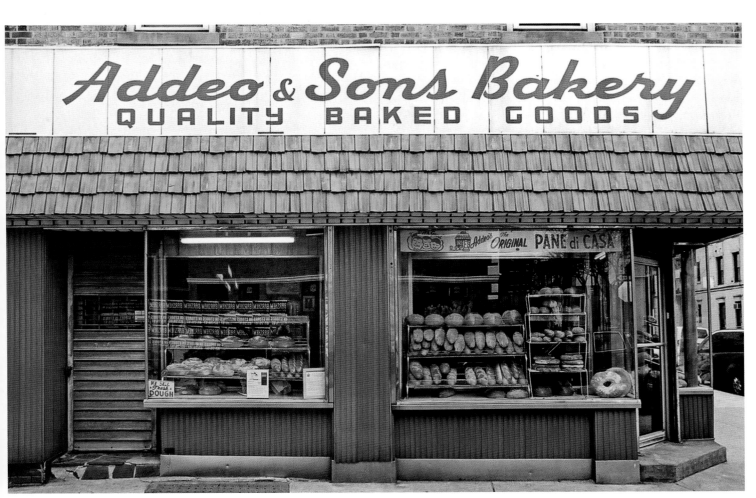

Hughes Avenue at East 186th Street *[Belmont]* (2006)

BROOKLYN

is the most populous borough in New York City and has many distinct neighborhoods. It is located in western Long Island and named after the Dutch town Breukelen. Until it became a borough of New York City in 1898 it was an independent municipality and the nation's third-largest city for nearly half a century. Brooklyn was originally only developed along its East River waterfront, facing Manhattan and was a major shipping port. When the Brooklyn Bridge was opened in 1883, the population grew tremendously since transportation to Manhattan was no longer limited to boats only. Development in Brooklyn further expanded with the opening of the Williamsburg Bridge in 1903, the Manhattan Bridge in 1909, and several subway tunnels in the early 1900's.

Before the passage of national immigration laws in 1924, Brooklyn attracted hundreds of thousands of immigrants, many of them from eastern and southern Europe. In the late 1950's and 1960's, thousands of white, middle-class residents abandoned Brooklyn and moved to Long Island, Staten Island and New Jersey. Many minority populations took their places and the neighborhood demographics changed. In the 1970's many working-class and immigrant communities were plagued by urban flight, despite the city's efforts to revive these troubled neighborhoods. Other historic Brooklyn neighborhoods flourished through the efforts of long-time residents and new arrivals. Despite gentrification, many Brooklyn neighborhoods still maintain their ethnic identity and distinct culture.

Bedford-Stuyvesant

BROOKLYN

Bedford-Stuyvesant is a neighborhood in north central Brooklyn bounded to the north by Flushing Avenue, to the east by Broadway and Saratoga Avenue, to the south by Atlantic Avenue, and to the west by Classon Avenue. It's often abbreviated as Bed-Stuy. The neighborhood was originally farmland and as early as 1790 more than a quarter of the residents were African American, mostly slaves. After the Brooklyn Bridge opened and subway service was brought to the area in 1936, the population increased dramatically. During and after Second World War, large numbers of African Americans from the Southern U.S. and from the Caribbean settled in Bed-Stuy. By 1940, Bedford-Stuyvesant had more than 65,000 African American residents and members of other ethnic groups left for the suburbs. In the 1960's and 1970's, race rioting in the neighborhood led to the destruction and looting of many businesses and the area entered a period of decline. Although crime has decreased significantly since the 1980's and the neighborhood has gradually improved, Bedford-Stuyvesant continues to be stigmatized by a negative public perception. Bedford-Stuyvesant is regarded as the second largest African American community in the United States, after Chicago's South Side.

KATY'S CANDY STORE has been in business since 1969. The sign and storefront are original.

My store is the last of the penny candy stores in New York. I still sell candy for a penny and I even sell C&C colas for 25 cents. I keep my prices low by buying everything in bulk. The colas I buy in cases of 100 and the candy I buy pounds and pounds of each variety. My most popular selling items are my ten different flavors of Tootsie Rolls, including pink lemonade, and the new cola flavor. I also sell balloons because I supply candy for a lot of parties and to fill piñatas. I am known around here as the 'Dinosaur of Tompkins' because I've been open for so long. I was born and raised in this Bed-Sty neighborhood and I've seen a lot of changes. I was here when it was all Jewish and Italian and when it changed to Spanish and black. I've been through the dope, crack, and everything else this neighborhood has thrown at me. I speak three languages, English, Spanish, and Motherfucker. You've got to be tough to survive around here.

I've been robbed quite a few times but I've never been hurt. One time, the robbers tied me up but they didn't actually hurt me because I knew who they were. They were from around the neighborhood. I tried to talk some sense into them, but these guys. It's like a phase they go through to show that they are bigger and badder than the next guy. They thought that I would put up a fight but I can't be bothered anymore because eventually they always wind up getting caught for something or other and going to jail.

But despite all that, I've stayed here and I plan to stay here until they force me out. This is home to me. I've lived around the corner for 44 years and I was born and raised on the corner of Tompkins and Lafayette.

Unfortunately, I will have to close this store in 2009 when my lease expires because a new owner bought the building and wants to raise the rent real high. I sell penny candy and I can't afford to pay $2,350 a month plus electric and everything. The landlord wants to convert the whole building into luxury-type apartments and have something more upscale in this space. They've already got this whole area empty of stores except for mine. They bought everybody out. They offered me $5,000 to move but I told him, "No way, I have more than that in candy in here." So in 2009, after 40 years in business, I'll be forced to close and the kids in the neighborhood will no longer have a place to buy penny candy.

— CATHERINE KEYZER *owner*

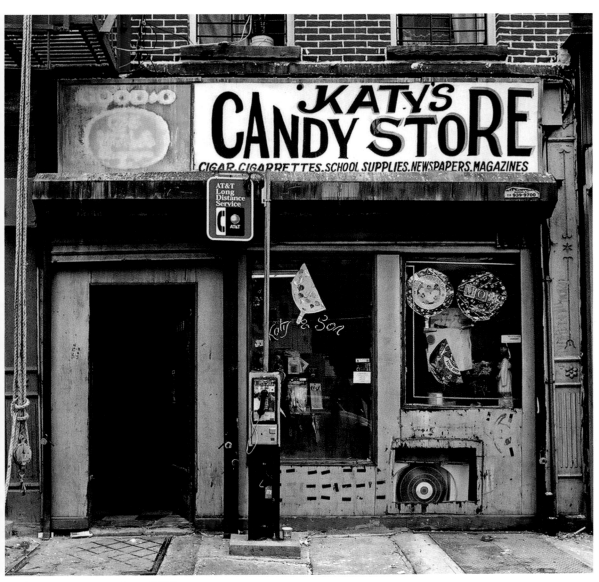

Tompkins Avenue near Vernon Avenue (2004)

BROOKLYN *Bedford-Stuyvesant*

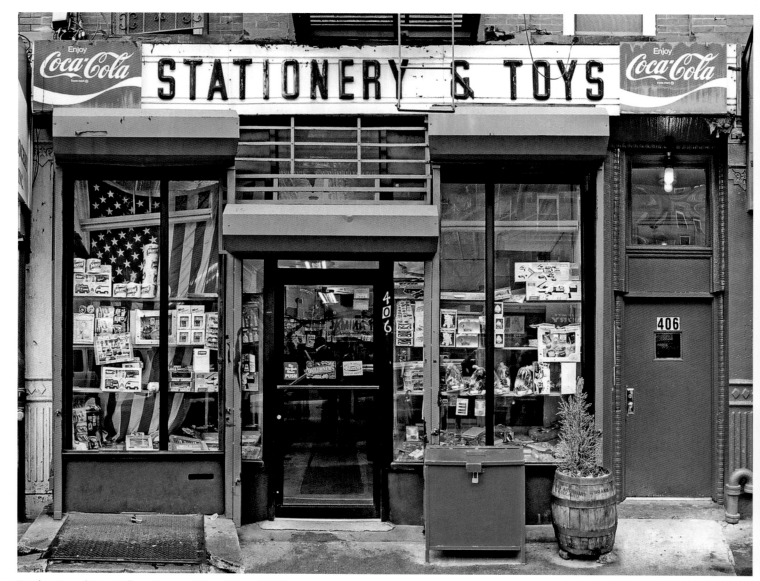

Tompkins Avenue between Jefferson Avenue and Hancock Street (2006)

JIMMY'S STATIONERY & TOYS has been in business for over 75 years. The current owner, James Leary bought the store in 1968. The interior is all original, including the tin ceiling, long counter, glass candycase and the private wooden telephone booths. Jimmy's Stationery & Toy Store which has remained virtually unchanged for decades looks much like Morris & Rose Michtom's Stationery Store, which stood directly next door to Jimmy's and was the birthplace of the original Teddy Bear in 1902. The Michtoms of Bedford-Stuyvesant were Russian immigrants who designed and sewed the first cuddly stuffed animals to be called Teddy's Bears. They were inspired to create the Teddy Bears after seeing a very popular cartoon which was originally printed in the *Washington Post* that showed President (Theodore) Roosevelt during a hunting expedition turning his back on a bear cub that had been captured by his aides and refusing to kill it. Roosevelt's compassion for the bear increased his popularity among Americans and when Morris Michtom saw the cartoon, he suggested to his wife Rose that she sew a replica of the bear cub represented in the cartoon. She created the bear from short mohair and sewed black shoe button eyes on it and stuffed it with fine shavings of wood. The Michtoms put the bear in the window of their stationery and toy store along with a copy of the cartoon and a handwritten notice saying "Teddy's Bear." When many people came into the store asking to buy the bear, Morris Michtom, not wanting to offend the President by using his name, mailed a bear to the White House and offered it as a gift to the President's children and asked Roosevelt for permission to call the plush toy 'Teddy's Bear.'

According to Roosevelt's biographer, the President responded with a letter saying he doubted the name would help its sales but that Michtom was welcome to use it if he wanted. The name did help sell the bears and they became so popular that within a year the Michtoms closed their stationery store and began making the stuffed toys full-time. They eventually founded the Ideal Novelty & Toy Company, building it into the largest Teddy Bear factory in the United States until it was bought by CBS, Inc. in 1982.

I've lived on this avenue for 50 years and have seen a lot of changes in this neighborhood but I never knew that the first Teddy Bear was created right next door to my store until Morris Michtom's granddaughter came to visit me one day. She told me the whole story and showed me pictures of the original store and the bears they made. She told me that their stationery and toy store was very much like the one I run today. I raised four kids out of this store and they all worked here at one time. My two daughters used to stand on milk crates behind the counter and help sell candy. Many of my customers have grown up and now bring in their children to shop here.

Everybody knows this place as Jimmy's Candy Store and have always looked out for me. I've never been robbed. My business has been down because I used to sell huge amounts of candy in the morning to the neighborhood kids before they went to school. About four years ago, the school instituted a new policy where they search the kids before they enter school and take any candy from them. So now kids don't come in here in the morning anymore. They still come in the afternoon but I used to sell lots more candy to them in the morning. It ain't helping them in school either. They still have lots of energy.

— JAMES LEARY *owner*

JOHN'S BICYCLE SHOP (› Page 206) has been in business since 1925. It is now run by the second-generation owners, William and John Jr. Rosa.

My father opened this store and I learned everything I know about bicycles from him. When he passed away my mother continued to run the store with my brother and eventually I took over after I retired from the police force. The sign we have outside was put up in 1975 but wind and time have taken their toll on it and now there are only a few letters left. We try to keep our prices low because we want people in the neighborhood to be able to afford a bicycle. We only sell new bicycles here but we also do repairs. Business has been down the past few years because kids don't really want to ride bicycles anymore, they'd rather play with video games and cell phones and other electric stuff. They don't want to go out and get some exercise.

— WILLIAM ROSA *second-generation owner*

IMPERIAL BEEF COMPANY (› Page 207) has been in business since the 1930's. The storefront and sign are from 1954.

My father originally opened Imperial Beef across the street from where it is now. In 1954 he moved to this location and bought the building. I learned everything about the butcher business from him and took over after he retired. I've seen a lot of changes in this neighborhood over the years. At first, the area had a lot of Italian families and we sold specialties like Italian sausage, and then many blacks moved in and we changed our offerings to include things like chitlings, the intestines of pigs. Now the area has been getting a bigger Jewish population again. I'm not sure who will take over the business when I retire, but I hope my children will be interested because they are working with me now.

— DOMENICK *second-generation owner*

FOXED LIQUOR (› Page 208) has been in business since 1935. The storefront is original.

I've owned this liquor store since 1992. I haven't really changed anything about it. The only thing that is new is the bulletproof partition between me and the liquor and the customers. This store has been through a lot over the years. The owner before me was shot and killed by a corrupt off-duty police officer during an attempted robbery.

— CHARLEY HU *owner*

Myrtle Avenue at Sandford Street (2004)

BROOKLYN *Bedford-Stuyvesant*

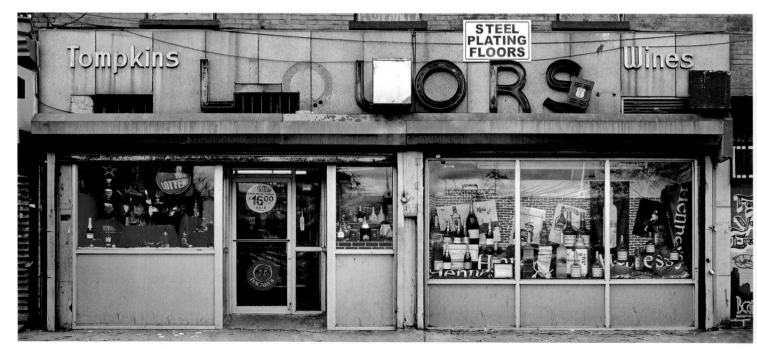

Tompkins Avenue near Myrtle Avenue (2006)

208.209

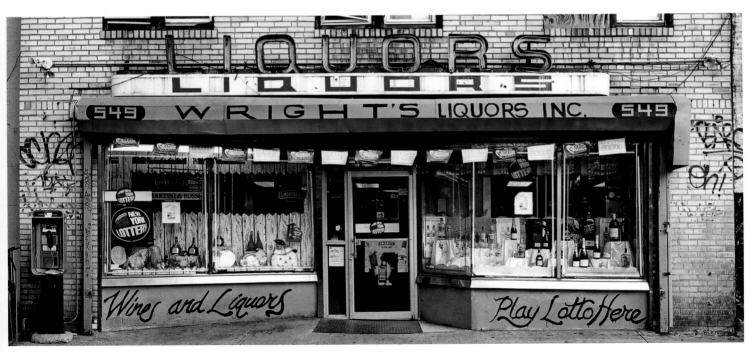

Classon Avenue at Fulton Street (2007)

Williamsburg

BROOKLYN

Williamsburg is a large neighborhood in northwestern Brooklyn bounded to the north by North 7th Street and the Brooklyn Queens Expressway, to the east by the Queens County line, to the south by Flushing Avenue, and to the west by the East River. After the Williamsburg Bridge opened in 1903 thousands of poor and working-class Jews from Eastern Europe moved to the neighborhood from the overcrowded slums of the Lower East Side. The Williamsburg Bridge was seen as a passageway to a new life and was nicknamed 'the Jewish highway.' Lithuanian, Polish, and Russian Orthodox immigrants also moved in and developed enclaves, and Italians settled mainly in the area between Bushwick and Union Avenues.

By 1917 the neighborhood was one of the most densely populated in the city. During the early 1930's many businesses in the neighborhood declared bankruptcy and the prosperous residents left. The Jewish community, however, continued to grow and a large number of Hasidic Jewish refugees escaping Nazism in Europe moved into the neighborhood, forming a distinct Hasidic district along Bedford, Lee, Marcy, and Division Avenues. Manufacturing jobs attracted many Puerto Ricans to the neighborhood in the 1950's. At about the same time, decaying housing and businesses were demolished to make room for enormous public housing projects and for the construction of the Brooklyn-Queens Expressway, which took place in 1957.

Looting and arson in the 1960's and 1970's left blocks of abandoned buildings, factories, and warehouses, but by 1980 some areas began to be renovated. By 1990 Puerto Ricans, Dominicans, and other Latin Americans constituted about half the population. The area centered around Berry Street and Bedford Avenue north of the base of the Williamsburg Bridge has become an enclave of artists, designers, and musicians. They occupy many of the loft spaces in former factories in the area and have opened their own galleries, shops, restaurants, and tiny cafes.

EMILY'S PORK STORE is a family-owned business that opened in 1976. Gennaro Aliperti took over the business when his mother's brother retired in 1989.

I've been working in the store since 1976 when I was a young boy, learning everything I needed to know. We are famous in the neighborhood for our dry sausage, which our family has been making for years. It's a whole process, you know. You just can't buy a fresh sausage and dry it out yourself and expect it to come out right. There are issues of temperature control and humidity and the salt and pepper have to be in just the right amount. Everything is measured. Back in Naples, where my family is from, they didn't have a lot of money so they would raise a pig and when it was big and fat enough, they would slaughter it. Then they would use everything from it. And I mean everything. Nothing would go to waste. You can literally use every part of a pig and make something to eat from it, whether it's a sausage, salami, a pudding, or an ingredient in something else. You can even eat the brains by frying them up with some eggs. I mean, I don't like the taste of some of the stuff, but my family really did use every part of the pig. Here in America, it's illegal to sell the lungs. I don't know why, but you just can't. In Naples, my family would eat the lungs too. Like I said, nothing went to waste.

When my aunt and uncle emigrated to Brooklyn to try and make a better life for my family, they couldn't raise a thousand-pound pig in their backyard, so they saved and opened up this pork store to keep up the family tradition. The whole neighborhood up and down Graham and Bushwick Avenues used to be very Italian. I was born here in Williamsburg in what I would call an 'Italian ghetto.' There were also 'Jewish ghettos' and 'Puerto Rican ghettos' near here. Everybody knew everybody in our ghetto. If you walked down the street, everybody would know who you were and where you lived. If you threw a ball and accidentally broke some old lady's window, she would shout out, "I know who you are, you're so and so's kid and I'm going to tell your father." Now, it's not like that. Lots of blacks and Puerto Ricans have moved into the neighborhood. We weren't racist but back in the 70's, if somebody black went into the store, we would be like, "What is he doing here?" Now, all the ghettos are gone and if somebody black or Puerto Rican comes into the store, it's because they live right next door.

My mother and father still come into the store from time to time to help me clean the meat and prepare the dishes and salads we sell. Even my young cousin comes in to help me. He's kind of like me when I was his age, hanging around the store and learning everything. The good thing about having my family help is that I don't have to pay them. I only have to feed them and we have plenty of food around here. I still do things the old-fashioned way here and I even like to keep all the cheeses cut up and on display just like old times. Even though the store is crowded, I've kept the original wooden shelves for displaying dry goods. And of course, even though it's my store now and all my business cards have my name on them, I still call the place, Emily's Pork Store.

— GENARRO ALIPERTI *second-generation owner*

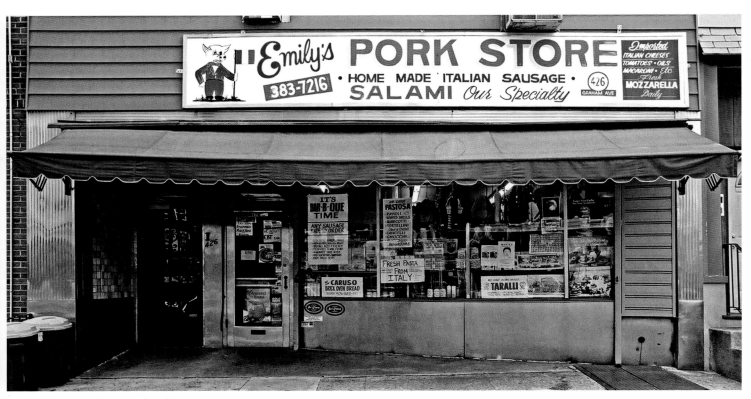

Graham Avenue near Withers Street (2004)

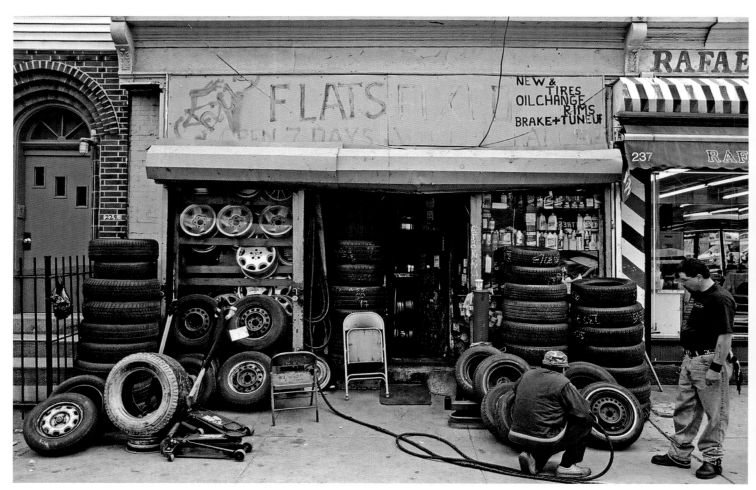

Bushwick Avenue near Montrose Avenue (2004)

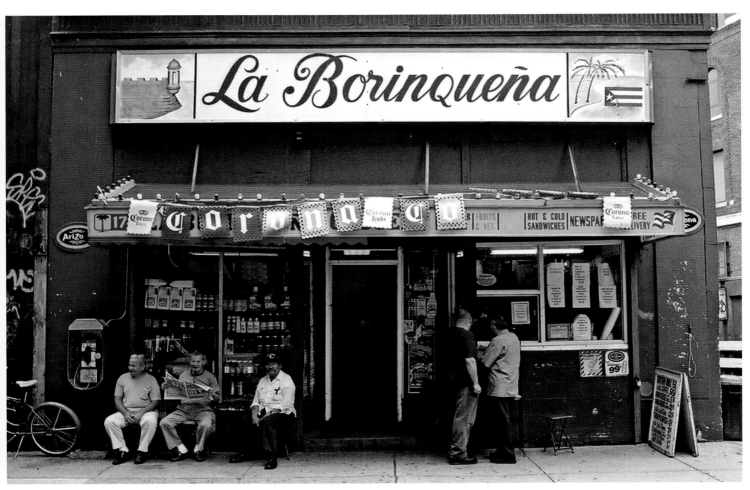

Marcy Avenue at South 5th Street (2004)

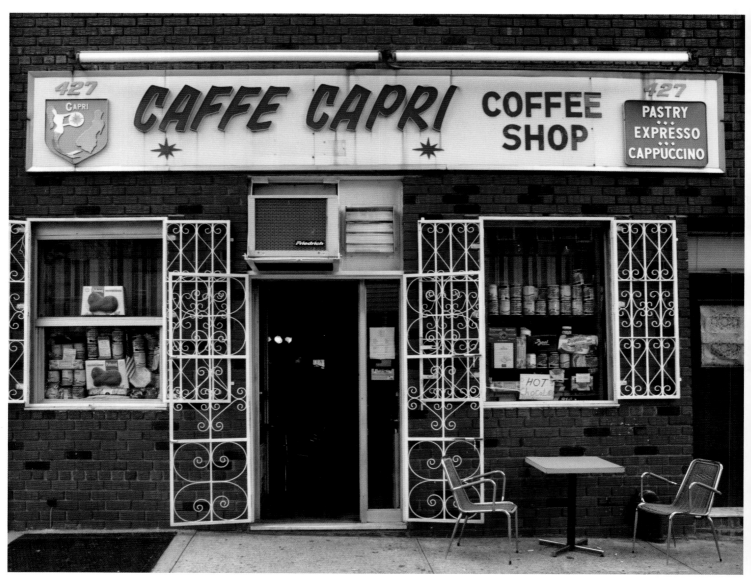

Graham Avenue near Withers Street (2008)

216.217

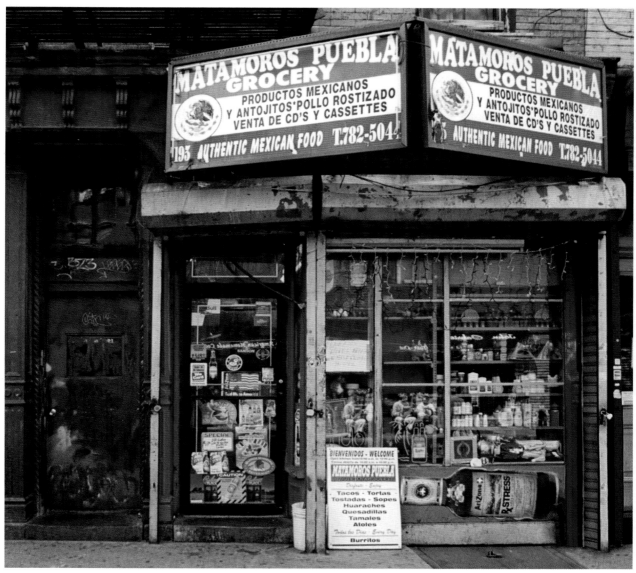

Graham Avenue at Seigel Street (2001)

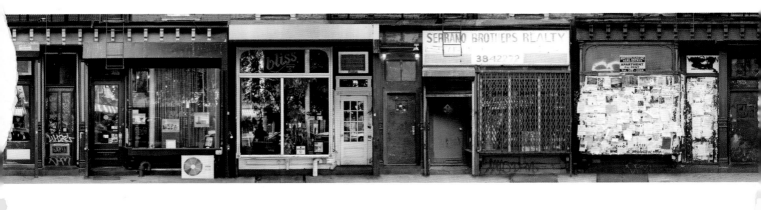

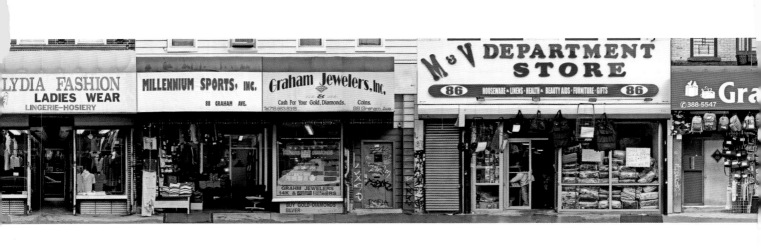

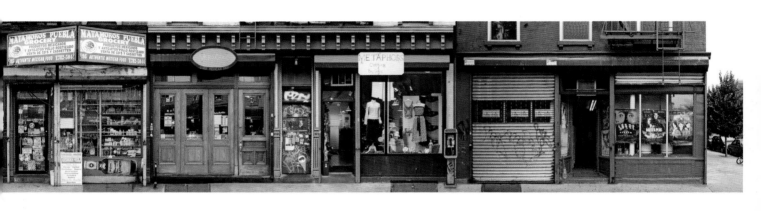

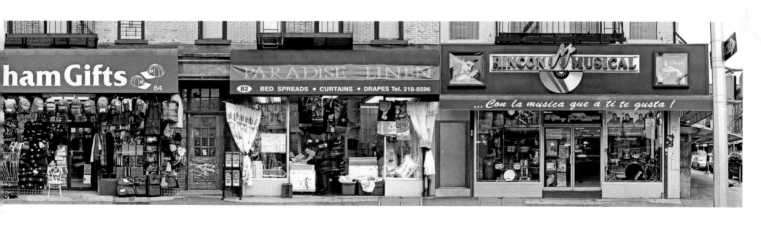

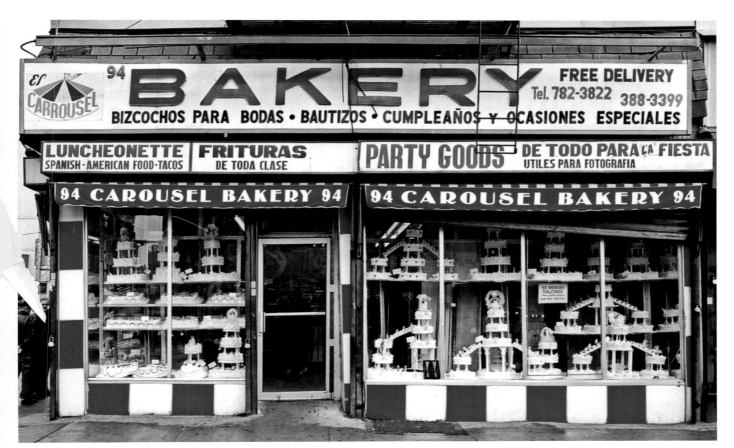

Graham Avenue at Seigel Street (2001)

Bedford Avenue between North 7th and North 6th Streets (2004)

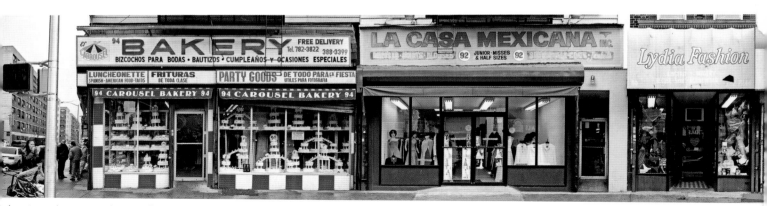

Graham Avenue between Seigel Street and Moore Street (2001)

Graham Avenue at Seigel Street (2001)

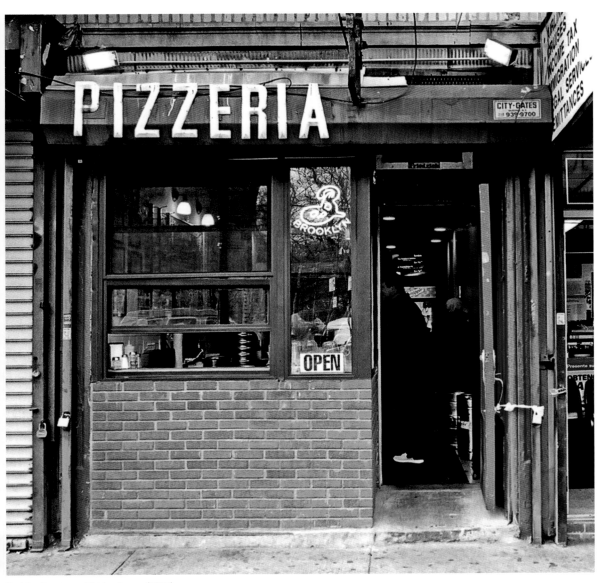

Roebling Street near Division Avenue (2006)

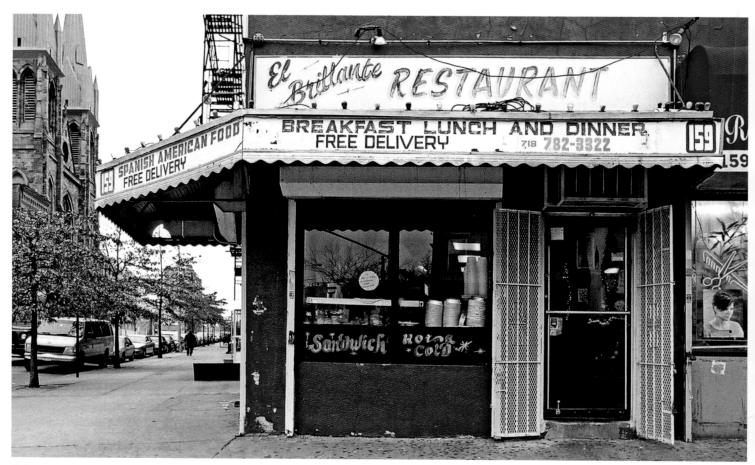

Graham Avenue at Montrose Avenue (2006)

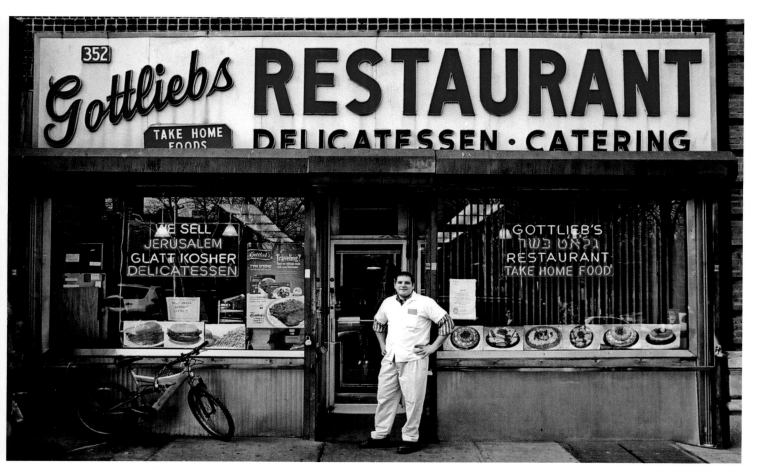

Roebling Street near Division Avenue (2006)

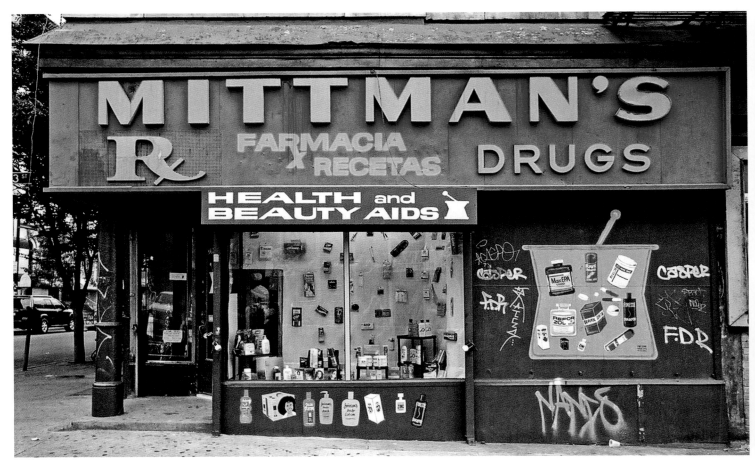

South 3rd Street at Havemeyer Street (2004)

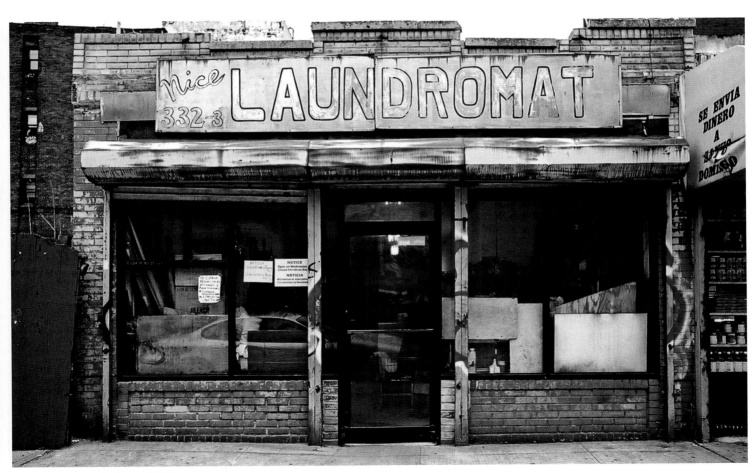

Hooper Street near South 4th Street (2006)

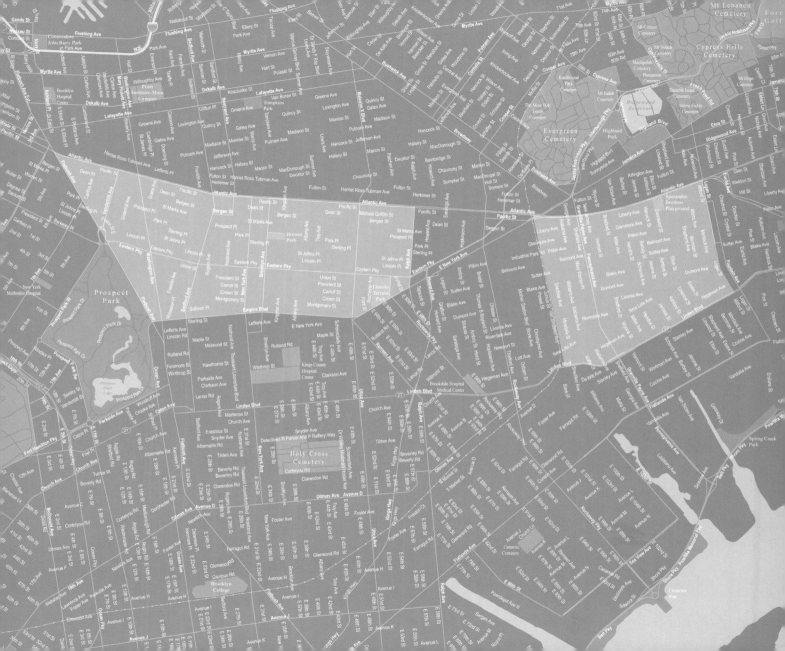

Crown Heights & Vicinity

BROOKLYN

Crown Heights is a neighborhood in west central Brooklyn, bounded to the north by Atlantic Avenue, to the east by Ralph Avenue, to the south by Empire Boulevard, and to the west by Flatbush Avenue. Beginning in the late 1800's, many brownstones were built for upper class residents, who moved to Crown Heights from crowded Manhattan. In the 1920's, Germans, Scandinavians, Irish, Italians, and Jews moved to the neighborhood and by 1940 most of the population was Jewish. After the Second World War many of the white middle-class residents moved out of the area and many immigrants from the Caribbean moved in. Beginning in the 1960's, many buildings were neglected and fires were set.

In the 1968 riots, after Martin Luther King's assassination, African American neighbors linked arms to shield Tom's Restaurant (Page 228) from being torched along with other white-owned businesses in the area. Preservation efforts in the 1980's, especially of the brownstones, helped to revitalize the neighborhood. In the 1980's and 1990's immigrants from the Caribbean, mainly Jamaicans and Haitians continued to settle in Crown Heights. Today, the population is about 90 % African American, of which 70 % are from the Caribbean.

Flatbush is a community in Brooklyn consisting of several smaller neighborhoods, which borders Crown Heights to the north. Flatbush has long been a diverse neighborhood with many Italians, African Americans and Jews. Most recently there has been a huge influx of immigrants from the Caribbean, India and African countries. Haitians are the largest ethnic group currently living in Flatbush.

East New York is a neighborhood in eastern Brooklyn, which is bounded to the north by Atlantic Avenue, to the east by the Queens-Brooklyn border, to the south by Linden Boulevard, and to the west by Van Sinderen Avenue. East New York in the 1930's was a neighborhood of mostly poor working class Italians and Jews. Over the years, many African Americans and Puerto Rican immigrants moved to the area and the population now is predominantly African American and West Indian, along with some immigrants from the Caribbean.

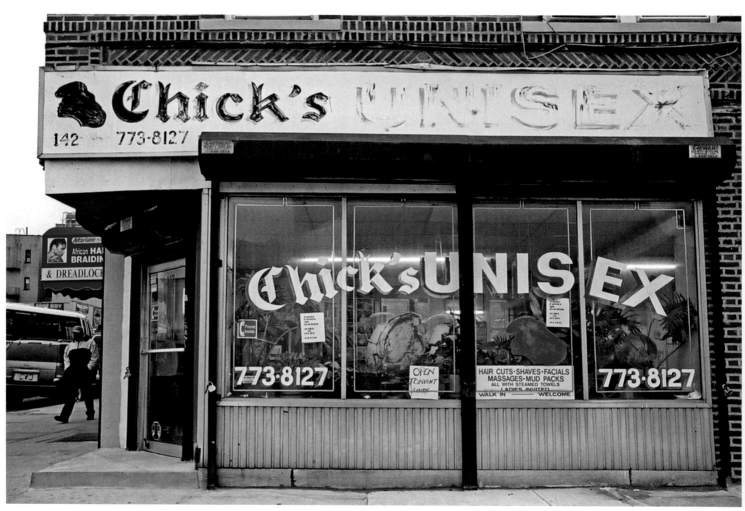

St. Marks Place at Utica Avenue (2006)

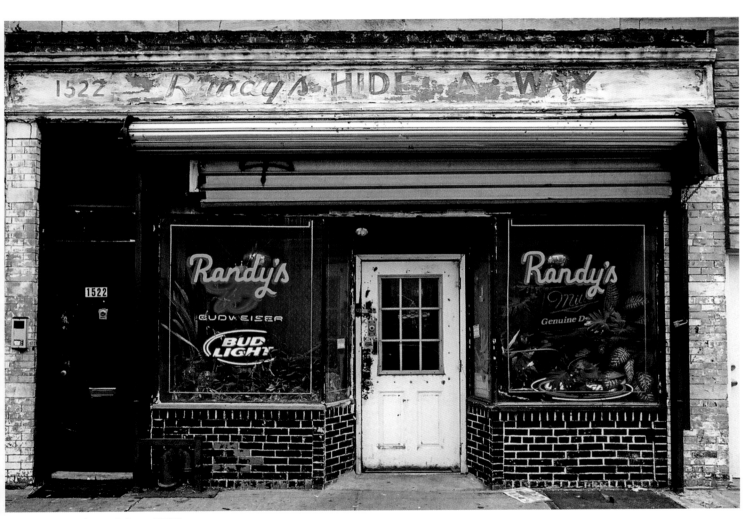

Bergen Street near Schenectady Avenue (2006)

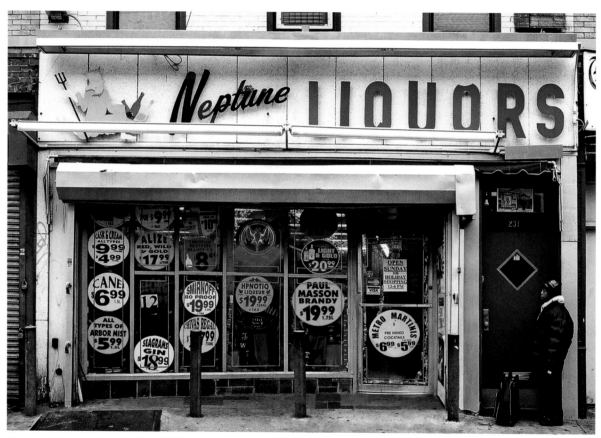

Schenectady Avenue near St. Johns Place (2006)

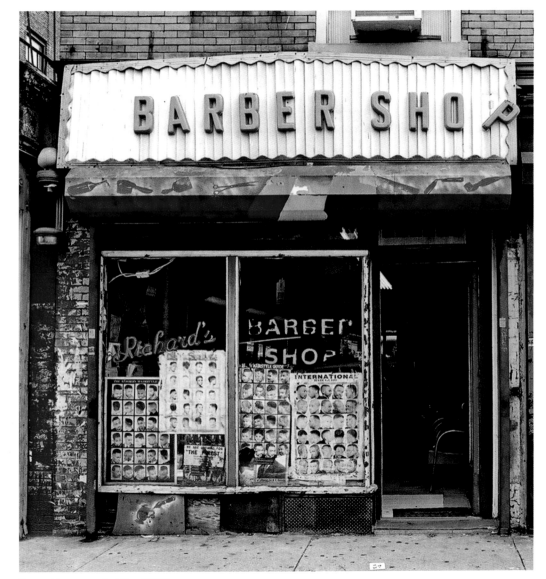

Nostrand Avenue near Park Place (2004)

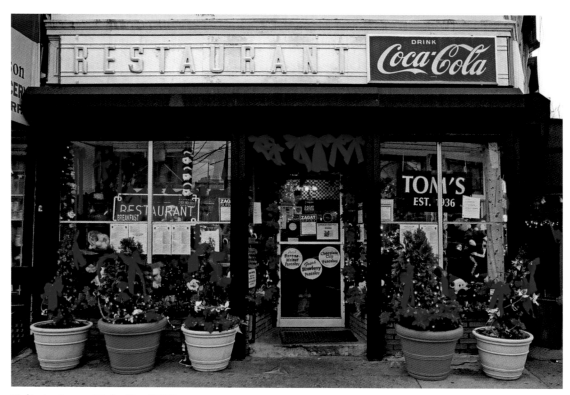

Washington Avenue at Sterling Place (2006)

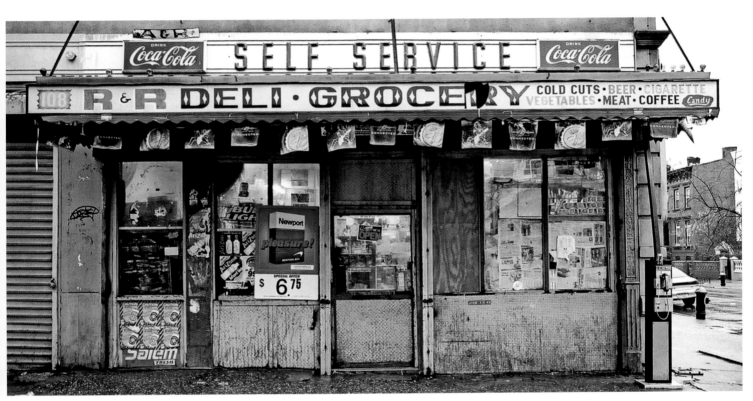

Albany Avenue at Pacific Street (2006)

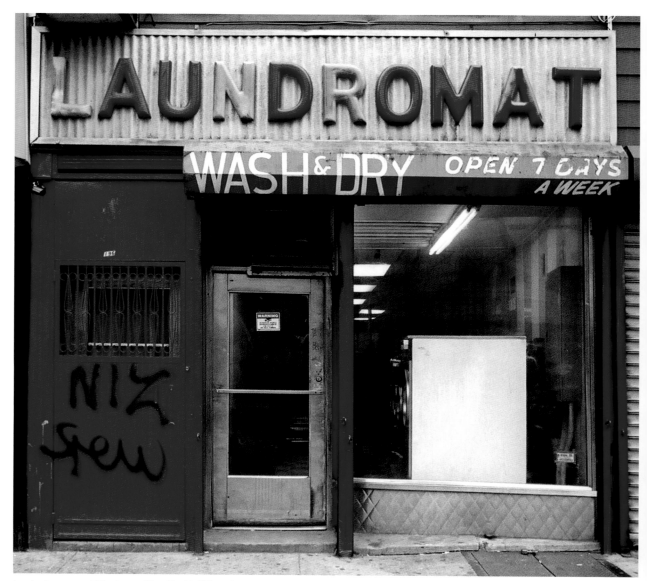

Jamaica Avenue near Miller Avenue *[East New York]* (2006)

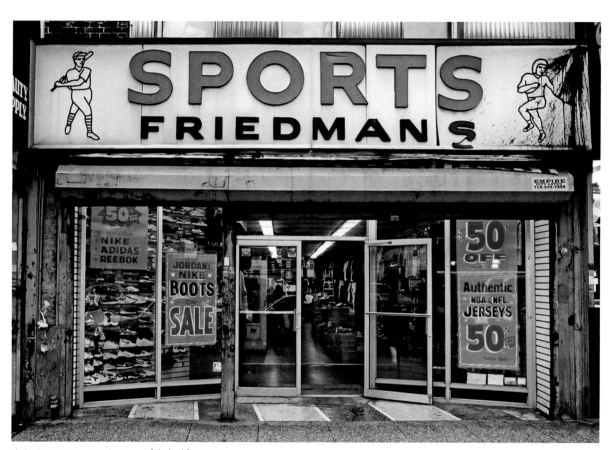

Flatbush Avenue near Snyder Avenue *[Flatbush]* (2006)

Bushwick

BROOKLYN

Bushwick is a neighborhood in northeastern Brooklyn bounded to the north by Flushing Avenue, to the east by the Queens County line, to the south by the Cemetery of the Evergreens and Conway Street, and to the west by Broadway. Bushwick was established as a farming community called 'Boswijck' (heavy woods) in 1660 and was one of the original six towns of Brooklyn during Dutch rule. Many Germans lived in the neighborhood up until the 1930's and then the area became heavily populated with Italians. After Second World War, most of the Italians moved to Queens and Long Island and African Americans and Puerto Ricans moved into Bushwick.

The neighborhood underwent a period of decline and widespread arson and looting during the blackout of 1977 damaged the neighborhood and its businesses even further. During the 1980's some sections began to be revitalized and many new immigrants from the Dominican Republic settled in the neighborhood. Bushwick's population today is now primarily Latin American and African American with some Italians and Asians. Although Bushwick is one of the poorest neighborhoods in Brooklyn, many young artists, professionals, and students have begun to seek affordable housing in the area, fleeing skyrocketing rents in Manhattan and Williamsburg.

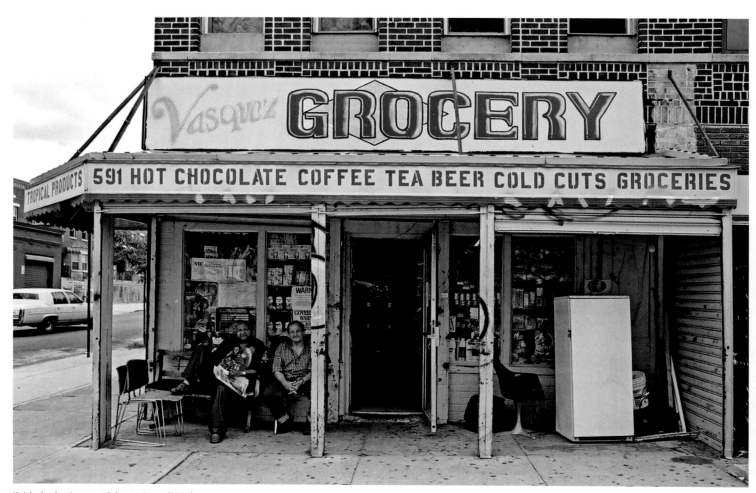

Knickerbocker Avenue at Palmetto Street (2004)

CIRCO'S PASTRY SHOP (›Page 236) is a family business that's been open since 1945. The current owner is Nino Pierdipino and his sons Salvatore and Anthony. The storefront is original and the neon sign was covered in mesh about 30 years ago for safety reasons. The shop has been making pastries and cakes using the same old family recipe brought over from Sicily by Nino Pierdipino, who began working for Mr. Circo in 1968.

The most popular item we sell is our Cannoli a la Siciliana. The secret to our store's success is that we adhere to my father's rule of, "It's the old way or no way."

Everything is made by hand, no machines. This neighborhood used to have lots of Italian families but most of them have moved away. Luckily for us, many of our old customers still travel back here to buy all their cakes and pastries, especially during the holidays like Christmas and Easter.

— ANTHONY PIERDIPINO *second-generation owner*

IDEAL DINETTES (›Page 237) has been in business since 1953. The storefront and sign are original.

My father-in-law opened this store in 1953 and had the neon sign installed soon afterwards. Our neon sign is still operational but we turn it off when we close for the night. Luckily for us, my husband Marvin and I own the building so we don't have to worry about ever changing our storefront or sign or the rent going up. Many businesses in the neighborhood have had to close due to increasing rents because the area has become really gentrified. We still sell a lot of dinettes because there are still many families living in the neighborhood.

— BARBARA MANN *second-generation owner*

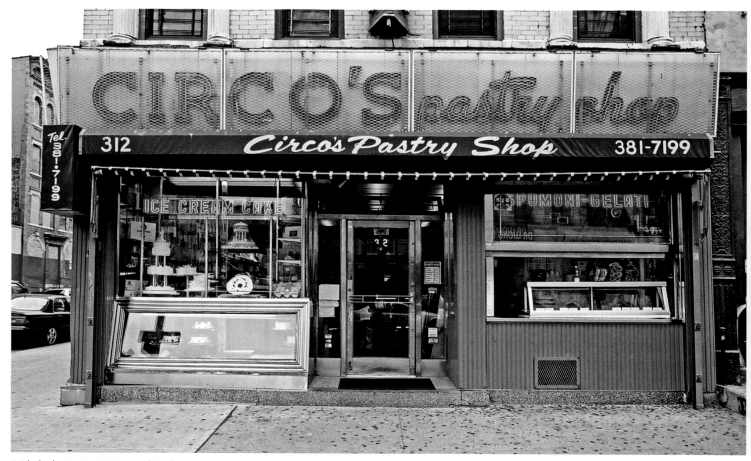

Knickerbocker Avenue at Hart Street (2004)

Knickerbocker Avenue near DeKalb Avenue (2004)

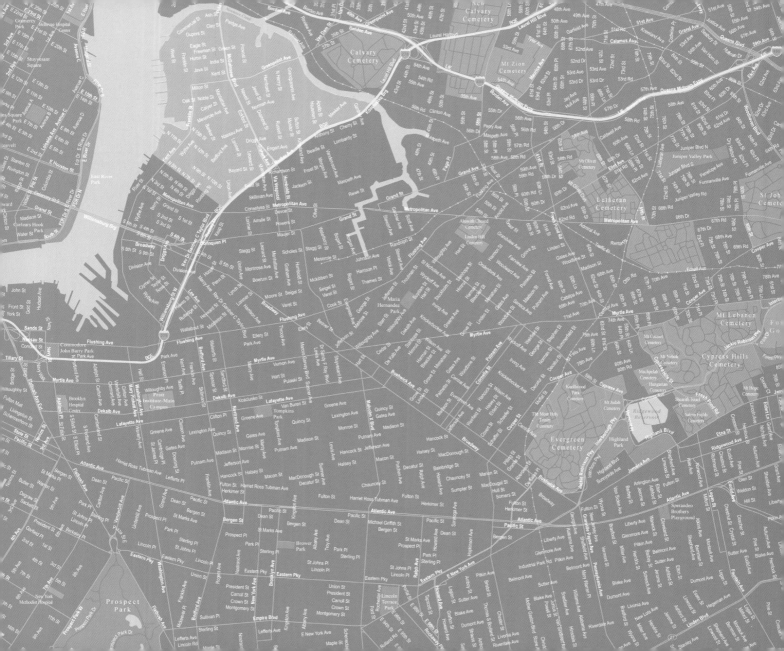

Greenpoint

BROOKLYN

Greenpoint is a neighborhood in northwestern Brooklyn covering a triangular piece of land bounded to the north and east by Newtown Creek, to the south by the Brooklyn-Queens Expressway and North 7th Street, and to the west by the East River. In the 1850's the neighborhood became the center for what was known as the five black arts: printing, pottery, petroleum and gas refining, glassmaking, and iron making. Most of the population was Dutch, English, and Irish until the 1880's when immigrants from Poland, Russia, and later, Italy settled in the area to work in the factories and warehouses.

According to tradition, the neighborhood was the place of origin of the dialect known as Brooklynese, a distinction also given to Flatbush. After Second World War, there was a large increase in the number of Polish immigrants who made the neighborhood the center of New York City's Polish community and accounted for about half of all the immigrants who settled in Greenpoint in the 1980's. According to the 1990 U.S. census, eighty percent of the area's residents were Polish and many stores and restaurants cater to the population.

Nassau Avenue at North Henry Street (2004)

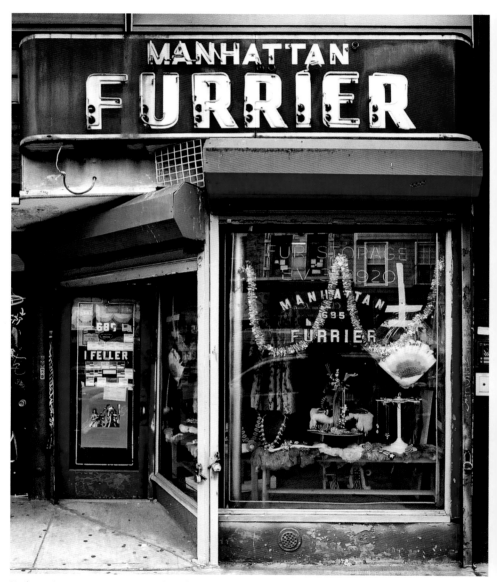

Manhattan Avenue near Norman Avenue (2006)

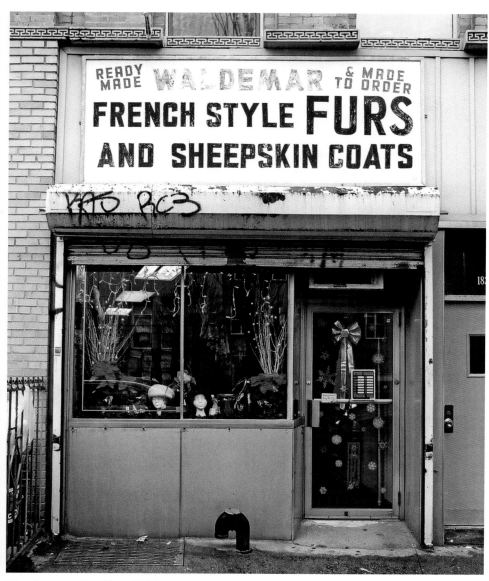

Driggs Avenue near Newell Street (2007)

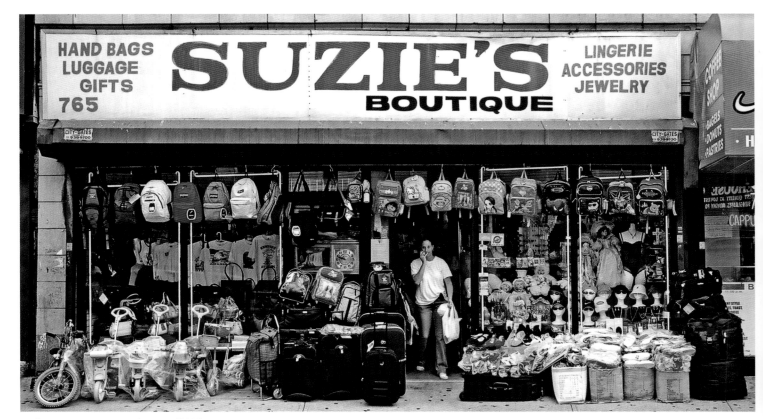

Manhattan Avenue near Meserole Avenue (2004)

Manhattan Avenue near India Street (2006)

Bedford Avenue between North 7th and North 8th Streets (2004)

Bedford Avenue between North 7th and North 8th Streets (2004)

Cobble Hill & Vicinity

BROOKLYN

Cobble Hill is a neighborhood in northwestern Brooklyn bounded to the north by Atlantic Avenue, to the east by Court Street, to the south by Degraw Street, and to west by the Brooklyn-Queens Expressway. The neighborhood got its name at the time of the American Revolution from a hill at what is now the corner of Atlantic Avenue and Court Street, known as Cobbleshill. Between 1840 and 1880 many brownstone and brick row houses were built for the mostly upper middle-class residents but in the early 1900's there was an influx of lower middle-class immigrants from Ireland, Italy, and the Middle East. The name Cobble Hill was revived in the late 1950's by brownstone enthusiasts who were instrumental in having the neighborhood designated an Historic District. Housing prices rose steadily during the 1970's and 1980's and by the early 1990's, Cobble Hill was again an affluent neighborhood.

Gowanus is a neighborhood in northwestern Brooklyn bounded to the north by Baltic Street, to the east by Fourth Avenue, to the south by 14th Street, and to the west by Smith Street. The neighborhood runs alongside and surrounds the Gowanus Canal, which was constructed in 1860. The area was settled beginning in the 1840's by many seamen and laborers who worked in nearby industries. Gowanus was once known by the nickname the 'Gashouse District' because there were dozens of taverns and rooming houses along a section of Smith Street. A small Italian enclave formed to the east of the canal around Carroll Street. The Gowanus area became an important center for industrial and shipping activity and remains today as one of the few manufacturing neighborhoods in Brooklyn.

Third Avenue at President Street [*Gowanus*] (2007)

THE LONG ISLAND BAR & RESTAURANT (›Page 252–253) is a family run business. The owner, Emma Sullivan and her late husband Buddy, opened the business in 1951 and have maintained its original storefront and neon sign.

We chose the name 'Long Island Bar & Restaurant' because Brooklyn was still considered a part of Long Island back then. They weren't thought of as two separate places like they are now. When my husband was alive we would keep the bar open until 4:00 AM, but now that I am running it by myself, I close up at 9:00 PM I like to keep working because it keeps me busy and that way I won't think about how much I miss Buddy. The bar has always had the best customers and for over 50 years we've never even had a fight break out in here.

— EMMA SULLIVAN *owner*

COURT PASTRY SHOP (›Page 255) is a family business that opened in 1948. Gaspar and Vincent Zerilli's father started the pastry shop with a partner and called it Court Pastry because prior to taking over the space, it had been a bakery called Court Bakery that had been in business since 1927. The present storefront and sign are from the 1950's.

We've been serving the same types of pastries since we opened in 1948. If you bought something back then, it would taste exactly the same if you bought it now. Our recipes are old family ones going back to Italy. We are one of the only pastry shops that still makes cannolis by hand. We roll each cannoli out individually by hand and that's what makes them taste better. We don't use a big sheet of dough with a cutter like most bakeries. It's the individual attention we give to everything we make. By far, our busiest time of the year is Christmas. The lines stretch around the block and people wait for hours. Even though this area of Carroll Gardens and Cobble Hill has changed a lot since my family started this business and many of the Italians have moved out, we still have loyal customers who have been coming here for years. I own this building so I don't have to worry about how the rents and prices of buildings in the neighborhood have gone up tremendously. Housing prices have reached ridiculous levels and now the area is full of professionals because they are the only ones that can afford to live here. They like it here because it's so close to Manhattan. This used to be a huge Italian neighborhood but now only a few of us remain.

I'm a little worried about what will happen to the bakery when I am gone because I am the last Zerilli baker. All my children are professionals so nobody wants to run the bakery. But you never know. They all worked here when they were younger. They all know how to make everything. My two sons worked here and even my daughter ... so you never know. But it looks like I'm the last of the Mohegans.

— GASPAR ZERILLI *second-generation co-owner*

G & D TELEVISION (›Page 256) has been in business since 1954. The current owner, Richard bought it in 1989, after working for the original owner for many years. The store is located on the ground floor of a building that was built in 1915 and was designated a landmark in 1970 by the landmarks Preservation Commission.

The storefront and the sign are all original and only the letter 'G' has been replaced because it fell off in 1991 during the big Nor'easter storm that hit the area, The Perfect Storm.

— RICHARD *owner*

SAM'S RESTAURANT (›Page 257) has been in business since 1930. Inside the restaurant is a freestanding pizza oven made of Philadelphia brick that was installed in 1930.

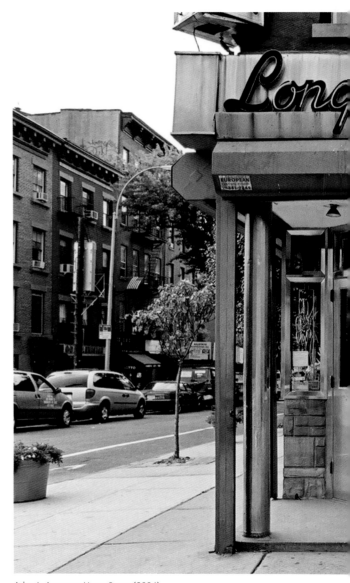

Atlantic Avenue at Henry Street (2004)

Court Street at DeGraw Street (2004)

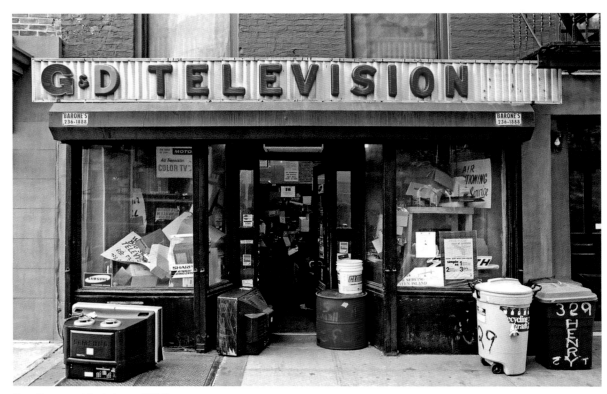

Henry Street near Atlantic Avenue (2004)

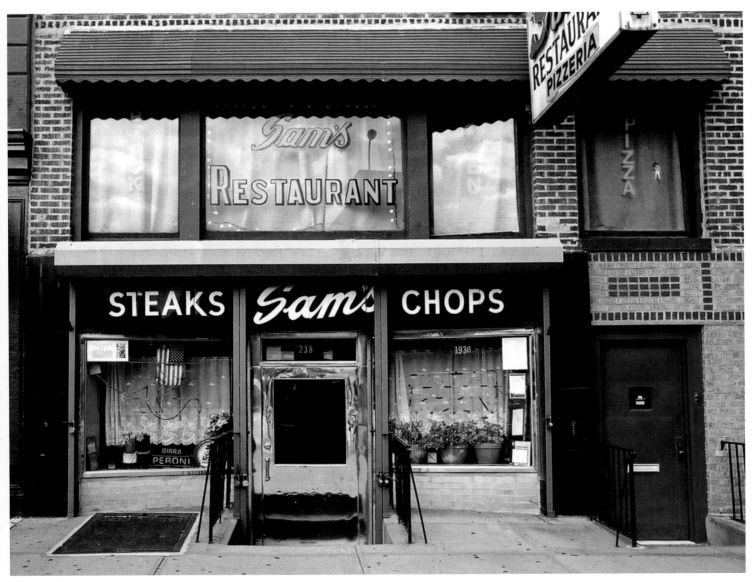

Court Street near Baltic Street (2004)

Borough Park

BROOKLYN

Borough Park is a neighborhood in southwestern Brooklyn bounded to the north by 37th Street, to the east by McDonald Avenue, to the south by 64th Street, and to the west by 8th Avenue. Initially the residents were Irish immigrants but there was also an influx of Jews and Italians from the Lower East Side in the 1920's and in the 1930's. The Orthodox and Hasidic population continued to grow in the 1970's and 1980's and today, Orthodox Jews account for 80 % of the population, most of them Hasidic, representing over 30 different sects. Stores and service businesses in the area provide everything that the residents require for their Hasidic faith as well as supply clothing and furniture needs for the typically large Hasidic family.

BAY LIGHTING has been in business since 1937. The storefront is original and the neon sign was put up in the 1940's. The current owner, David Marks, took over the business from his father, Stewart Marks.

I am the second-generation owner of this business but nothing much has really changed over the years. We have always sold many different kinds of lighting and still sell and repair many antiques. Many of our customers have been coming to us for years.

— DAVID MARKS *second-generation owner*

PASKESZ KOSHER CANDIES (›Page 262) was founded in 1954 by Lazar Paskesz, a Hungarian immigrant. His father, Anshel Paskesz introduced him to the candy and citrus fruit business in Mako, Hungary. After moving to New York in 1954 with wife, three children and no means, he discussed his situation with Rabbi Teitelbaum of Satmar, who suggested he open a candy business. He opened his first store in East New York and later moved to a larger location in Borough Park. Paskesz Candy marketed the first kosher chewing gum in the 1960's. In addition to their domestic line of kosher candies and confectionery, they sell and import products from all over the world.

THE LUNCHEONETTE (›Page 264) has been in business for over 75 years. The current owner is Shaif Fidel.

I bought the business over 20 years ago from an old Jewish man, Martin Wassell, who recently passed away at the age of 97. He sold the store because he was in his 70's and wanted to retire. I've kept everything just about the same as it's always been. The storefront and sign are original and date back to the late 1920's.

— SHAIF FIDEL *owner*

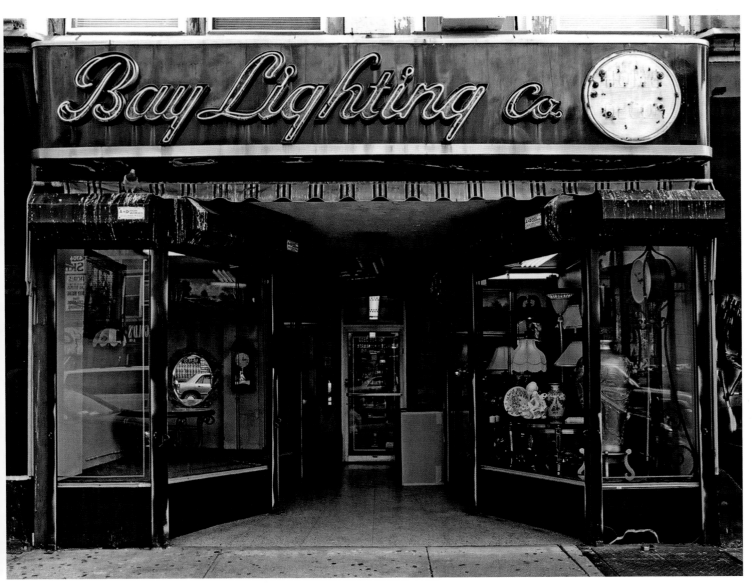

13th Avenue near 47th Street (2004)

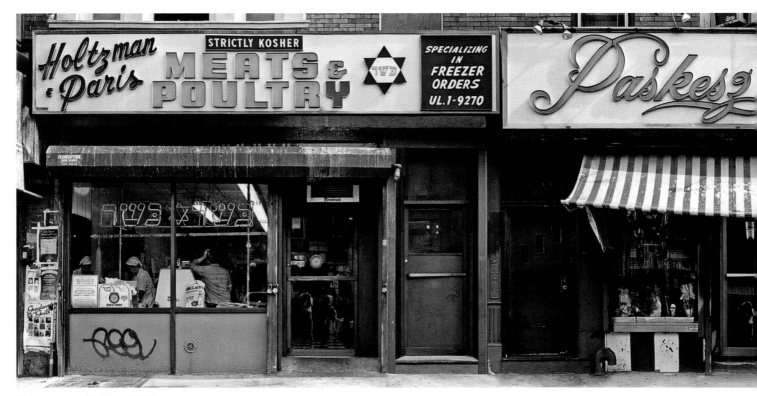

13th Avenue near 53rd Street (2004)

13th Avenue at 53rd Street (2004)

New Utrecht Avenue near 14th Avenue (2004)

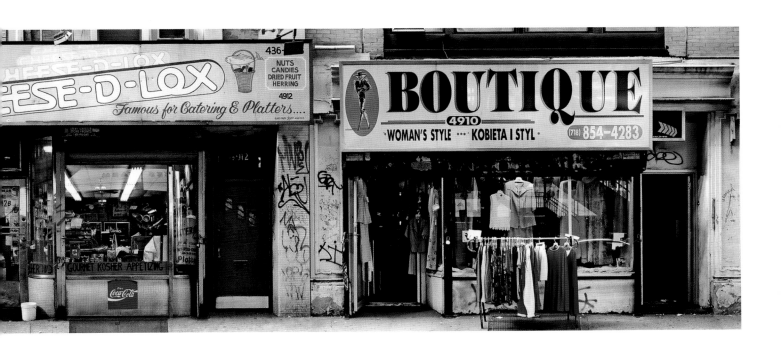

44th Street near 15th Avenue (2004)

Ditmas Avenue near East 5th Street (2004)

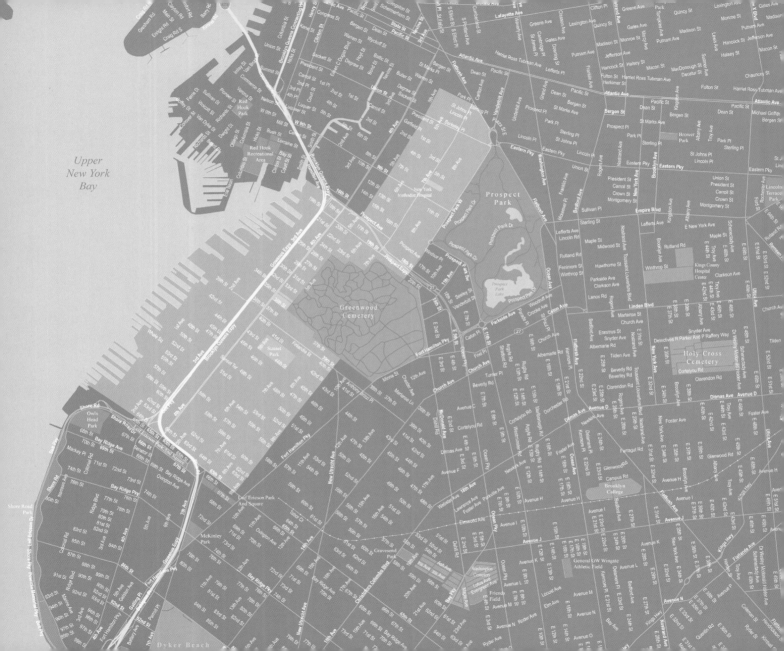

Sunset Park & Vicinity

BROOKLYN

Sunset Park is a neighborhood in southern Brooklyn bounded to the north by the Greenwood Cemetery and the Prospect Expressway, to the south by 65th Street and the Gowanus Expressway, to the east by 9th Avenue and to the west by the Brooklyn Army Terminal and piers. In the 1800's through the early 1900's, Sunset Park's population grew rapidly due to large numbers of Irish, Polish, and Norwegian immigrants who settled in the area and worked in the Brooklyn shipping industry.

After Second World War, the area went into a decline due to the closing of the Army Terminal and the rise of truck-based shipping and ports in New Jersey. The white population decreased but in the 1980's many immigrants from Puerto Rico, Mexico, the Dominican Republic, and other Latin American countries moved in. By 1990, Hispanics comprised 50 % of Sunset Park's population and helped rebuild the community. Since the 1980's, the neighborhood has also attracted many East Asian immigrants, particularly in an area now known as 'Brooklyn's Chinatown,' along 8th Avenue from 42nd to 62nd Streets.

Park Slope is a neighborhood in western Brooklyn, which is bounded to the north by Park Place, to the east and south by Prospect Park West and Prospect Expressway and the Greenwood Cemetery to the west. The neighborhood was given its name because of its location on the western slope of neighboring Prospect Park. Many mansions and brownstones for the wealthy were built in Park Slope in the late 1800's, taking advantage of the beautiful park views. In the 1950's, the area began to decline as wealthy and middle-class residents moved to the suburbs. Despite widespread abandonment in the 1970's along Fifth Avenue, many of the historic homes were preserved. By the 1990's, Park Slope was revitalized and many young professionals and families moved to the neighborhood.

CASH & CARRY FOOD MARKET is a family-owned business that has been open since 1959.

Everything about this store is original. The sign was given to us by the Coca-Cola Company when we opened in 1959. Back then they would issue signs to businesses that sold their product. Our place has always been a family business. My brother originally opened the store in 1959 but when he retired, he sold the business and the building to my cousin with a verbal agreement that when my cousin was ready to retire that he would keep the business in the Cruz family. My cousin didn't keep his end of the promise and instead kept the building and business for himself after he retired. So I've been forced to pay my own cousin an ever-increasing rent to the point that he's made it so expensive for me that I am forced to move the business. My family and I bought the building next door and by the end of 2005, we will shut down and move next door. Unfortunately, we will have to replace the sign and our store will lose some of its original flavor.

— SANTOS CRUZ *owner*

LUIGI'S PIZZA (› Page 272) has been in business since 1973. It is now being run by the second-generation family member, Giovanni Lanzo.

My father, Luigi, emigrated here from Calabria, Italy. He was a farmer but learned to cook well from his mother. He opened this pizza place in 1973 using his family's recipes. He's retired now but still grows many of the fresh ingredients we use such as tomatoes and herbs at his farm in Staten Island. Yes, he actually has a farm! It's hard to believe that there is a farm anywhere in New York City but he has a small one. I think that's what makes our pizza taste so good, the fresh ingredients. Our specialty is our fresh mozzarella pizza, which is sprinkled with our home-grown fresh herbs.

We own this whole building, thank god, and that's why we are still here today. This area between Sunset Park and Park Slope has gotten so expensive that we would never be able to afford the rent. And yeah I call it area because this neighborhood in Brooklyn really has no name so we've created the name Greenwood Heights for ourselves. Sunset Park won't include us in their holiday festivities and either will Park Slope.

Lots of people who live here now like to say that they live in Park Slope but I grew up in this neighborhood and back in the late 70's and early 80's it wasn't so desirable. There were lots of abandoned buildings and crime was really high. As a kid, my parents wouldn't even let me walk on 7th Avenue. I remember when the City was selling whole buildings in Park Slope for $1.00. If you lived in the building and you wanted to buy it, they were actually offering it to you for a dollar. Now of course, the neighborhood has changed but it's still a big melting pot of different nationalities.

— GIOVANNI LANZO *second-generation*

NEW PUBLIC MEATS (› Page 273) has been in business since 1939. The present owner is George Portorreal.

I bought this butcher shop from the original owner, Louie, in 1996. It used to be an Italian meat market and sold many Italian specialties like homemade sausages. By the time I took over, the neighborhood had changed drastically. The Italians had moved away and the area became mostly Hispanic. At first I continued to sell some Italian sausages because some old-time customers would still come in but little by little they either died or finally moved away. Now I cater to people from South America so I sell many Latin specialties.

— GEORGE PORTORREAL *owner*

RAINBOW CAFÉ (› Page 274–275) has been in business since 1945.

This café was called Rainbow Café because the original owner's name was John Garland. He owned the whole building and lived with his family over the restaurant. He had a daughter named Judy and named the place Rainbow Café for her because she loved the movie The Wizard of Oz and that way she would live 'somewhere over the rainbow.' The neon sign is original and so is the wooden bar. When all the neon was lit years ago it looked amazing and you could see it for miles.

This café is really enormous. We have many separate party rooms where we cater events. Before this place was a café it was an old German beer garden and the basement held all the old barrels of beer. Now the place is owned by Mr. Garland's son-in-law, Harold Martinson.

— TOM *chef*

GARRY JEWELERS (› Page 277) has been in business since 1951. It was founded by Ralph and Rose Garafola and is now being run by their son, Michael. The exterior and interior are all original.

My father Ralph started this business in 1951 and I took over after he passed away. My mom, Rose, still works alongside me. We haven't changed much in here over the years and we intend to keep it that way. We own the entire building so we don't have to worry about the rent going up like many other businesses in this neighborhood. It's your 'ace in the hand' when you own the entire building because nobody can force you to move. It takes a long time for a business like mine to build a clientele and if you have to move, all that hard work can be lost. Customers also appreciate the stability of a long-time business. They see our sign outside and know that we've been in this neighborhood for years.

I've lived in Park Slope my entire life and it's always been a melting pot for different immigrants. In the 1950's and 60's, one block would be Italian and the next would be Irish, the next African American, and the next one would be Puerto Rican. Now, many other cultural groups have arrived along with not only the so-called 'younger' generation, but transplants from Manhattan and from every state in the Union. People move in and out of Park Slope at a faster rate than years ago when families would come and stay for generations.

— MICHAEL GARAFOLA *second-generation owner*

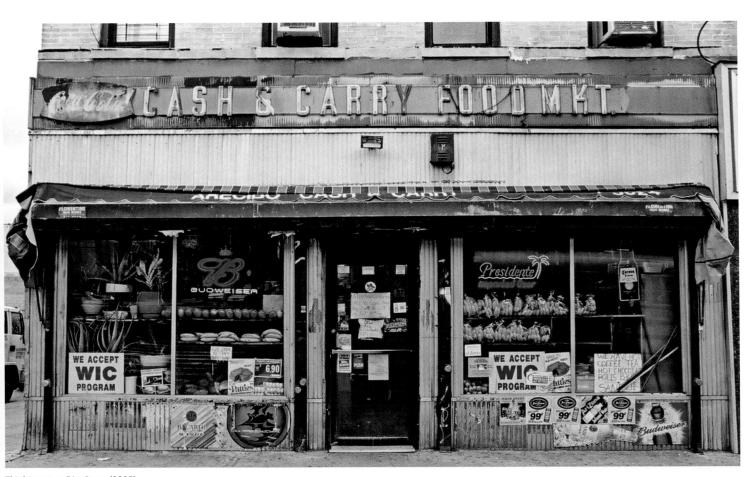

Third Avenue at 51st Street (2005)

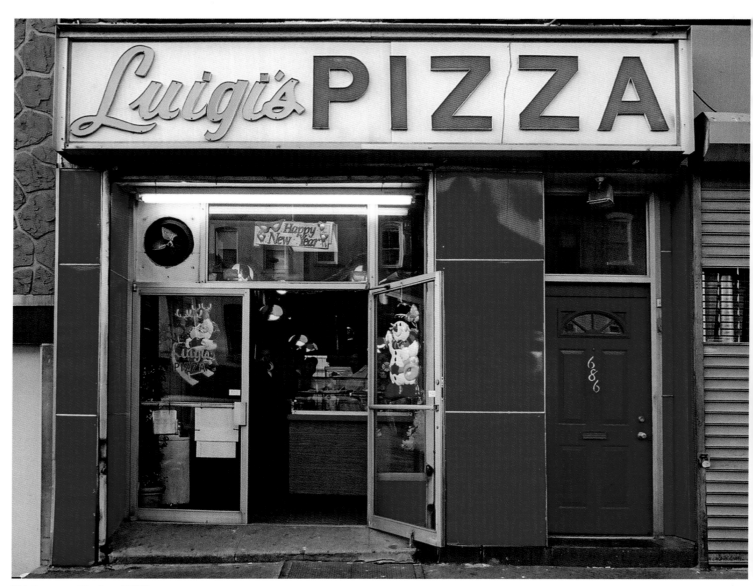

Fifth Avenue near 21st Street (2006)

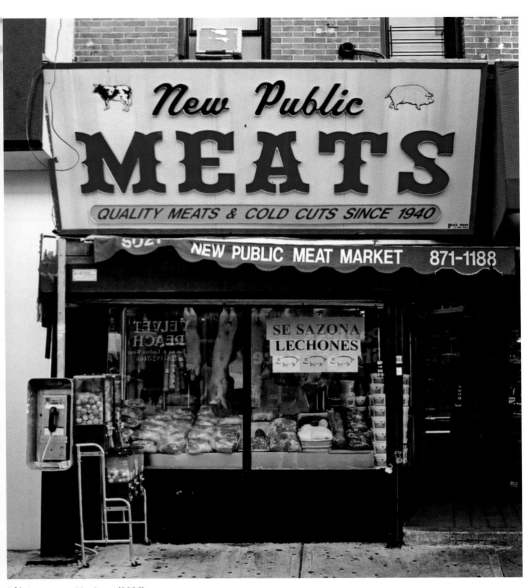

Fifth Avenue near 51st Street (2006)

Fifth Avenue near 39th Street (2006)

274.275

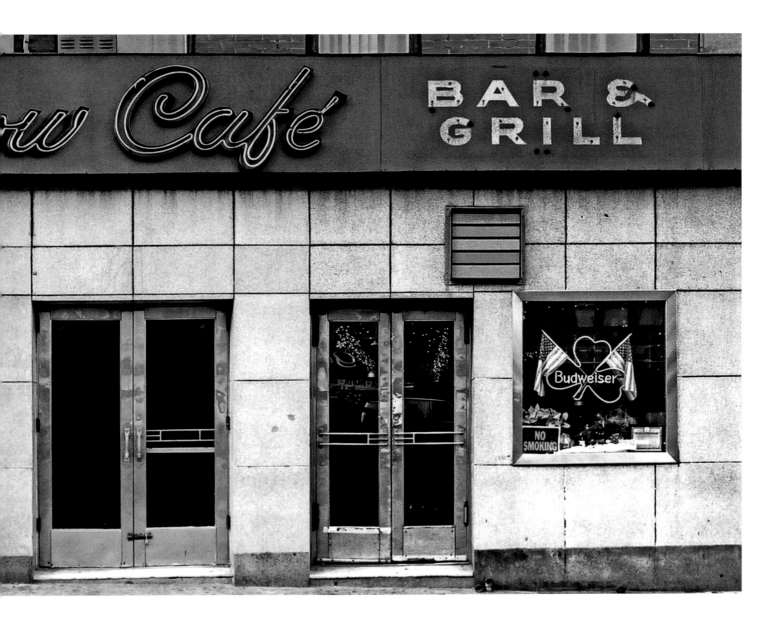

Fourth Avenue at 42nd Street (2005)

Fifth Avenue near 10th Street *[Park Slope]* (2006)

Fifth Avenue near 59th Street (2006)

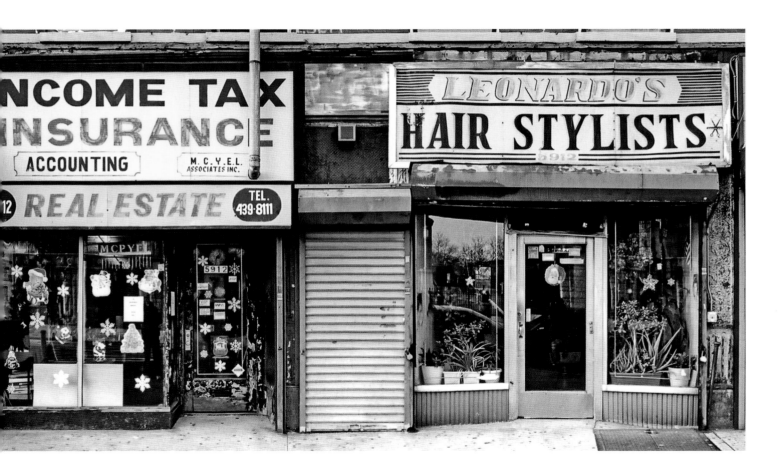

Fifth Avenue near 44th Street (2006)

Fifth Avenue at 49th Street (2006)

Bensonhurst & Vicinity

BROOKLYN

Bensonhurst is a neighborhood in southwestern Brooklyn bounded to the north by 61st Street, to the east by McDonald Avenue, to the south by Gravesend Bay, and to the west by 14th Avenue. Many Italians and Jews from Manhattan's crowded Lower East Side moved to the neighborhood after 1915, when the subway reached the area and single and multi-family homes were built.

In the 1950's, thousands of immigrants from Southern Italy settled in the area and by 1980, nearly 80% of the residents in the neighborhood were Italian. Many residents of Bensonhurst have planted grape arbors and fig trees in their backyards, recreating a feel of their native Italy, and several generations of families often live on the same block. In the past twenty years many immigrants from Asia and the Soviet Union have also moved into Bensonhurst.

Sheepshead Bay is a neighborhood in southeastern Brooklyn overlooking the ocean inlet called Sheepshead Bay. It is bordered to the north by Marine Park, to the east by Shell Bank Creek, to the south by Manhattan Beach and to the west by Gravesend. The neighborhood began as a small village of wooden houses but gradually became more developed and was known as the center of recreational fishing in New York City. The population of Sheepshead Bay by the early 1990's was mostly Italian and Jewish. In recent years, increasing numbers of Asian and Caribbean immigrants have also moved into Sheepshead Bay.

PARK RIDGE PHARMACY has been it its present location in Bensonhurst since the late 1960's.

I bought this pharmacy in 1980. It's been at this corner for over 35 years but it was originally located across the street. When I bought the store it had an external enclosure around the whole front of the store that I tore down because I was afraid that homeless people would start sleeping inside of it while we were closed for the evening. Otherwise, the building's exterior and interior have remained the same for the 35 years it's been open.

— KENNETH DI MARCO *owner and pharmacist*

TONY'S LUNCHEONETTE (› Page 286) has been in business over 50 years.

I bought this coffee shop in 1972. The storefront and interior are all original, including a very unique circular wrap-around counter. This Bensonhurst neighborhood has changed a lot over the years. It used to be a very Italian neighborhood with lots of large Italian families but now a lot of Chinese have moved in and they don't usually eat here. Luckily, my wife and I own this building so we don't have to worry about the increasing rents in the area or anything.

— ANTONIO LOMBARDO *owner*

RISPOLI PASTRY SHOP (› Page 287) has been in business over 70 years. Connie Savarino bought the business from Mr. Rispoli in the mid 1980's but kept the original storefront and sign.

My brother worked for Mr. Rispoli and when he retired, my brother and I bought the store and his family recipes. We kept the name of the store since we used all his original recipes from Italy. Our most popular items are homemade cannolis and Italian ices. We make everything fresh daily and don't use preservatives. The neighborhood has really changed over the years. The Italian population has dwindled and many families moved to Staten Island.

— CONNIE SAVARINO *owner*

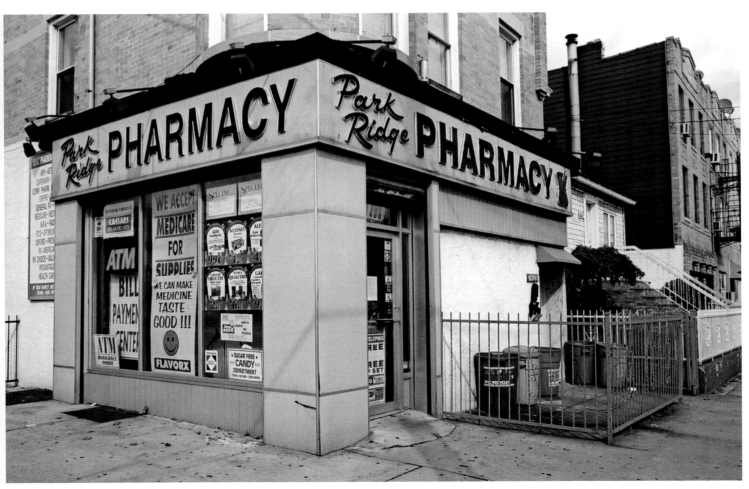

Fifteenth Avenue at Bay Ridge Parkway (2005)

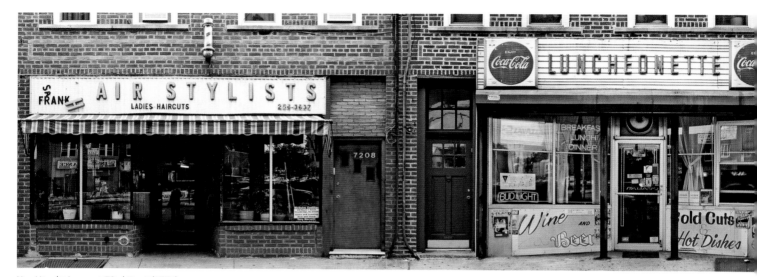

New Utrecht Avenue at 72nd Street (2005)

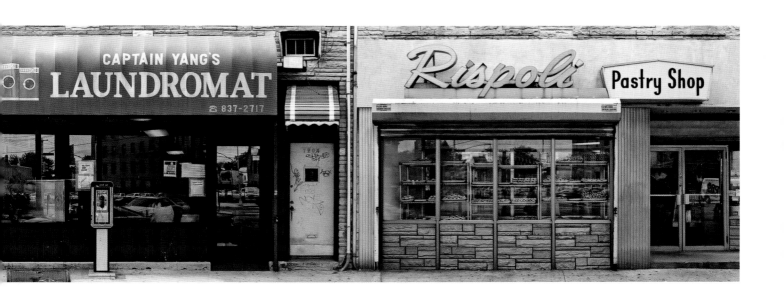

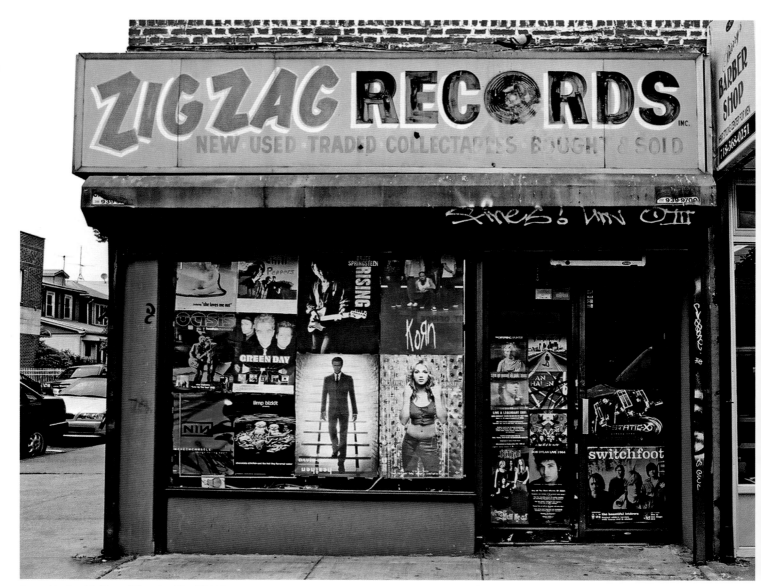

Avenue U at East 23rd Street [Sheepshead Bay] (2005)

Fort Hamilton Parkway near 70th Street (2005)

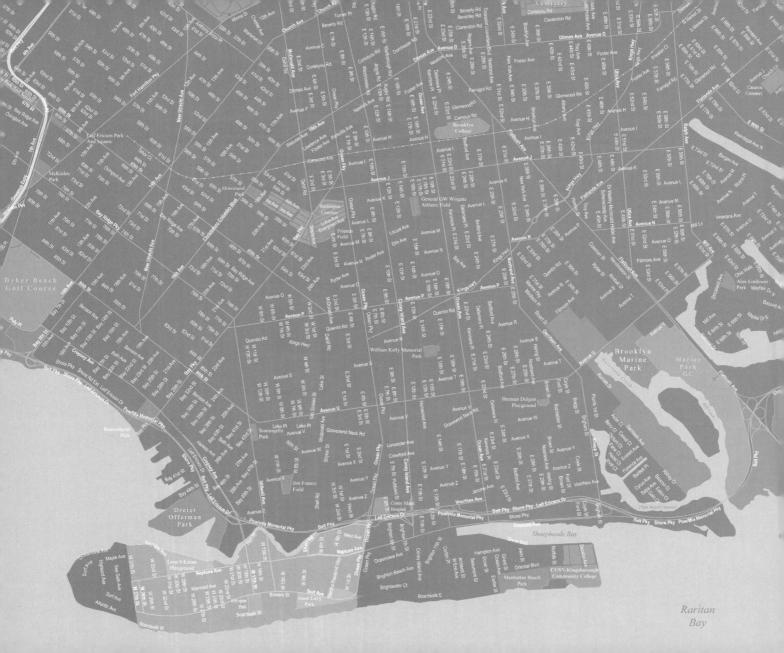

Coney Island

BROOKLYN

Coney Island is a peninsula located in southwestern Brooklyn with a famous beach lying on the Atlantic Ocean. Between 1880 and Second World War, Coney Island was a major summer resort destination and was the largest amusement park area in the United States attracting several million visitors per year. At its height it contained three competing amusement parks, Luna Park, Dreamland, and Steeplechase Park, as well as many independent amusements.

After the subway reached the area in 1920, over a million people would visit the amusement parks and beaches every weekend and many Jews and Italians moved to the neighborhood. Coney Island declined after Second World War due to the advent of air conditioning in movie theaters and homes as well as increased automobile access to less crowded and more appealing Long Island beach state parks, such as Jones Beach. Luna Park closed in 1946 after a series of fires.

Street gang problems of the 1950's discouraged people from visiting the remaining rides and concession stands and Steeplechase Park eventually closed in 1964. A few remnants of Coney Island's past remain, such as the Wonder Wheel and the world famous Cyclone roller coaster. In recent years an influx of Russian immigrants from the Soviet Union, many of them Jewish, have settled in Coney Island, helping to revitalize the area.

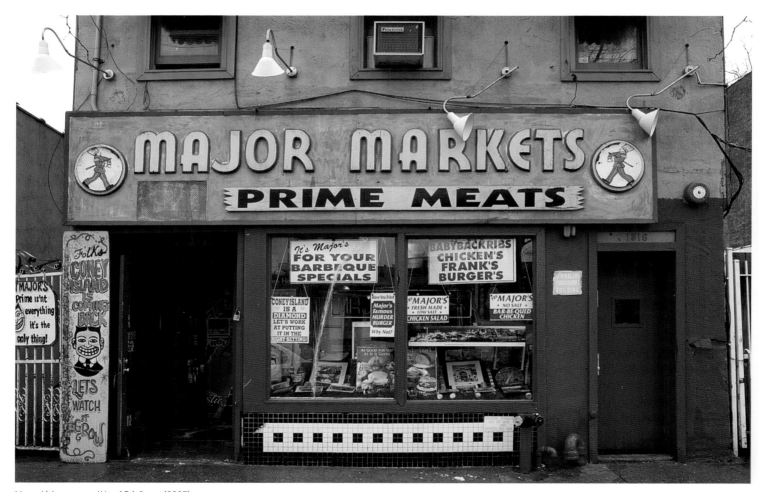

Mermaid Avenue near West 15th Street (2007)

is one of the last amusement parks still operating at Coney Island. It opened in 1962 and is the home of the world famous Cyclone wooden roller coaster, which was built in 1927 and later added to the park in 1975. The Cyclone is an 85-foot tall, fast, twisting-style coaster that was popular with the enormous Coney Island summer crowds when it opened in 1927. Lines typically reached 3–5 hours long during the summer. Though the famed roller coaster will be preserved, Astroland was sold for roughly $30 million dollars in 2006 to Thor Equities, which plans to transform the amusement park into a year-round destination after the summer season of 2008.

THE WONDER WHEEL () was erected in Coney Island in 1920 and still operates today as part of Deno's Wonder Wheel Amusement Park located on the Boardwalk by Denos Vourderis Place (formerly West 12th Street). It is 150 feet high, has a diameter of 140 feet, and holds 144 people at once. Its unusual design incorporates sections of curved tracks connecting an outer wheel and a smaller inner wheel. When the wheel revolves, the tracks incline and the 16 swinging cars, each seating 4 people, roll back and forth between the two wheels. There are also 8 stationary cars. All the cars give riders a panoramic view of the Atlantic Ocean, the Jersey Shore and the New York City skyline. Over 200,000 people of all ages ride the Wonder Wheel every year. Denos Vourderis purchased the Wonder Wheel from the original owners, the Garms family, in 1983. His 2 sons, Steve and Dennis run the park today.

My father always loved taking the family to Coney Island and seeing the Boardwalk and Wonder Wheel. He often told my mother, Lula that one day he would buy the Wonder Wheel for her as a wedding present, a ring so big that everyone in the world would see how much he loved her, a ring that would never be lost. Since the 1960's my father operated a Boardwalk restaurant and managed a kiddie park, which he eventually purchased in 1981. When the Wonder Wheel was put up for sale in 1983, there were several interested buyers with higher offers, but the Garms family decided to sell it to my father because they knew that they could trust him to personally maintain its grandeur and brilliance. With the help of the entire family, he built Deno's Wonder Wheel Amusement and Kiddie Park. The Wonder Wheel itself was landmarked in 1989 by the City of New York. It has maintained a perfect safety record for its entire history and every year during the winter season, the 400,000-pound ride is overhauled and painted to protect it from the elements of weather and wear and tear.

— DENNIS VOURDERIS *second-generation owner*

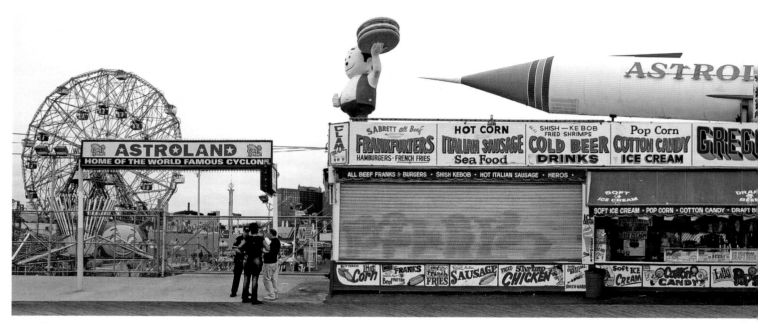

Boardwalk at West 10th Street (2005)

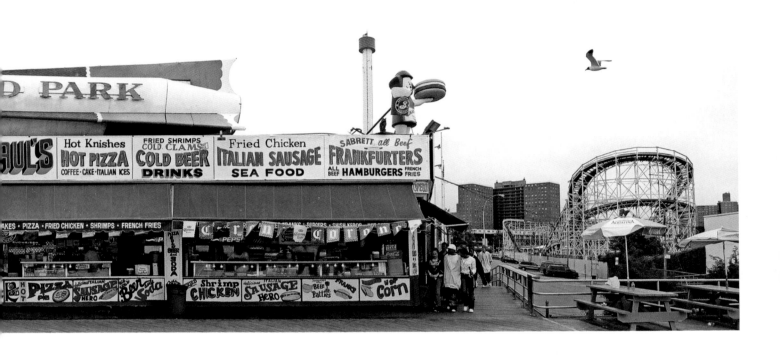

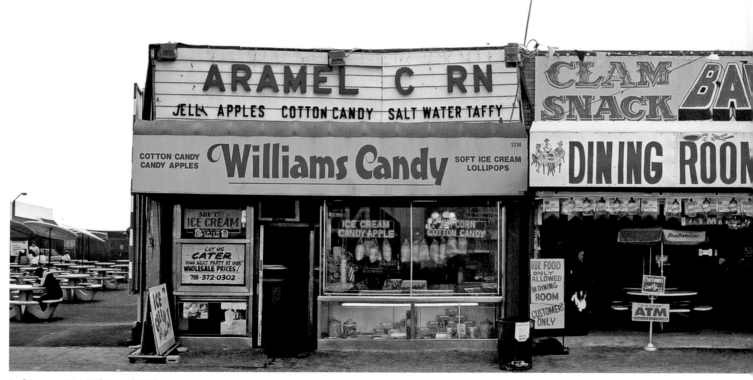

Surf Avenue at West 15th Street (2001)

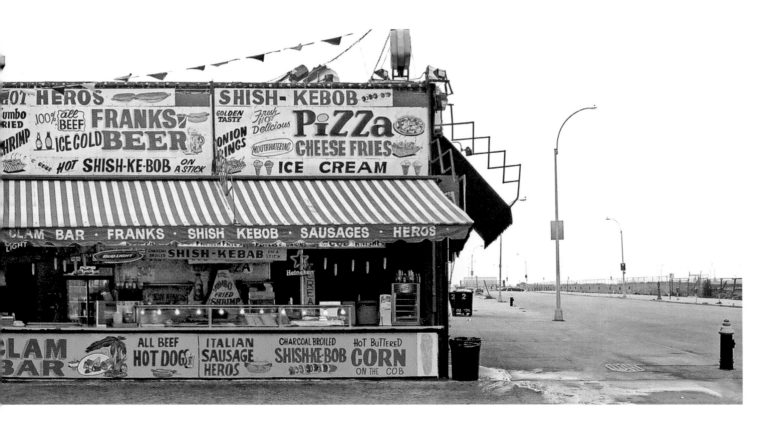

QUEENS

is the largest borough of New York in area. It is almost as large as Manhattan, the Bronx, and Staten Island combined. It is bounded to the north and west by the East River, to the east by Nassau County in Long Island, to the south by the Atlantic Ocean and to the southwest by Brooklyn. Queens was originally farmland but became more populated in the mid-1800's when the railroad reached the area and large numbers of Irish and German immigrants moved in. With the expansion of the subway system in the early 1900's, and the opening of the Queensboro Bridge in 1909, the population of Queens grew tremendously.

After the immigration laws changed in 1965 many new immigrants settled in Queens, especially Asian and Latin Americans. The foreign-born population increased by nearly 30 percent during the 1970's making Queens the city's most ethnically diverse borough, which it still is today. Residents of Queens often closely identify with their neighborhood and even postal addresses in Queens are written with the neighborhood, state, and then zip code, rather than the borough or city.

Astoria, in northwestern Queens, has traditionally had a large Greek population. One-third of all Greeks who moved to New York City in the 1980's settled in Astoria and by the mid-1990's they accounted for slightly less than half its population. Forest Hills, in central Queens, historically has had a very large Jewish population and in more recent years, many Asians and Latin Americans have moved to the neighborhood. Forest Hills has long been and still remains the most exclusive address in Queens. Jackson Heights and Corona, in north central Queens, are ethnic melting pots with many different Latin American immigrants and Asian immigrants living alongside older Italian, Jewish and Irish residents. Flushing, in north central Queens, has a huge Asian population with distinct communities from China and Korea as well as immigrants from Latin America.

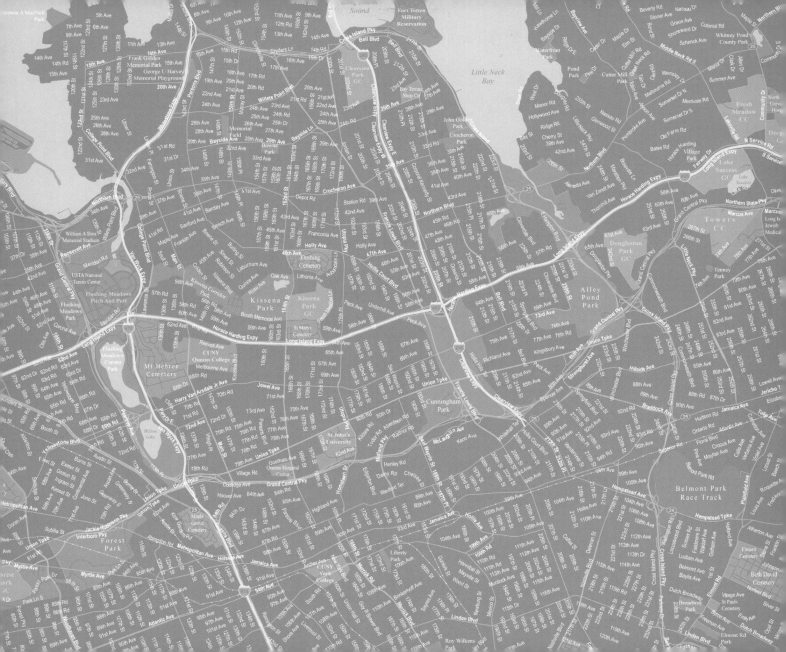

WALTERS HARDWARE COMPANY was founded in 1922 by Marty Walters.

I purchased this business in 1978 from my uncle, Maurice Osteror, who was Marty Walters' cousin. Nothing in here is any different than it was in 1922. The oak floor is original and so are all the wooden shelves and cabinets. We even still use the original rolling wooden ladders that hook into a railing that runs much of the length of the store to reach the upper cabinets and shelves. My store even has the distinctive smell of a hardware store, which is produced by a co-mingling of odors from fertilizer and oil among others. The arrival of Home Depot in the neighborhood has made us even sharper and more considerate and aware of our customers' needs. We carry a wider selection and have a wider inventory than ever before because we have to keep up with the times. Our motto is "If we don't have it, you don't need it." We primarily cater to apartment dwellers and especially the new, young New Yorkers that are not very tool-friendly. I often have to teach them how to fix things in their house. They can't get that kind of attention at Home Depot. The workers there won't take the time to teach them how to do things.

— BOB SHAPIRO *owner*

BROADWAY SILK STORE (›Page 304–305) has been in business since 1931. The sign was put up in the 1960's.

My wife's parents, the Laxer's, started this business when there was practically nothing in this neighborhood. They bought the whole building for about $20,000, which sounds like nothing nowadays but it was a large amount of money back then. Nothing has really changed in here since then. The shelves and furniture are the same and we even have the old sewing machines here including a 'New Home' machine that is from around 1910. The only thing here that is new is 'ME' and the cash register. We even still have the original cash register with the old hammer-type keys in storage in the basement.

— NORMAN GOULD *second-generation owner*

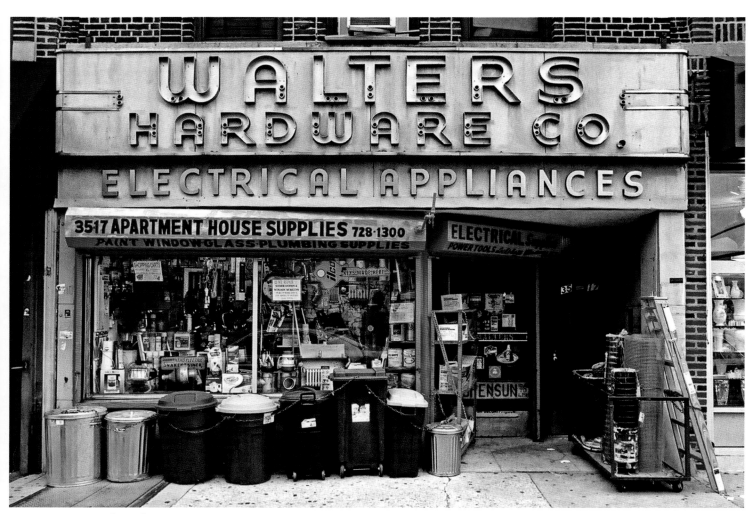

Broadway near 36th Street *[Astoria]* (2006)

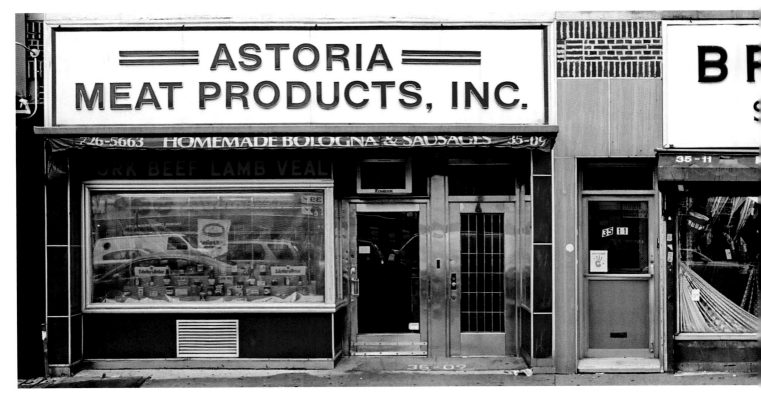

Broadway between 35th and 36th Streets *[Astoria]* (2006)

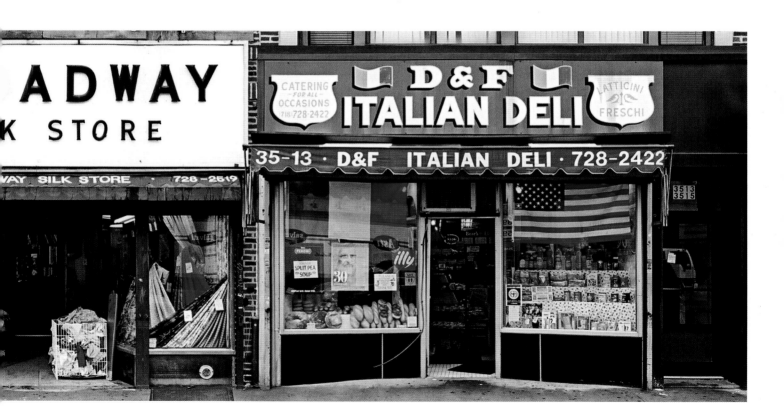

ADWAY
K STORE

WAY SILK STORE · 728-2519

CATERING
- FOR ALL -
OCCASIONS
718·728·2422

D&F
ITALIAN DELI

LATTICINI
FRESCHI

35-13 · D&F ITALIAN DELI · 728-2422

3513
3515

SPLIT PEA
SOUP

30

illy

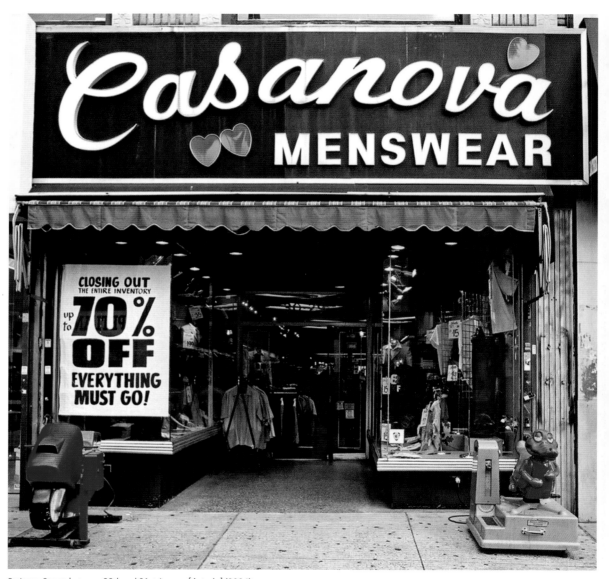

Steinway Street between 30th and 31st Avenue *[Astoria]* (2004)

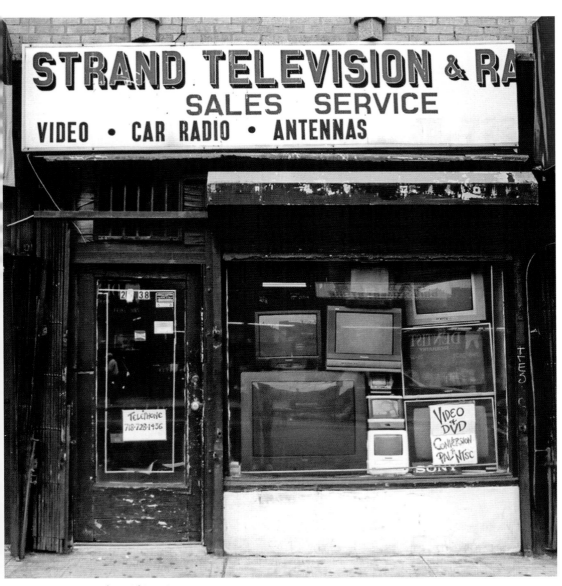

Broadway near 29th Street [Astoria] (2006)

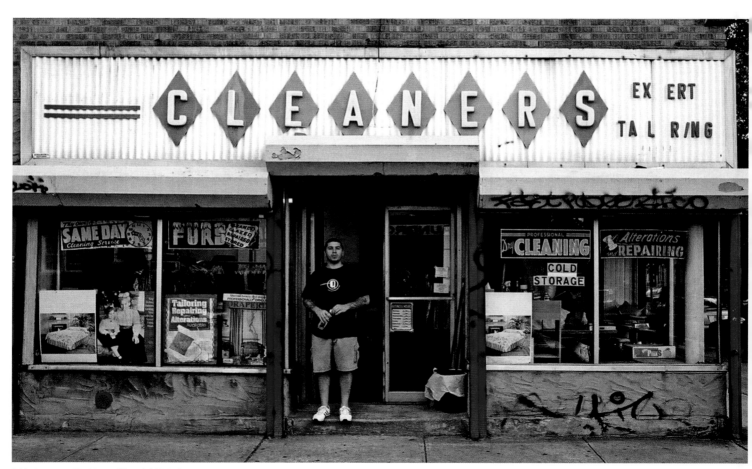

34th Avenue at 42nd Street [Astoria] (2004)

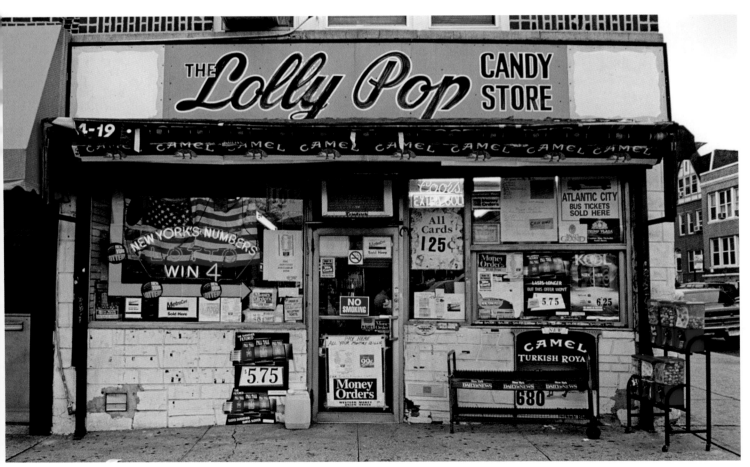

30th Avenue at 34th Street [Astoria] (2003)

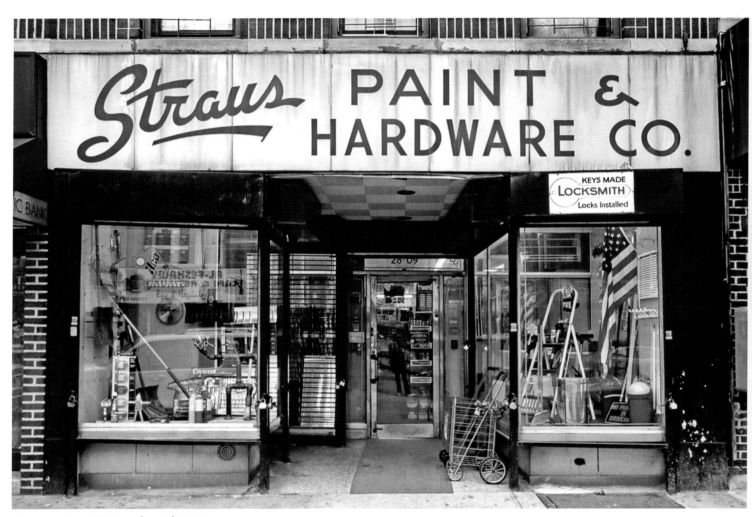

Steinway Street near 28th Avenue *[Astoria]* (2006)

Broadway near Steinway Street *[Astoria]* (2004)

EDDIE'S SWEET SHOP has been in business for over 90 years. The present sign is from 1968.

This has been an ice cream parlor for over 90 years. The entire interior, including the marble counters, stained glass windows, tin ceiling and inlaid wood cabinetry, is original. The cabinet-style refrigerator we still use is over 75 years old. I am now the fourth owner but the store has been called Eddie's Sweet Shop since 1968.

I first worked as a counterboy for Eddie and then took over the store when he retired. We still use some of the original owner's recipes for our homemade ice cream but we've added many of our own touches over the years. We also now sell over 18 different flavors versus the five or six original flavors that were sold in the beginning. We make all our own ice cream on the premises using the freshest ingredients. We also make most of our own syrups and toppings and even hand whip our own whipped cream. Our most popular flavors are vanilla and chocolate but many people still request old favorites like rum raisin and maple walnut, which are hard to find in other ice cream shops.

We are very fortunate in that many of our old customers, even if they have moved out of the area, still return to eat here. We really have very loyal customers so we don't have to rely on just local street traffic. This Queens neighborhood is pretty unique in that there are still many families living here and there is also a very strong sense of community.

— VITO CITRANO *owner*

JACKSON HEIGHTS FLORIST (› Page 314) was in business for over 75 years before it closed in 2008. The neon sign outside is from 1950.

I took the business over from my father, George Keffas, when he retired. My family also had another floral shop around the corner on 82nd Street, which was in business since 1924 until it closed a few years ago. We were never competitors, just neighbors. This neighborhood has changed a lot over the years. It used to be very Irish but now many Hispanics have moved into the neighborhood.

— JOHN KEFFAS *second-generation owner*

THE LEMON ICE KING OF CORONA (› Page 316–317) has been in business since 1944.

In 1944, I opened this store on the corner where my garage is and expanded it in 1963 where it is now. So the storefront and sign are all from 1963. When I first opened I only sold two flavors of ice, lemon and pineapple. Now I sell 30 different flavors. I basically added one every year or so but stopped when I reached 30 flavors. After all, I'm not Baskin & Robbins. I use real fruit in all my flavors, nothing artificial and all the recipes I created myself. I dreamt up all the flavors at night when I couldn't sleep so that's a lot of sleepless nights. Everyone in this neighborhood knows me as 'The Ice King of Corona.' This place has become an institution.

Corona has really changed over the years. There used to be mostly Italians and Jewish people living here but now lots of Puerto Ricans and Dominicans have moved into the area. Even though many of my longtime customers have moved out of the neighborhood, they still come back to buy ices here and sometimes bring their children and even their grandchildren.

— PETER BENFAREMO *owner*

Metropolitan Avenue at 72nd Road [*Forest Hills*] (2005)

Roosevelt Avenue near 82nd Street [*Jackson Heights*] (2004)

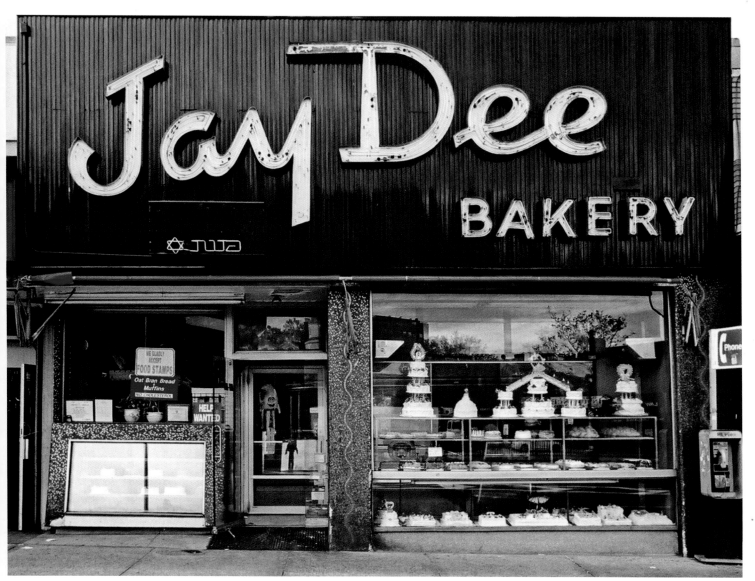

Queens Boulevard near 66th and 67th Avenues *[Forest Hills]* (2005)

108th Street at 52nd Avenue *[Corona]* (2004)

ING OF CORONA

ICES WITH REAL PIECES OF FRUIT IN IT

Benfaremo
THE LEMON ICE KING OF CORONA

ICES IN 25 FLAVORS

NG OF CORONA

OPEN ALL YEAR

52-02 108st

CUPS ICES
PRICE LIST

WE DO NOT MIX
OR EXCHANGE ICES

Corona Avenue near 52nd Avenue *[Corona]* (2004)

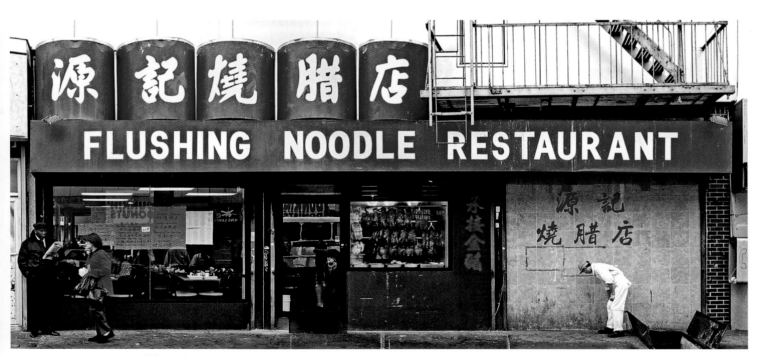

源記燒腊店

FLUSHING NOODLE RESTAURANT

源記
燒腊店

Roosevelt Avenue near Prince Street [*Flushing*] (2001)

STATEN ISLAND

is the borough of New York City at the juncture of Upper and Lower New York Bay. It is the third largest borough in area but the least populated. It is also the borough farthest from Manhattan, separated at its closest point by a five-mile stretch of water, without direct tunnel, bridge, or subway linkage. It can be reached from Manhattan only by the world-famous Staten Island passenger ferry. The Staten Island Ferry, which runs twenty-four hours a day, remains a lifeline for the large commuting population of Staten Island. The Ferry is also a favorite with tourists because of its free fare and amazing views of the New York harbor and Statue of Liberty.

Staten Island began as a coastal fishing community and agricultural area with vast farmland. The growth of Manhattan and Brooklyn spurred residential development but the borough remained relatively undeveloped except the areas along the harbor. Staten Island became a borough of New York City in 1898 and in the 1920's there was a building boom in anticipation of a planned system of bridges to New Jersey and a promised direct subway connection with the city. Staten Island was promoted as a 'borough of homes,' similar to Queens.

The opening of the Verrazano Narrows Bridge in 1964 connected Staten Island with Brooklyn and led to more growth in Staten Island during the 1970's and 1980's. There are more Italian-Americans living on Staten Island than in any other county in the United States. Staten Island remains a largely residential borough with the highest proportion of one-family housing and owner-occupied housing in the city.

MILLER'S PHARMACY was founded by the pharmacist, Arthur Miller, in 1916. He sold the business in 1982 to pharmacist Ethan Asedo.

This pharmacy was originally located directly across the street but Mr. Miller was forced to move here in 1958 when the City of New York demolished his old building in order to build the housing projects, 'Stapleton Houses.' The storefront and neon sign are all original from 1958. I haven't changed a thing. When I bought the store in 1982, I wanted to keep the name so I fixed the neon sign outside but it only lasted one day before neighborhood kids threw rocks at it and broke all the letters. It was so expensive to fix that I just decided to leave the letters all broken like it is today. I still have to pay the City for the right to keep the sign even though the letters don't light up anymore.

— ETHAN ASEDO *pharmacist and owner*

LIEDY'S SHORE INN (› Page 326) is Staten Island's oldest bar. It was established in 1905 by Jacob Liedy, a German immigrant who continued to run the bar as a speakeasy during Prohibition with liquor supplied by rumrunners who rowed their contraband across Kill Van Kull from Bayonne, New Jersey. The bar is now owned by the fourth-generation family member, Larry Liedy, who lives in one of the two apartments located above the tavern.

DE LUCA GENERAL STORE (› Page 327) has been in business for over 30 years. The owner, John De Luca

sells various hardware items as well as electrical and plumbing supplies.

I am originally from Italy and I came to New York in 1958. I first worked as a glass blower on Long Island and when I retired from that job I opened this store. I like to work with my hands and being a glass blower, I have a lot of patience so I figured this was a good thing for me to do. I haven't changed a thing about this store since I opened it over 30 years ago. The sign and storefront are original and so is the interior, including the tin ceiling that I painted myself. I work many hours here because ten years ago I lost my wife so I can't stay home. I'm 75 years old now and I was pretty much retired at that time but when I lost her I said I'm going to work full-time again because I can't stay home alone. It's better to keep busy in order to keep going. I own this building and I've got a son so if he wants the business after I'm gone, it's his.

— JOHN DE LUCA *owner*

PASTOSA RAVIOLI (› Page 328–329) was founded by Anthony Ajello over 25 years ago. The main store and manufacturing location in Bensonhurst, Brooklyn has been in business since 1962.

I opened my first store in Bensonhurst, Brooklyn in 1962 after working for Polly-O Cheese Company for many years. I was born here in America but my parents are originally from Naples, Italy. My father had a latticini, a dairy and cheese business in Naples. He made his own ricotta and mozzarella cheese on his dairy farm before moving to New York. I came up with the name Pastosa

for the store because in Italian 'pastosa' means honesty and integrity. So to me 'Pastosa' equals tasty because my business takes pride in their honesty and integrity and that makes for tasty products. My son, Michael and my grandson, Anthony are running the businesses in Brooklyn and Staten Island now because I am pretty much retired.

— ANTHONY AJELLO *founder*

We make ravioli fresh every day here in our Bensonhurst store and produce about 5,000 ravioli per an hour on just one of the machines. We go through approximately 2,000 to 2,500 pounds of ricotta every day just for the ravioli machines. We don't make our own ricotta cheese, we buy it from Polly-O, where my grandfather used to work. We add our own imported grated cheeses into it, fresh eggs, fresh parsley, salt, pepper, and whatever special fillings we want.

We sell over 30 different flavors of ravioli from cheese to lobster to crab meat and our newest flavor, truffle ravioli, cavatelli, and stuffed shells. All of the recipes we use are originally from my grandfather but my father has expanded the fresh pasta line and added recipes for the newer flavored products. Thirty years ago, nobody would ever have thought to mix ricotta and lobster together to make lobster ravioli. But people's eating habits change over the years and we've changed with them. Our customers want different varieties so that's what we give them.

— ANTHONY AJELLO JR. *third-generation owner*

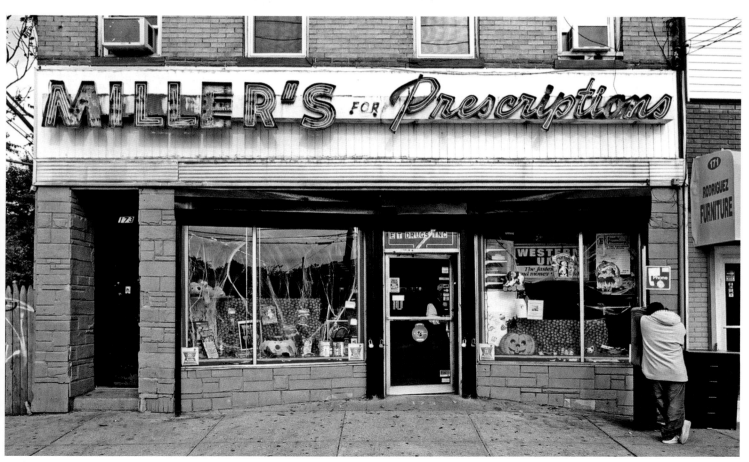

Broad Street near Cedar Street (2005)

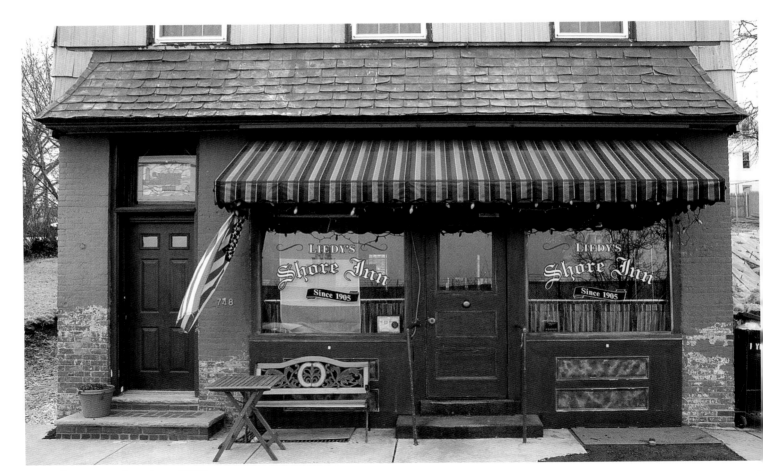

Richmond Terrace near Lafayette Avenue (2007)

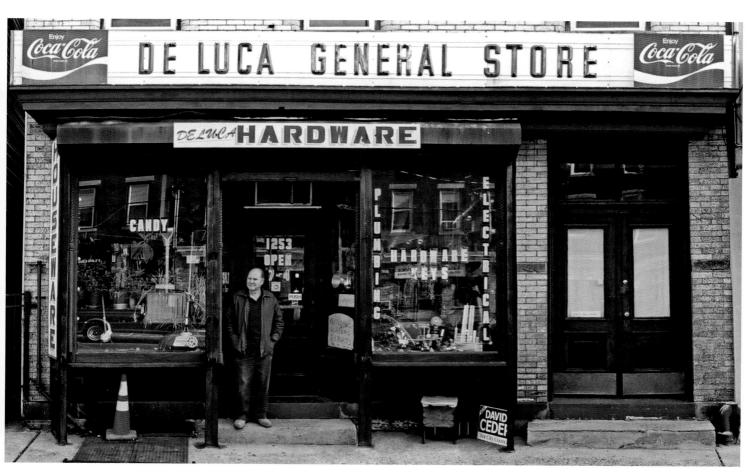

Bay Street near Maryland Avenue (2005)

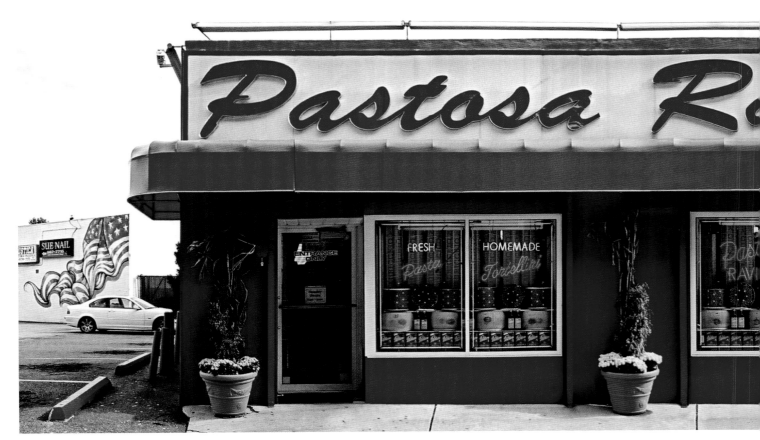

Richmond Road near Columbus Avenue (2005)

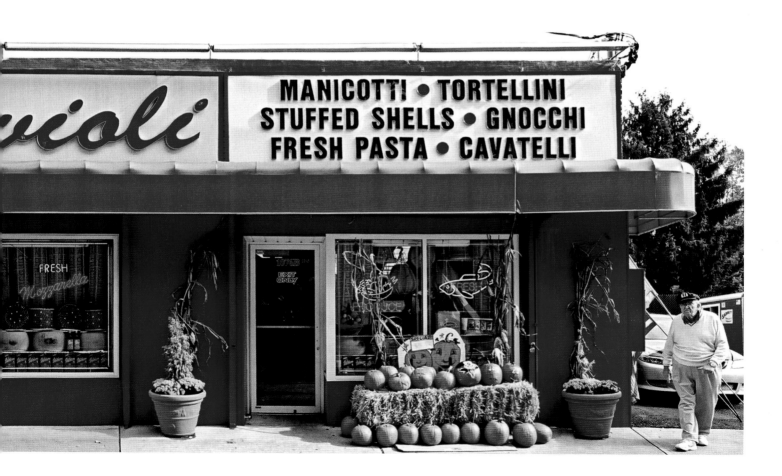

MANICOTTI • TORTELLINI
STUFFED SHELLS • GNOCCHI
FRESH PASTA • CAVATELLI

violi

FRESH
Mozzarella

STATEN ISLAND

This book is dedicated to the many 'mom and pop' stores across the city who have survived despite the many challenges.

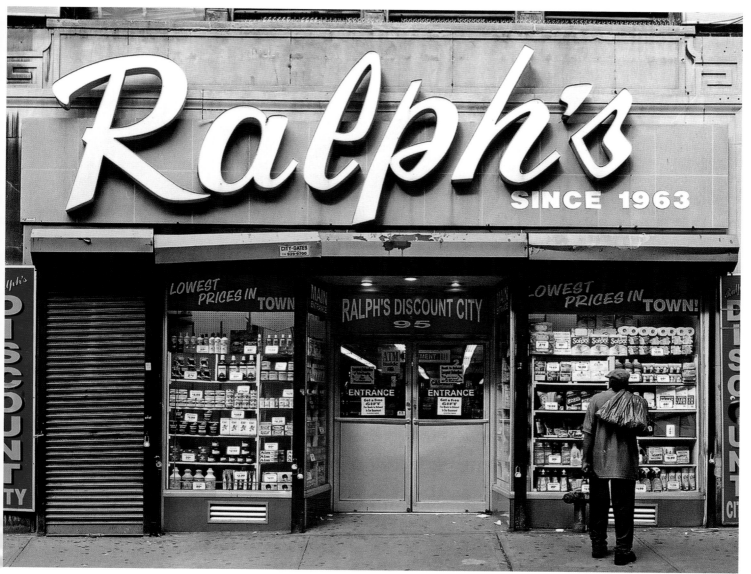

Chambers Street near Church Street [*TriBeCa*] (2004)

RALPH'S DISCOUNT CITY was in business from 1963–2007.

Authors James and Karla Murray are professional photographers who specialize in urban and low-light photography using both film and digital formats. James and Karla's photographs have been exhibited at The New-York Historical Society in New York City, the Brooklyn Historical Society and in galleries throughout the metropolitan area.

Their work is housed in major permanent collections, including the Smithsonian Center for Folklife and Cultural Heritage in Washington, D.C. and the New York Public Library. They are represented by CLIC Gallery in New York City, East Hampton, NY and St. Barthelemy, FWI.

James and Karla Murray have published three landmark books on graffiti art, *Broken Windows-Graffiti NYC* (Gingko Press 2002, revised 2009), *Burning New York* (Gingko Press 2006) and *Miami Graffiti* (Prestel 2009), which have set the standard for urban documentation. Their photographs have regularly appeared in publications around the globe including, *The Source, City Magazine, Rolling Stone, Stern* and *Time Out New York.*

James and Karla live in New York City and Miami with their dog Tabasco. Their work can be viewed at *www.jamesandkarlamurray.com.*

This book would not have been possible without the help of many people. We particularly want to thank all of the owners whose businesses and quotes appear in this book. We would also like to acknowledge the following books, which we used while researching the project: Diana Cavallo's *The Lower East Side – A Portrait in Time* (New York, 1971. Crowell-Collier Press) and Kenneth Jackson's *The Encyclopedia of New York City* (New Haven, 1995. Yale University Press).

We would also like to acknowledge our publisher Mo Cohen, and editors David Lopes and Anika Heusermann of Gingko Press. Thanks also to Benjamin Wolbergs for his design.

STORE FRONT – THE DISAPPEARING FACE OF NEW YORK
also available as coffee-table book (ISBN 978-1-58423-227-8)
336 pages, 4 fold-outs, 13 1/4" x 12", 246 color illustrations

If you're at all interested in the passing cityscape, this book is a documentary mother lode.
— THE NEW YORK TIMES

These unfussy, elegant, and richly colored photographs [...] give connoisseurs of signage, folk typography, and ambient erosion much to pore over.
— THE NEW YORKER

An enchanting new book of photographs illustrates the history and downfall of these stores, places where each and every shop window was a work of art.
— DER SPIEGEL

Soon James and Karla Murray's vivid collection of photographs may be all that remains of New York's colourful and distinctive shopfronts.
— THE LONDON TELEGRAPH

Gingko Press, Inc.
1321 Fifth Street
Berkeley, CA 94710, USA
Phone (510) 898 1195 / Fax (510) 898 1196
Email: books@gingkopress.com
www.gingkopress.com

ISBN: 978-1-58423-407-4
LCCN: 2010940793

Photography, Image Editing, Layout and Text
James T. Murray & Karla L. Murray
www.jamesandkarlamurray.com

Managing Editor
Anika Heusermann

Art Direction, Layout and Design
Benjamin Wolbergs

Copyright © 2010, Photographs and Texts
James T. Murray & Karla L. Murray

Printed in China
Fifth Printing
Other books by James & Karla Murray:
Broken Windows (978-1-58423-376-3)
Burning New York (978-1-58423-173-8)